Joe Dowden's
COMPLETE GUIDE TO PAINTING WATER IN WATERCOLOUR

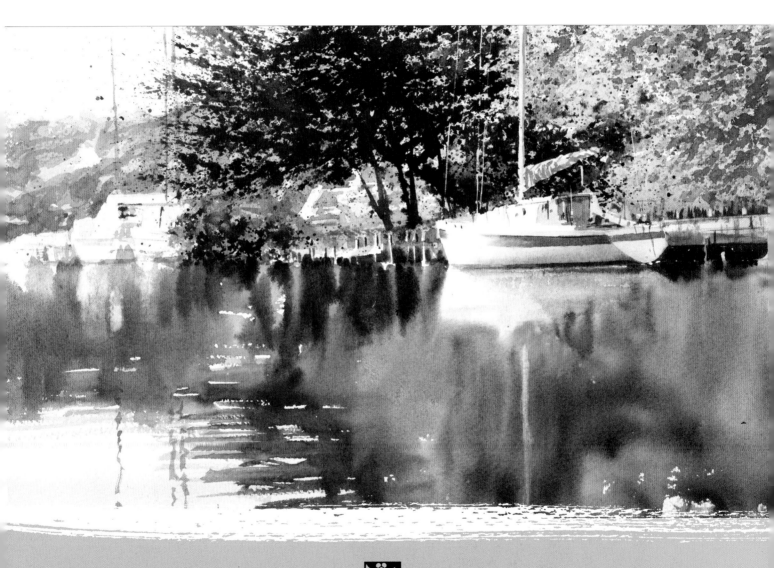

SEARCH PRESS

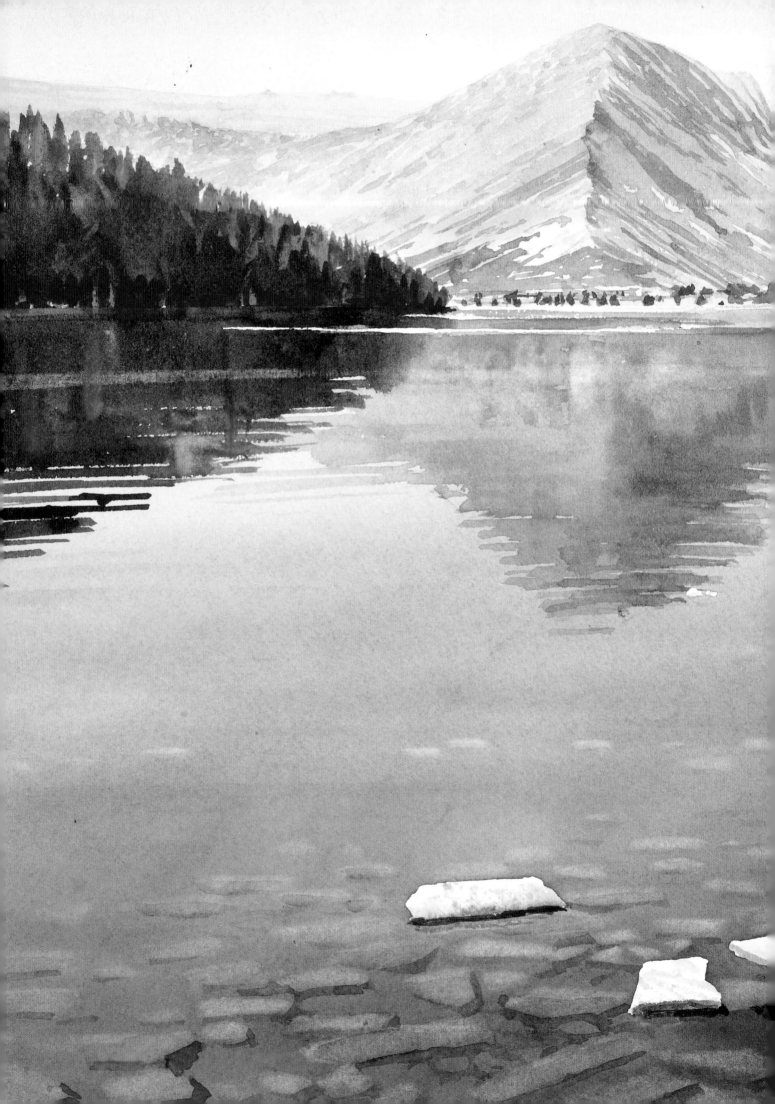

Joe Dowden's
COMPLETE GUIDE TO PAINTING WATER IN WATERCOLOUR

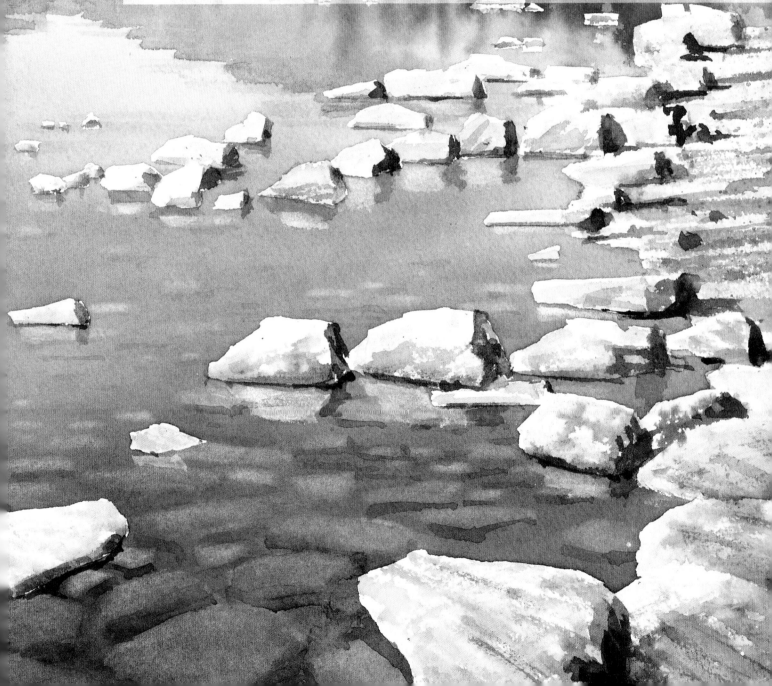

First published in Great Britain 2014

Search Press Limited
Wellwood, North Farm Road,
Tunbridge Wells, Kent TN2 3DR

Text copyright © Joe Dowden, 2014

Photographs by Paul Bricknell at
Search Press Studios

Photographs and design copyright
© Search Press Ltd. 2014

ISBN: 978-1-84448-768-4

Suppliers
If you have any difficulty obtaining any of the
materials and equipment mentioned in this book,
please go to the Search Press website:

www.searchpress.com

Publisher's note
All the step-by-step painting photographs in this
book feature the author, Joe Dowden, demonstrating
watercolour painting techniques. No models have
been used.

Acknowledgements

With thanks to Elise Dowden and Stanley Caldwell for allowing me to
paint their images in the publication. Thanks also to Richard Thaxter
for the photographs of Yosemite, USA, and to Ray Venner for the
photographs of Plitvice Falls, Croatia.

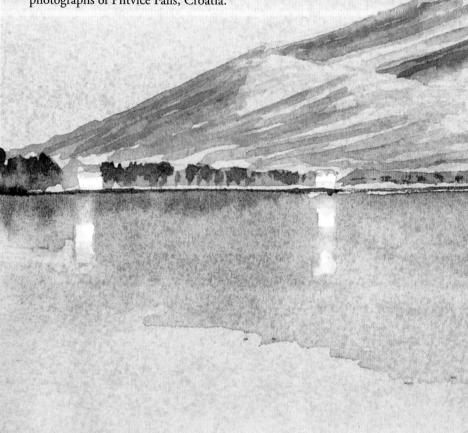

Page 1
'Freetime' on the River Ant near the Wayford Bridge
This painting is also shown on pages 142–3.

Pages 2–3
Fleetwith Pike and Buttermere
This painting is also shown on page 158.

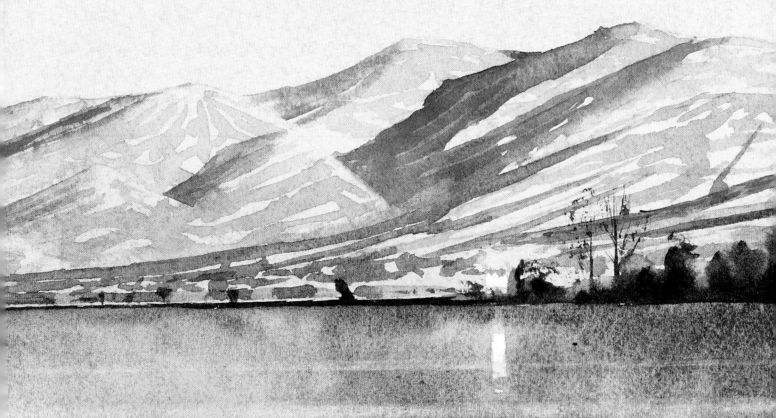

Contents

Introduction

This book is about creating realism in any kind of landscape or seascape anywhere in the world, in fact in any painting that includes water. It is about painting what you see the way you see it. I show you many simple methods for doing this which could change the way you see and interpret the world through painting. These methods work; it is astonishing to see the results. There is no limit to what you can achieve once you know how.

I paint in multi-layered watercolour, applying one manageable layer at a time. The layers combine to give realism. These techniques can give you realistic textures for almost anything. You can create not only the effect of sparkle on water, but also foliage, architecture and people. The results can represent almost anything you see.

I show you how to make water look wet and how to paint it in its many forms: rippled, reflective, deep, dappled, puddled, fast-running and sparkling with light, and there are seven step-by-step demonstrations for you to follow. Work one step at a time. There is no need to recreate the artwork in this book exactly; your paintings can be brighter or paler, looser or more controlled. Use the principles I show you, and with them you may be able to paint not only water, but just about anything else.

Joe Francis Dowden

The River Tillingbourne

This view shows the river at the entrance to Albury Park, Surrey, UK. With thanks to the Albury Estate. The techniques for painting water, the glare of sunlight and foliage as seen in this painting are all shown in this book.

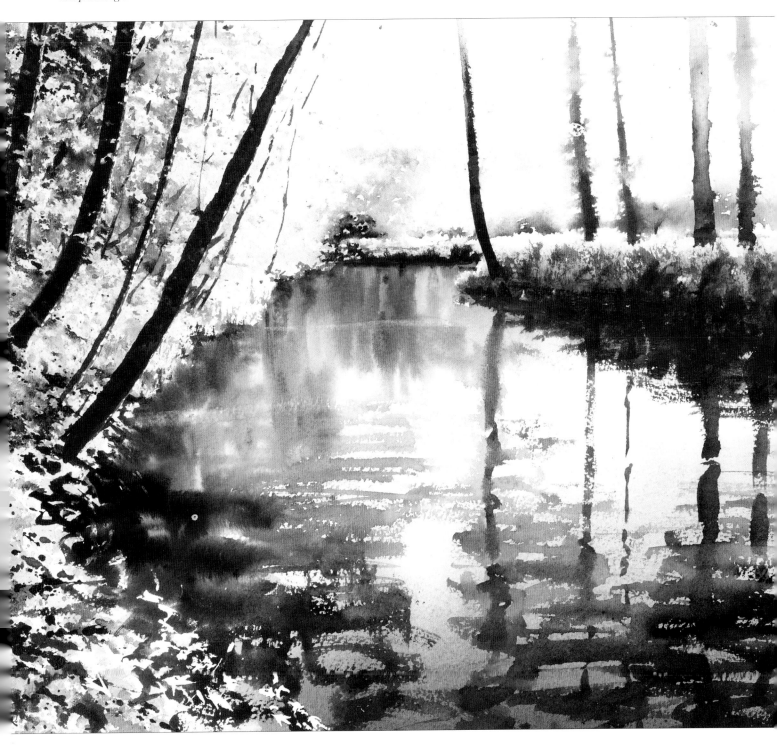

Materials

Good quality materials help but you can achieve a lot with a minimal list, and without the very best. Painters all over the world make the best of what they have and add to their collection when they can.

Paints and palettes

A suggested minimum requirement for paints would be a few tubes of good students' or artists' quality paint, perhaps the following: burnt sienna, cadmium lemon, Naples yellow, quinacridone magenta or alizarin crimson, Payne's gray or neutral tint, raw sienna or yellow ochre, ultramarine blue (or French ultramarine), cobalt blue, phthalo green and phthalo blue. If you want to reproduce the demonstrations in this book, look at the colours listed at the beginning of each project.

Some artists use a limited palette; I use an unlimited palette because I enjoy colour and want to let it infuse life into my work. This does not necessarily mean having a large number of paints; it means experimenting with new colours and new mixes. A vast range of greys can be obtained from cobalt blue and burnt sienna, but I try another route sometimes: cadmium red and phthalo blue or green, or cerulean blue and cadmium orange. This experimentation helps me to keep learning and could prevent your work from getting stale. Initially all colours are new, but when you gain confidence, that is the time to invigorate your work with new colours or ways of mixing them. I don't just try to achieve realism in my painting; I want to enjoy it and I want it to be colourful, then it will have an impact on others. On page 22 I show my current palette of colours, but I will go on making changes.

I mix colours on crockery plates. These give large, flat mixing areas, allowing lots of space for lots of paint. For travelling, I use plastic palettes with flat mixing areas. Paintings can succeed or fail on the palette. A strong tonal range requires lots of colour, so mix more than enough and make sure you do not run out. Keep paint tubes handy, as a shortage of paint, especially near completion, ruins paintings. Coaxing meagre pigment on to paper by pressing the brush becomes a kind of 'anti-watercolour', since you are using hardly any water or colour. This damages paper fibres, which absorb colour like blotting paper, and muddiness results. The palette should be well loaded, acting as a reservoir to the end, with some paint left over. Paint should flow from a loaded brush to the last stroke.

Some of my paints and palettes. For a list of my current palette of colours, see page 22.

Brushes

I have done many paintings with only one or two sable brushes, and nothing else. These are my main tool and nothing else duplicates their blend of characteristics. Sable brushes are made either from pure red sable, or Kolinsky fibres. Kolinsky fibres are generally superior, but both types are superb. They include the right springiness for conventional brushing and techniques like spattering. Sables are economical on paint because they release pigment on to the paper with ease. They clean easily so you can change colours fast. Sable fibres are wider in the middle than at the ends, creating the 'belly' of a sable, which is useful for many techniques including dry brush. Sable fibres work water upwards so the paint flows off their tips. The body has the ability to return to its original shape with a dip in water and flick of the wrist. Synthetic or mixed fibre brushes are less expensive than sable but do not share all these qualities.

Most brushes come in size and series numbers. Size refers to the ferrule diameter, the series refers to the length of fibre and the shape of the head. My main watercolour tool is the round brush, which is round-ended when dry, but pointed when wet. Sometimes round brushes are named 'pointed' or 'pointed round'. Round brushes can come in shorter, manageable lengths, which are good for detail and illustration, or longer lengths for flowing strokes and more specialised work. I favour a shorter fibre no. 6 for detail, a longer fibre no. 7 or 8 for water reflections and larger areas, and a no. 12 for large washes. Shown below are the brushes used for the demonstrations in this book:

Hake brushes Large and small flat goat-hair brushes, useful for applying large amounts of water rapidly, or gently glazing a wash of flat colour over an underlying dry wash, without disturbing the existing colour.

Round sable brushes These are my main painting tools. Shown below are numbers 10, 12, 7 and 6. Note that these are wet brushes and still pointed, though the heads are round when dry. I use the larger ones for spattering.

Sword liner These are great for painting trees and branches. This one is ox fibre, but I also use synthetic sword liners which work well.

Small, round synthetic brush Developed for oil painting but useful for masking. The fibres are similar to hog hair.

Fan blender I use my fan blender occasionally for blending large, intense washes for smoothness. The one shown in the photograph (right) is ideal. It is made of firm but soft mongoose fibre.

Bright or bristle bright This is small, chisel-ended and made from stiff white hog or synthetic hair.

Flat brush Both this and the bright are used for lifting colour from paper. Gently scrub to create a light. The smaller the brush, the sharper the light.

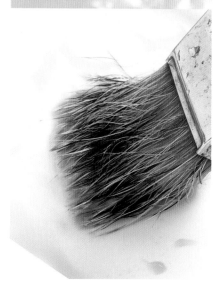

Paper

Watercolour paper is defined by weight, surface, material, and manufacturing method. Paper was once made from ships' old canvas sails, and then this changed to cotton rags. Now the main ingredients are cultivated cotton and wood pulp, and sometimes linen.

Paper weight defines its thickness and resistance to buckling or 'cockling' when wet. Common paper weights are 190gsm (90lb), which is thin; 300gsm (140lb), which is medium; 425gsm (200lb), which is thick and 640gsm (300lb), which is very thick. My preferred type is 300gsm (140lb) or 425gsm (200lb). For paintings larger than 76cm (30in) across, I use 425gsm (200lb), 640gsm (300lb) or occasionally 850gsm (400lb).

Paper surface can be Hot Pressed, which is smooth; Not (meaning not hot pressed), also known as Cold Pressed, which is slightly rough; and Rough. I use Rough paper up to 425gsm (200lb), and Not above this weight. The roughness of the surface increases with paper weight.

The material the paper is made from also affects its qualities. Cotton-based paper tends to be less white, but colour dries bright on it and it has a tough surface that resists tearing when it is masked. Some cotton papers are tub sized, which means they are dipped in gelatine size, and some are internally sized, or both internally and tub sized. Colour can be more stable when glazed or over-painted on many well-known cotton papers. My strong, multi-layered paintings require cotton paper.

Wood pulp paper can be whiter. It performs best with colour applied generously, and speedily, then left alone. Surfaces are sometimes softer and can tear when masked. These papers are often internally sized, so have synthetic wax throughout the paper, meaning that paint lifts well but can be less stable when over-painted. Wood pulp papers are cheaper, but I prefer to use cotton-based paper.

Paper quality also varies according to the manufacturing method. Handmade papers are usually based on cotton or other plant fibre, but not wood pulp. The quality varies, but the best are exceptional. Fourdrinier machine-made papers are of lower but more consistent quality. These include the cheapest watercolour papers. Mould-made papers, made by cylinder mould machine, are the finest, along with the best handmade papers. The majority are made with cotton or similar product, but there are some wood-based cylinder mould papers.

Papers vary in whiteness. Some cotton papers have a mellow tint. Some come in extra white variants, which I use for brightness. I like my paper to be as white as possible.

I use mould-made paper, 300gsm (140lb) upwards, Rough cotton paper, or Not paper above 425gsm (200lb). Most of the paintings in this book were painted on cotton 300gsm (140lb) Rough.

Paper expands when wet, and shrinks when dry. To stretch it, I soak it for ten minutes, then staple it to varnished plywood. Keep the staples away from the edge of the paper and closely spaced. Some artists do not stretch paper, others stretch those with weights up to 300gsm (140lb), to avoid the paper cockling. I stretch all papers. Make sure it is completely flat when stapled down. Bulges indicate dry spots underneath, so lift the paper and rewet these to make it flat. When the painting is complete, I cut it off with a knife first, then I lift one end of each staple with a tack lifter and then remove all the staples with a self-grip spring-loaded wrench.

Resists and mediums

I use masking fluid in two ways, protectively and constructively. Protective masking involves masking an object so you can paint the background without having to paint carefully around it. It gives a three-dimensional feel, because the background can be painted straight over the object. When the masking fluid is removed, it gives the illusion that the background carries on behind the object. Protective masking allows you to mask light, and the results can be spectacular. Constructive masking involves using masking fluid to create elements impossible to achieve by other means. The inherent qualities of masking fluid can render a wide variety of shapes, patterns and textures, for instance to create the glint of sunlight on water. I often apply masking fluid over white paper at the start of a painting, and then over subsequent washes, protecting dark tones as well as whites from still darker layers, to build a multi-layered painting.

Shown below are masking fluid and some of the tools used to apply it in the demonstrations in this book, as well as a medium I use for effects. However, even this is not a full list of what I use; whatever I need to do, I will go out and find the tool for the job. I have applied masking fluid with dried-up plants before, and used them to spatter or drag paint too.

Torn and twisted pieces of photocopier paper Dip these in masking fluid and dab them on to the painting to help create sea sparkle or lights.

Colour shaper This has a neoprene or synthetic rubber head and is used by pastel painters, but it is also useful for masking.

Hog hair brushes You can apply masking fluid with these, as in step 2 of the Sailing Boat demonstration on page 128. They were also used to create the glinting ripples in 'Scurri,' Chichester Harbour, shown on page 124–5.

Toothbrush For spattering masking fluid or paint.

White synthetic round brush This is used when you need to apply masking fluid for controlled detail.

Indian ink dip pen This can be used for fine detail and fine lines.

Ruling pen For straight and ruled lines. Use the screw to set the thickness of the nib.

Ruined brush A small, old sable brush coated with dried masking fluid can be used to create useful shapes when applying fresh masking fluid.

Gum arabic This is the binder in paint. By adding small amounts to wet paper, you can create blurred effects. The gum arabic acts like glue, keeping these soft areas stable and slowing the progress of paint over the wet paper. This is a way of reserving soft-focus areas and getting super wet-looking reflections. Gum arabic must be used sparingly because too much makes it very difficult to apply pigment, since it is like painting into glue.

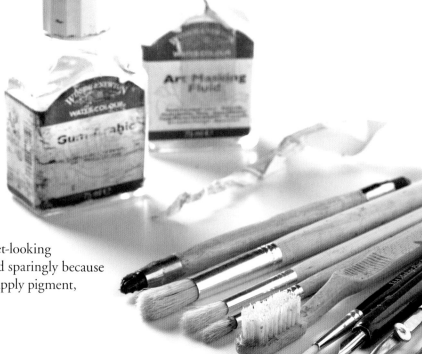

Other materials

Paint kettle Put three jam jars full of water in a paint kettle, and fill the kettle with water around them. The jam jars will not fall over and spill, and you use these for clean water. Use the kettle water to clean your brushes, which avoids getting the jam jar water dirty. You will not have to change your water for ages.

Mirror Check your work in the mirror. I use an old car wing mirror. An honest appraisal of your own work is easier when you are looking at a reflection, because the reversed image is new to the visual mind. Mistakes that others might see but that escape you become obvious in the mirror image. It is especially good for perspective errors.

Masking tape Tape the edges of the painting. It is a joy to peel this off when you have finished painting, revealing a well presented image. Be careful not to tear wood pulp papers. Peel at right angles so any tearing pulls outwards, without affecting the image.

Scrap paper Vital for testing colour, and trying ideas.

2B pencil Keep it sharp, for drawing.

Craft knife Sometimes used for scratching out lights, (sgraffito).

Ruler Check horizons with a straight edge.

Kitchen paper I always have some to hand for cleaning brushes and dabbing spills.

Template This is sometimes a rough drawing on tracing paper done in a minute or two before commencing a painting; sometimes it is a more detailed project template. It can also be used to reinstate the drawing later in the painting process, when the pencil work can disappear.

Varnished board This is a piece of 9mm (³/₈in) varnished softwood ply. The varnish prevents acid from being leached out of the board on to your work.

Wax candle Drag this across your paper as a resist, to create highlights in water or texture on rock.

Hairdryer I have three hairdryers, two big ones for the studio and a small one for travelling. They are used to speed up the drying process when appropriate.

Plenty of space The invisible but most vital commodity. Keep your work area clear of obstructions from beginning to end. You need elbow room. You cannot produce relaxed brush strokes while being constrained by objects next to the painting. Make sure you have enough room to completely revolve the painting on its board within your work area, without it colliding with water jars or tubes of paint.

Painting what you see

Ravenglass

This painting of a tidal estuary at sunset recreates the look of low evening light sparkling on wet sand. The boxes show what the constituent parts look like in isolation. The scene was painted from close observation of every detail, and I have explained how I created the effects needed to recreate what I saw. These effects don't look real until you step back and view the scene from further away, as a whole. The strength of this painting comes from observing and then recreating the contrast between light and dark in the scene. Colour has little to do with the power of many watercolour paintings; the key is strength of tone. The painting looks colourful but is painted in muted pigment. It is based on one flat wash, covering the whole painting, and a grey wash painted into it wet in wet, that is, while the first wash was wet.

Halation

This is the blurring or spreading effect of light around bright areas, an optical effect mimicked by photography. The light area was kept dry and water was brushed on to the surrounding area. I applied cadmium lemon away from the light, dry area. It spread inwards with a lost edge – a soft edge that partly disappears. An orange mix of burnt sienna and quinacridone magenta was applied outside the yellow, and allowed to blend. I applied a dark brown mix of burnt sienna and ultramarine blue around the outer edge of this, giving a soft-edged dark-to-light sequence, with white in the centre.

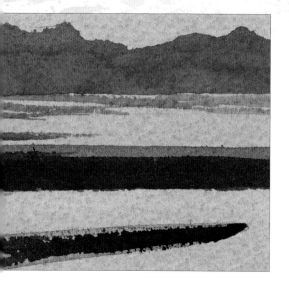

Sandbar

I allowed the initial grey wash of Naples yellow, cobalt blue and burnt sienna to dry before applying the dark brown bands of ultramarine blue and burnt sienna.

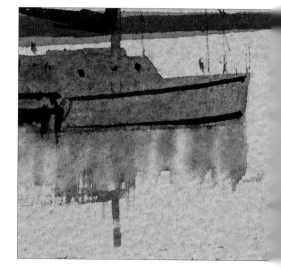

Boat and reflection

I wet the boat hull reflection area and brushed on a very small amount of gum arabic. While this was still wet, grey vertical marks were brushed into it for soft-edged reflections. The mast reflection was brushed wet on dry.

Rippled reflection of the sunset

A rough, hog hair brush was dipped in masking fluid and gently dabbed on the paper to get these masked lights. I then spattered and dragged paint from a round sable brush.

Wet sand with stones

As the tide drags in and out, it elongates dark hollows in the mud round the stones. To get these elongated effects, I spattered thick, wet Payne's gray horizontally along the beach, holding a large sable brush downwards like a pendulum and hitting the shaft against my hand. Always experiment first until you get the shapes you want. Spattering can give many variants.

Ravenglass

I masked all the lights in the painting first. The light reflections are glare on the rippling, shiny mud, not on the deep water. The sun itself is above the skyline, out of the picture. When the masking fluid was dry, I soaked the whole paper and covered it with a wash of Naples yellow. A grey of cobalt blue and burnt sienna was added to this wet in wet (while the first wash was wet). When this stage had dried, I added the skyline, mud banks, foreground texture and boat. The masking fluid was then removed to complete the painting. This painting will work with any number of different colour mixes.

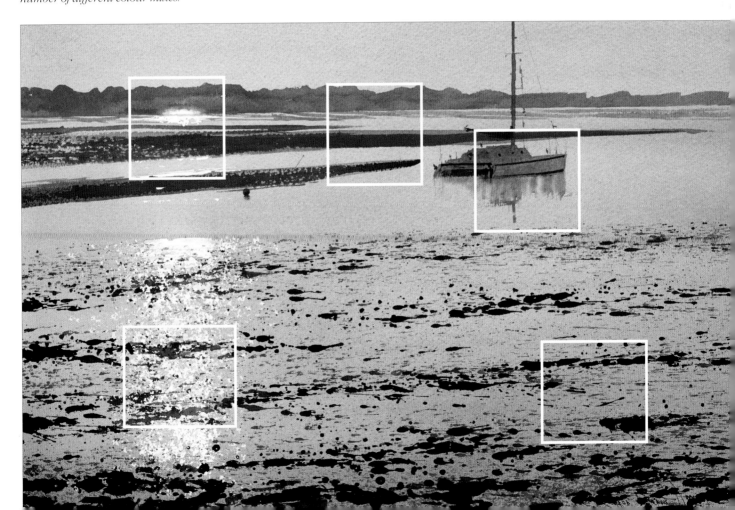

Mill Reach

When you work in this way, painting what you see in fine detail, the work can be so abstract that individual areas of the painting are impossible to decode visually, but when seen together, they create a realistic scene. This river scene is an example, as the close-up details I have pulled out show. If you want to recreate the scene, paint loosely and try not to be too tidy. See the Mixing greens chart on page 23 for the colours.

The key to painting foliage with my methods is to work in layers, and stop painting each layer before it becomes overworked. Allow it to dry before applying the next layer. When painting water, mix twice as much colour as you think you need. Work wet in wet, either on wet paper or on the previous layer of watercolour before it dries. Apply paint fast, starting with lighter colours and finishing with intense darks. Don't let the painting dry while you are still working on it. If it dries – game over! Stop working.

The riverbank and deep water

I mixed a huge quantity of colour in advance. I brushed very rich, wet yellow-greens on to dry paper, leaving the reflections of sky holes, then added darker colours wet in wet, ending with intense darks of Payne's gray and phthalo green.

Tree branches

I masked the light edges of the branches with masking fluid, then brushed on yellow-green and dried it. I spattered water on the area, then dark green. I used the dry brush technique and a brown mix of ultramarine blue and burnt umber for the twig mass, and then painted the branches with the same mix.

Dappled foliage

When the spattered foliage had dried, I spattered more water over it and then painted some branches showing through. I let the colour blend with the water and left some spaces, giving complex patterns.

Rippled branch reflections

A few highlights that were masked using a hog hair brush show through these loose streaks, painted with a mix of quinacridone gold and grey when the background reflection wash was dry.

Riverbank with overhanging foliage

Seen close up, this reflection is revealed to be black and brown with ragged holes. I loosely applied a wet mix of ultramarine blue and burnt sienna, leaving untidy holes and lights for the sky reflections.

Mill Reach, Chilworth, Surrey

Rivers like this can be seen in the temperate zones of the earth in the higher latitudes. Texture and light are combined in the painting to create foliage and water.

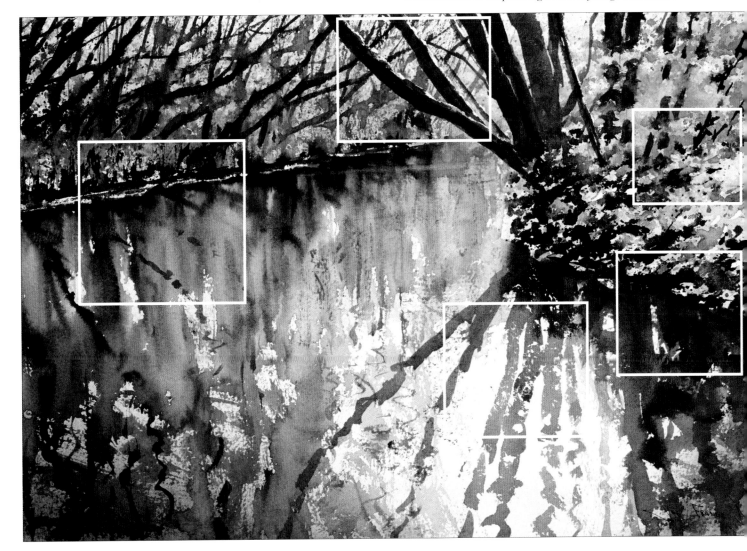

Composition and format

To compose simply, place the horizon and find the focal point. Keep both away from the centre of the painting. Draw a vertical line through the focal point, composing the entire image with two lines, one horizontal and one vertical, both offset from the centre of the image, creating four unequal sized boxes (see right).

Another method is to divide the painting into eight equal spaces horizontally, and the same vertically. Place the horizon and main composition elements at three eighths or five eighths vertically and horizontally. The division between a dark woodland mass and the sky could be placed on the vertical five eighths division line above the horizon. The horizon could be on the horizontal five eighths line. These lines are five eighths one way and three eighths the other (see below).

The principle with both these methods is to keep distinctive elements away from the centre.

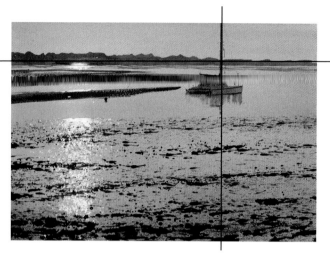

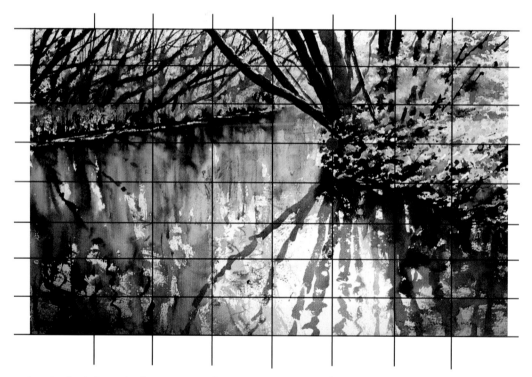

horizon

A painting's 'opening' or aperture has an aspect ratio, also known as its format. Choosing and varying formats improves your paintings. You can give your painting a boost at the outset by paying attention to the format you choose.

Landscape format equates to the human field of vision. Generally landscape will work if the aspect ratio is just over 6:4 in any unit of measurement. The short vertical sides are two-thirds the length of the long horizontal sides. Simply multiply a short side by 50% for the length of a long side. I find that it is best to add a little to the length, so the format becomes 6 and a bit by 4, or just under 6.5:4, or 8:5.

Portrait format removes everything to the sides so it can be used with minimal subject matter. A river and a few trees will create a composition in this format.

Panorama format, which is a wider version of landscape, removes foreground problems and creates drama and a sense of space, allowing you to include wide skies.

A **square** format can create impact when used on a large scale.

Calendars have given us spectacular photographs of around 5:4 aspect ratio, taken by large format 5:4 cameras, which are regarded by some as unsurpassed in landscape photography. Calendar format can also work well in paintings.

A **quarter-imperial** sheet of paper measures 38 x 28cm (15 x 11in), a format with a ratio close to 4:3, which is close to that of old-fashioned television screens. Use this format if it suits your subject and composition, but not just because the paper shape dictates it.

Choose the view you want to portray, then choose a format to suit it rather than arranging your subject matter inside a pre-decided format.

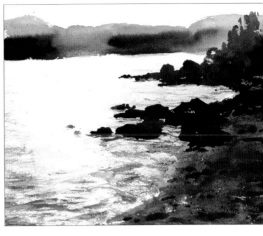

Srebrno, Near Dubrovnik, Croatia

This is 4:3, the shape of many paintings done on standard quarter-imperial sheets of paper. This format can result from simply conforming to the paper size when doing the painting. Here, however, the aspect ratio suited the scene, a rapid sketch of the Adriatic.

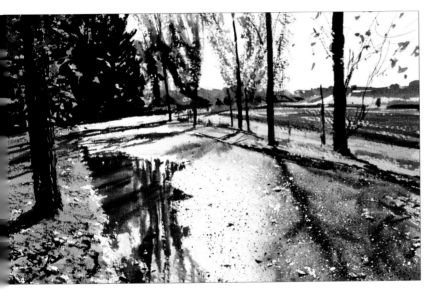

The Lane to Woolfly Farm

This is wider than landscape format with its aspect ratio of 6.5:4, being about 11:6, but narrower than a panorama. The main elements follow the three-eighths and five-eighths principle. The dark mass of trees ends approximately three-eighths across the image and the horizon runs at roughly five-eighths high. The focal point where the eye comes to rest is just inside the right-hand tree, away from the centre. A deep foreground allowed room to paint the puddle. I cropped the top to give the landscape the wider format and shift the horizon upwards.

Yosemite, USA

This painting has an extended portrait format. Richard Thaxter's photograph required a specially created composition when I used it as reference for a watercolour painting. He used the panorama format available on his camera and turned it sideways, so this is a panorama portrait. You should always make the format suit the subject.

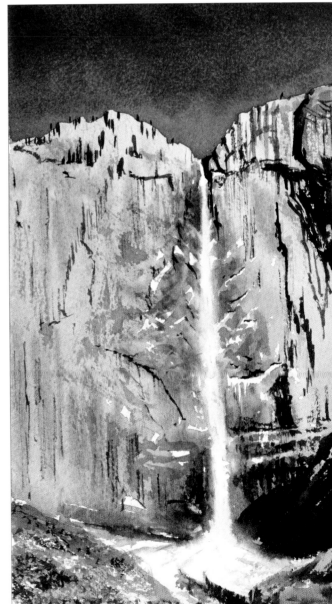

Source material

Sketching

I have sketched in situ since I was six years old. The trick is to get down what you see without worrying too much. I find the mind goes into autopilot after a while and interesting things happen on the paper, almost by coincidence. Planning broad shapes between things helps me most. Treat each sketch as a warm-up, and be prepared to start again on a fresh piece of paper.

Use the following pointers to help you overcome a fear of blank paper and get started.

- Get a clear idea of what the image looks like just in black and white.
- Do tonal sketches to show contrasts, simplifying the tones with a pencil or pen.
- Choose one of the images and sketch it on your watercolour paper.
- Put your painting board to one side and get some scrap watercolour paper.
- Start mixing your colours, using plenty of paint, and test the mixes on scrap paper.
- On your watercolour paper, apply a layer of warm, pale grey wash. Reserve all the lights by keeping them dry and not painting them. Let it dry.
- You have a drawing, a tinted sheet and the lights. Now you can start your watercolour sketch.

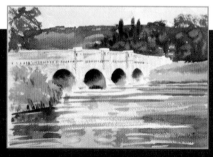

Houghton Bridge, The River Arun, Sussex

This sketch was painted in the morning with the bridge in shadow, but I barely painted it at all, simply letting the dark background define it, with the arches standing out in the bridge. The light-dark-light tonal plan is the basis of the painting. All the background detail was painted wet in wet in a few minutes, but by pulling a few distinctive shapes into the sky, I made it look much more detailed. In the afternoon the sun lit the bridge a bit like the painting.

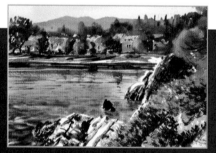

Zupa Dubrovacka, Dubrovnik, Croatia

A wash of blue-grey was brushed on to the entire painting, leaving whites on the limestone rocks and far beach. All the colours for the rest of the image were prepared in advance. This preparation leaves you free to paint with vitality. The hills were brushed with a blue-grey, and darks for the trees were added wet in wet. I added more washes to build up darks while reserving lights. These were painted wet in wet except where it was vital to retain white or light such as the roofs and rock detail. Saving whites, building up grey, and using plenty of rich pigment were the keys to this watercolour sketch.

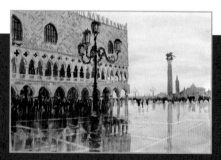

St Marks Square and the Doge's Palace, Venice

I brushed a wash of grey over the whole image, then painted the building on the left over this, wet on dry. I brushed in reflections and placed darks wet in wet on the ground, but wet on dry on the buildings. The pavement markings were lifted out when the painting was dry.

Photography

Here are some tips for taking good reference photographs.

- Take photographs in bright sunlight.
- Take photographs early or late in the day: before 10.30am or after 2.30pm.
- Shoot into the sun, (often with the sun out of the picture but just above or to one side).
- Set your digital camera to the 'cloudy', or 'shade' setting to get warm colour and beautiful landscapes.

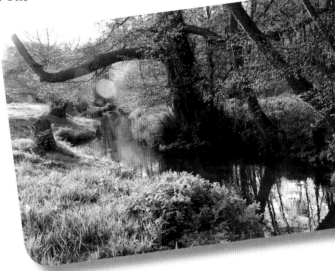

This scene was shot on a spring evening, looking towards the sun. The camera was set on a colour temperature of 5600 Kelvin. Kelvin is used as a measure of the hue of light. Colour temperature goes from cold and blue at about 8,000–10,000 Kelvin, down through yellow to warm and red at below 2000 Kelvin. By experimenting with colour temperature settings and reviewing images, you can increase or decrease the warmth of an image and compare it with the real setting. In addition, this can correct cold blue/grey images taken in low light. For simplicity you could warm up photographs by setting your camera to 'cloudy' or 'shade'. The picture will be warmed up or shifted away from blue and toward orange hue. Here, the sun is just out of the image. The lens flare is useful because it points to the sun, so I know where the light source is when I paint it. Imaginative use of photography has broadened my range of work, and I still paint in situ.

Spooners Reach, Albury

This was a demonstration painting for Romney Marsh Art Society. I soaked the paper for too long and the size had been partly washed out, so it kept absorbing colour as I was painting it. To get the warmth of the image, I used green gold and quinacridone gold. It lost some of its vibrancy but in the end became mellow and moody; almost sombre. The painting was drinking all the colour I could mix, and at the end I was running out of time so I had to throw the reflections down in a minute or two, but those last few seconds of work lifted the painting. While the reflections were wet, I brushed some elongated darks for underwater markings in the river.

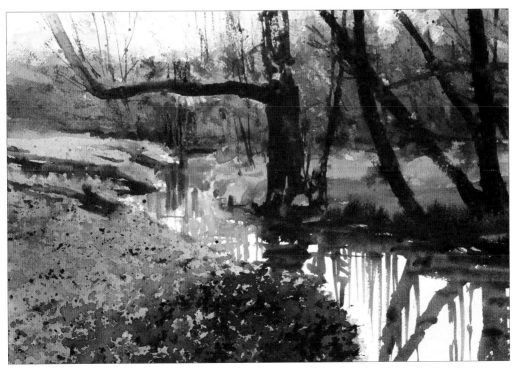

Colour

The human eye can discern about a million colours, according to some research. These come from six spectrum colours, consisting of three primary colours, red, blue and yellow, and three secondary colours, violet, green and orange. Between each primary and secondary are tertiary or third rank colours, turquoise between green and blue for example. These are all bright colours, and they occur only when two primary colours are mixed. If all three primary colours, blue, yellow and red, are mixed, a grey is produced. For example, red is a single colour but green is made from yellow and blue, so a mix of red and green involves all the colours: red, yellow and blue. Watercolour pigments will mix to produce a vast range of different greys (see page 24). Using and understanding these greys is important. This also generates diversity of colour.

My palette

A full palette of useful colours is shown below. I enjoy colour and feel that experimenting with new colours and different mixes infuses life into my work. Sometimes I avoid my favourite colours so that I have to try new ones. Use the lists of colours at the beginning of each project if you want to follow them step by step.

Cadmium orange	*Cobalt violet*
Quinacridone gold	*Quinacridone magenta*
New gamboge	*Cadmium red*
Cadmium lemon	*Indian red*
Green gold	*Light red*
Phthalo green	*Burnt sienna*
Permanent green	*Burnt umber*
Cobalt turquoise	*Raw umber*
Cerulean blue	*Raw sienna*
Winsor blue (green shade)	*Yellow ochre*
Cyan	*Naples yellow*
Cobalt blue	*Neutral tint*
Ultramarine blue	*Payne's gray*

Mixing greens

There are estimated to be 750,000 greens visible to the human eye, or three-quarters of all colour. The secondary colour green, mixed from just blue and yellow, is seldom seen in nature. What we call green is actually a mix of all three primaries. A good way to mix natural greens is to do the same. I start with a lot of yellow, add a little phthalo green to make it a little green, then warm it with some burnt sienna, then add a little more green. If it goes too green, put that colour to one side and start again. Yellow can be turned green easily, but green cannot be turned back to yellow. Start with yellow and turn it green with small steps. You can use virtually all other colours to make a green.

I find lemon a useful base colour because it is close to the primary yellow; and cadmium lemon because cadmium colours are semi-opaque. These yellows are less easily overpowered in mixes than non-cadmium yellows. Experiment with your own mixes. Adding burnt umber can give very realistic grass greens. Make a colour chart by masking a grid, as shown below. Start with yellow at the top of each column and then gradually add other colours to create different greens. Remove the masking to observe the grid and select the mixes you need.

A panel of colour applied wet in wet, with burnt sienna in the bottom right-hand corner, cadmium lemon on the left and phthalo green in the top right-hand corner. The blend area has a range of natural greens, which mixed on the paper.

The green grid

Column 1:

cadmium lemon with Payne's gray

Column 2:

cadmium lemon with cerulean blue

Column 3:

cadmium lemon with cobalt blue

Column 4:

cadmium lemon with phthalo green

Column 5:

cadmium lemon with burnt sienna and phthalo green

Mixing greys

Greys are immensely useful in watercolour, not just for working tonally but for adding to colour to mix realistic hues. If you can't work out what a colour is, it is most likely to be some kind of grey. Experiment by making greys, then adding a colour to them. A tree trunk could seem brown, but it might also be seen as grey with a green/brown bias. Start with a brown-biased grey from this chart and add small amounts of green, perhaps mixed green as on the green grid.

You could try mixing cerulean blue with cadmium orange; cobalt blue with burnt umber or light red; or other blues with other oxide earths (earth-based pigments such as raw sienna, burnt sienna, yellow ochre or Indian red). The grid shown below was produced by mixing three different blues: ultramarine blue, cerulean blue and cobalt blue, all with burnt sienna. The most neutral greys appear in the middle of the grid.

The grey grid

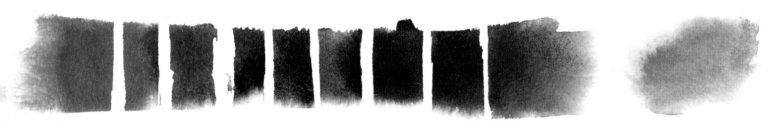

Ultramarine blue with burnt sienna gradually mixed in.

Grey mixed from ultramarine blue and burnt sienna.

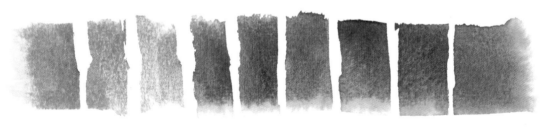

Cerulean blue with burnt sienna gradually mixed in.

Grey mixed from cerulean blue and burnt sienna.

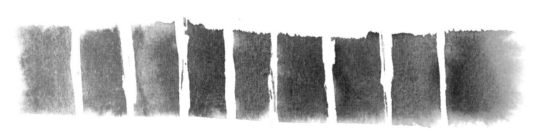

Cobalt blue with burnt sienna gradually mixed in.

Grey mixed from cobalt blue and burnt sienna.

Tone

Much success in watercolour is about grey scale, the relative darkness and lightness in a painting, and not about colour. This concept can be hard to grasp. An understanding of grey scale, also known as tonal value, can be achieved by painting in situ with black pigment only. Students are surprised at the professionalism of their first monotone paintings. Conveying the visual message without colour enables painters to use tone effectively. They can apply this to normal painting, but it can take practice when using colour. Black and white photographs of your paintings can reveal a lot of useful information about tone. If they work in black and white, they are likely to work in colour.

Exercise

Try painting a bright scene with only black paint. Being dependent on tone alone for results is good training. A general principle is as follows: If a painting works in black and white, it will work in colour, and if it doesn't work in black and white, it won't work at all. You can test a painting out by photographing it in black and white.

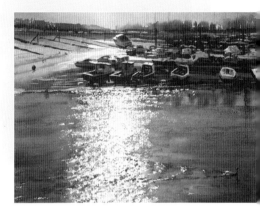

Littlehampton

This painting illustrates the concept of grey scale, and its success depends almost entirely on grey, not its use of colour, which is secondary. Notice the brightness is still achieved in the black and white. I use the whitest paper possible, remembering that some very white wood product papers rip when this type of masking is applied. As with most projects in this book, I painted this on 300gsm (140lb) Rough paper. The sunshine is achieved through layers of tone. The light in this painting is rendered using techniques demonstrated on steps 1 and 2 of the Sailing Boat project on page 128. I masked the sparkle and white highlights in a broad vertical band. Then I applied a big wet wash of pale colour, consisting of cobalt blue and burnt sienna, with quinacridone gold added. The wash was made darker at the outer edges, and I varied the colour, making it warmer and paler towards the centre and nearer the masked reflections. The pigment reflects the warmth and colour of the scene, but not the light and structure. The following layers of grey were darker: I applied a blue-gray layer to the boat area with the shape of the top left boat, and those below, defined against the light. After I painted these boats, I masked the lights on them again. A common mistake would have been to mask white, where they are actually pale grey, which I achieved by masking over the first layer of paint. After masking, I applied further layers of dark, using French ultrmarine and burnt sienna and letting each dry before continuing. I used Payne's gray for the darkest darks. The painting now has the full range of tone.

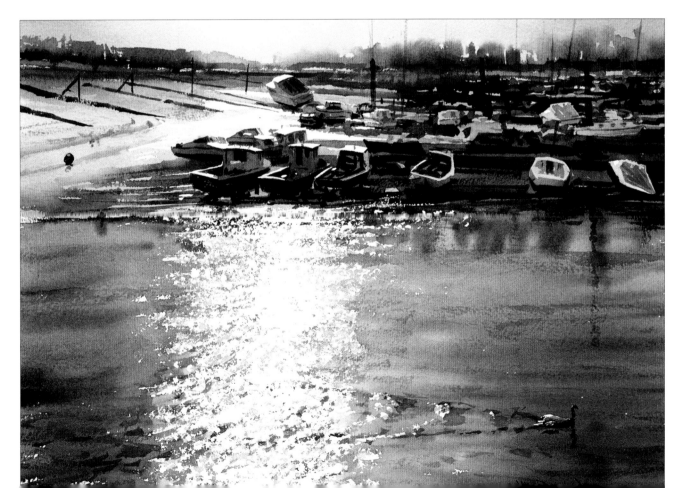

Perspective

Perspective need not be difficult. Get it right and it will go unnoticed; get it wrong and it is all that will be noticed. Here are some simple guidelines.

Finding the horizon and vanishing point

Find the horizon. The horizon level or line is always at your eye level. You look down on everything below your eye level and you look up at everything above it. Perspective lines or edges below this level will slope up towards it, and if you draw them in and extend them, they should meet on the horizon. A straight road disappearing into the distance would have lines converging to a point on the horizon, like the lines along the river in the illustration shown here.

The river meanders so it does not have straight sides like the added guide lines, however, loosely defining perspective helps to find where the river is and place its disappearance at or below the horizon. In this scene, the river disappears from our view below the horizon line because it goes round a bend and out of our sight at a point nearer than the horizon. The principle factor is that it simply will not go out of sight above the horizon. On level ground, the horizon is approximately three miles away. The river disappears out of sight round a corner at a few hundred feet, which is still a little way below the horizon.

Lines defining any object which is above your eye level, such as a building, would slope down towards the horizon like the image lines above the horizon on the left. Reference points for perspective above the horizon are absent from this natural image, but understanding the principle is still important when painting the natural world.

A river scene with a horizon line drawn in, and guide lines showing the river's edges sloping upwards towards the horizon. In this natural, wooded scene, the river actually bends out of the viewer's sight below the horizon, but it is still useful to the artist to plot the perspective lines meeting at the vanishing point on the horizon.

Painting water

The following are seven simplified projects using only four steps, and brief instructions, with more explanation for each project with the finished painting. Use the images as your guide. The paintings were all painted with a no. 7 round brush and a no. 3 for fine detail. Dry the painting after each step unless otherwise stated. Read through each set of instructions before following them through to do a painting.

Using tone to paint low sunlight on water

In this painting the grey scale runs from 1 to 5 (see the grey scale chart below), plus the white of paper:
1) an extremely pale tone for the orange/grey sky
2) pale grey for the darker sky
3) mid-tone grey for the horizon
4) dark for the distant mud banks
5) intense dark for the foreground mud banks and the boats.
The vibrancy in this painting comes from tone and has little to do with colour. The intense dark in the foreground contrasts with the white paper of the sun. It also sets off the orange reflection glare.

Colours

Cadmium orange and neutral tint

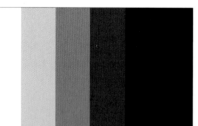

1 Mask the sun and reflection. Allow the masking fluid to dry. Wet the paper and apply a pale mix of cadmium orange with a little neutral tint.

2 With the paper still wet, apply neutral tint, avoiding the sun and reflection area. Paint dark lower down, and use the darkest tone on the left. Allow to dry.

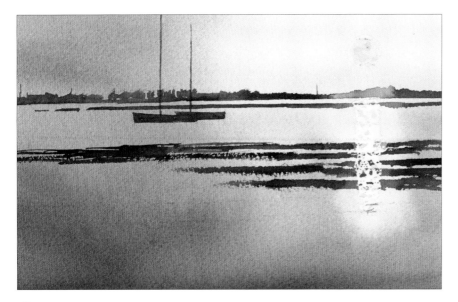

3 With the paper dry, brush the horizon tree-line with a pale mix of cadmium orange and neutral tint. Keep the areas round the sun's masked glare and reflection pale and paint the horizon and distant mud banks with darker neutral tint. Apply a darker mix to paint the boats and mid-distance mud banks.

4 At the final stage, paint in more intense darks with neutral tint to suggest the foreground mud banks. These darks contrast with the orange of the reflection. Allow to dry, then remove the masking fluid. The sun is barely visible, but was kept pigment free by the masking fluid. Join the pale mud banks with a light mix of orange and neutal tint across the masked track of the sun.

The finished painting.

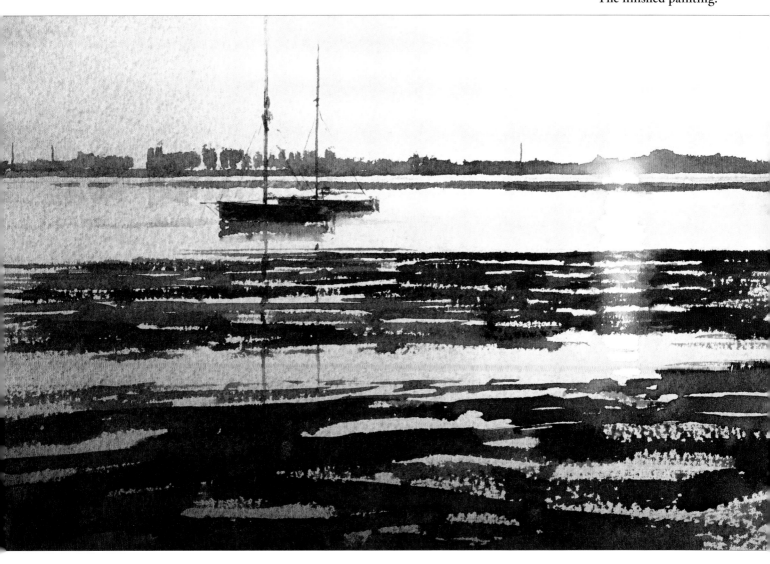

Sunlit water

This translucent muddy water is alight with sunshine. Paint it very loosely. The key is high tonal contrast from light to dark. Here the lesson of grey scale applies to a colourful image. For greens, refer to the green grid on page 23 and use page 24 for greys. Mix and use plenty of rich, wet colour at all times.

Colours

Cadmium lemon, burnt umber, Naples yellow, ultramarine blue, burnt sienna, phthalo green, Payne's gray

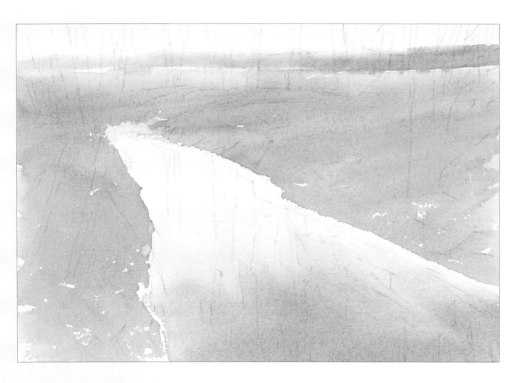

1 Apply brown/yellow green to the grass and blue-grey along the horizon. Wet the river and apply blue-grey from the bottom, graduating to white paper half-way up.

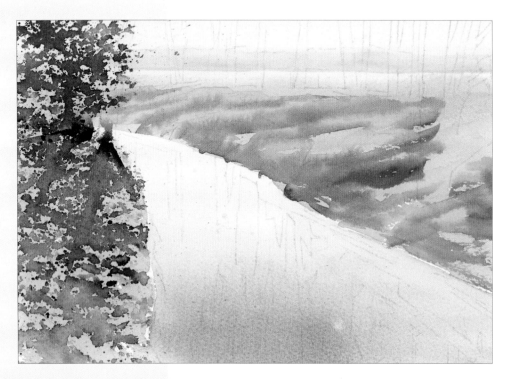

2 Wet the far riverbank and apply grey-greens in stripes wet in wet. Spatter water on to the near riverbank and trees by banging the brush handle down on your palm. Work from the bottom up each time you reload with water so droplets diminish as you go. Repeat with rich, dark green paint on top, using the point of a no. 7 brush. Allow to dry before spattering another layer of water, then paint.

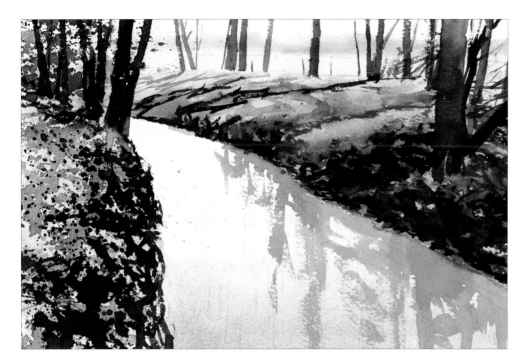

3 For the trees on the opposite riverbank, drag a grey mix of ultramarine blue and burnt umber upwards. Brush and spatter a dark green mix of Payne's gray and phthalo green over the nearside and opposite riverbanks. Brush in the tree trunks on the right-hand side. Spatter dark green on the left and brush in the tree trunks. Make a strong, wet mix of Naples yellow, burnt sienna and yellow-green. First, drag water across the rough paper suface, leaving a textured pattern of wet and dry, then apply the colour with the brush to create the effect of reflections in sparkling water. This is known as water feathering.

4 At the final stage, dry brush more wet colour across the wet reflection area and add Payne's gray shadows. Leave sky-hole reflections. Apply Payne's gray darks to the riverbank. Use a damp brush to lift out some tree roots on the right-hand side, then dab them with kitchen paper. To create the edges of trunks at ground level, brush upwards over the edges of a paper mask set below the trunk bases.

Brook near Kirdford, Sussex

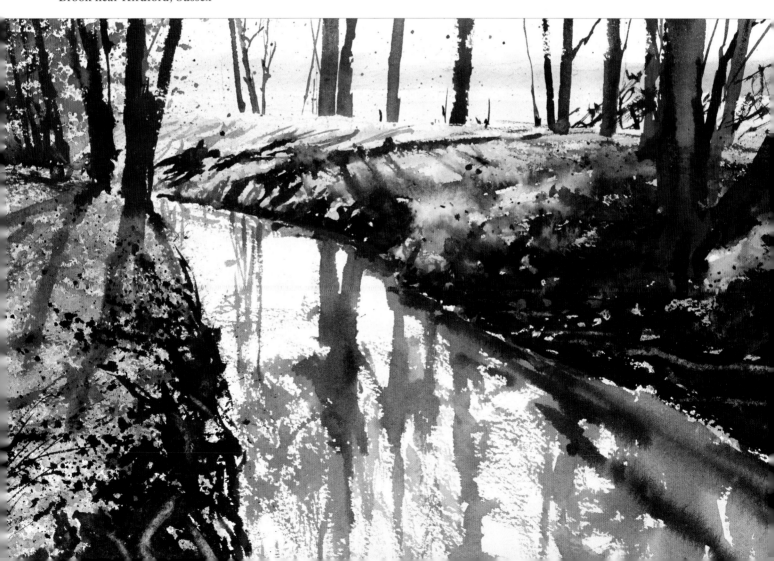

Deep water

Realism in water painting depends on the water's surroundings. On its own, the water in this image would not look real. Build the rocks wet on dry, one layer at a time. Apply paint to the water wet in wet. For the rocky greys, start with the cobalt blue and add the brown in small amounts. Reserving the whites throughout is vital. Make sure you mix all the washes you need before beginning each stage.

Colours

Cobalt blue, burnt sienna, yellow ochre, ultramarine blue, quinacridone magenta, phthalo blue, Payne's gray, green gold, phthalo green, Naples yellow, cobalt turquoise light

1 Dry brush generous quantities of a grey mix of cobalt blue and burnt sienna on to the rocks, adding yellow ochre to the mix before applying it to the warm areas on the left side of the rock. Add a dark of ultramarine blue and burnt sienna wet in wet from the point of a brush to the deep shadow areas. Dry brush the upper rocks with a quinacridone magenta, burnt sienna and cobalt blue mix for a pinkish grey. Wet all the water area and apply strong phthalo blue darkened with a little Payne's gray. Let it spread upwards. Apply a wash of cobalt blue and burnt sienna grey for the distant ridge, and green gold with phthalo green and Payne's gray for the 'v' of foliage in the gap to the left of this.

2 The paint has dried a little lighter but more dark will be applied. Apply grey as in step 1, using ultramarine blue and burnt sienna, in large wet washes, dry brushing in places, and reserving whites. Apply dark of strong ultramarine blue and burnt sienna to the top area, leaving light spaces for wilting palm fronds. Apply a wet on dry wash of Naples yellow with the cobalt blue and burnt sienna grey to the pool, stopping at the edge of the blue area. Apply darker grey wet in wet to the shadow area in the pool.

3 Apply medium cobalt blue and burnt sienna greys to the background rocks, and darks of ultramarine blue and burnt sienna to the foreground rocks. Apply water first where you want soft, 'lost' edges. Apply strong cobalt turquoise light to the water, reserving Naples yellow lights for the rock reflection and avoiding the sky reflection.

4 Apply palm trees with a mix of phthalo green and Payne's gray. Dry brush the rock surface texture using greys. Apply the fissure pattern with Payne's gray, using the water feathering technique. Drag a well-loaded brush of clean water over the fissure area. Immediately apply the dark with the point of the brush for a broken, textured effect, as the colour flows into the dry brush texture of the feathered water. Work on the water area while it is still wet from step 3. Blend darks of Payne's gray into the wash. Place a lot of dark reflection below the rocks. Brush soft-focus vertical marks. Save some soft-focus, wet-in-wet lights and add more Naples yellow and cobalt turquoise for richness and depth. Reserve hard-edged lights by keeping them dry. Lift out lights that are lost with a damp brush. A few extra lights were lifted in the dark reflection mass on the right.

Arabian Wadi

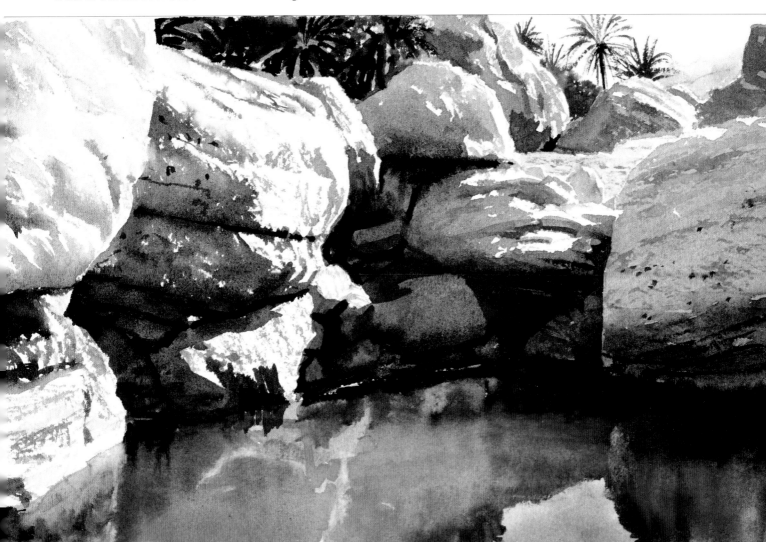

Upside-down sky

An upside-down wet in wet wash painted from the bottom up can create the effect of water for you simply. Use water to soften the colour from dark to light, as when painting a sky downwards. When the water is dry, the other reflections can be applied. There is little visible sky in this image, but the foreground water reflects the sky the same distance above the horizon as the reflection is below. The sky being reflected is above the top of the painting, and it is darker there. The foreground reflection also picks up dark colour from the lake bed.

Colours

Cobalt blue,
quinacridone magenta,
burnt sienna,
cadmium lemon,
phthalo green,
Payne's gray,
ultramarine blue

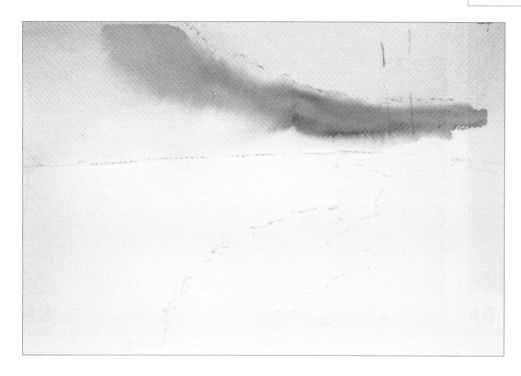

1 For this demonstration, the sky is left as white paper. Paint the hillside with clean water. Apply a blue/violet grey to this with a mix of cobalt blue, quinacridone magenta and burnt sienna. Do not paint the colour right to the top edge of the hill, but allow it to find its own way there to give the soft, misty effect.

2 While the hillside is still wet, finish it rapidly by applying a varied green mixed from cadmium lemon, a little phthalo green and some burnt sienna. Mix a dark of ultramarine blue and burnt sienna, then paint this darker mix on the lower part of the woodland.

3 Wet the lake with clean water and brush in a dark blue/grey mix of phthalo blue and Payne's gray from the bottom in horizontal strokes one above the other. Reduce the pigment on the brush as the brushstrokes get higher. About halfway up the lake, apply clean water only and blend the blue/grey mix into the wet white paper.

4 Finish the hillsides with dry brushed and dragged tree canopies of ultramarine blue and burnt sienna. Spatter and drag the foreground lakeside bank with darker versions of the green colour. Brush the reflection mass in quickly with a very wet dark brown of ultramarine blue and burnt sienna, then drop in many other colours previously used above and streak them vertically downwards. Create the ripples on the reflection edge with loose, sideways brush strokes. Brush down some final darks, then leave the painting to dry. Lift out streaks with a damp brush. Paint a few grasses along the water's edge with their reflections.

Lathkilldale, Derbyshire

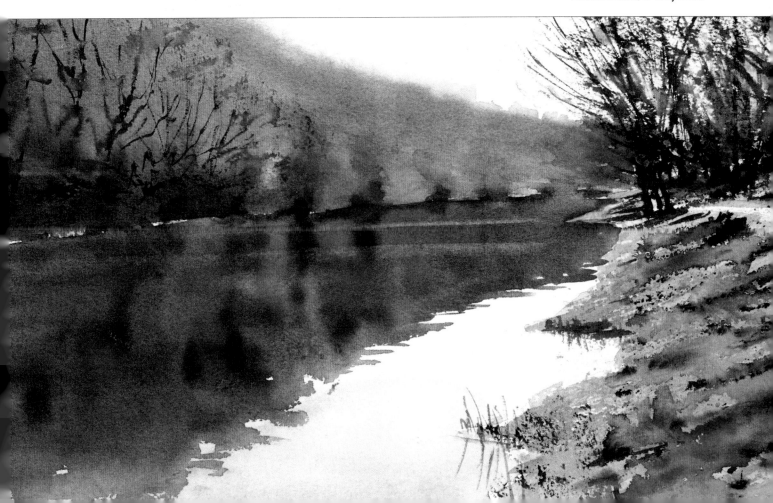

Rippled water and boats in Venice

A complex scene can be painted by having a simple management plan. First identify the lights. Second, create a simple blueprint which defines not only the light, but how everything else appears. Next find the components: the pigments which will give us the overall colour and tone of the scene. After placing that layer, find the darks and put on the descriptive final elements which say what the painting is, here the darks are for windows, boats and roofs.

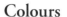

Colours

Cobalt blue, Naples yellow, cadmium red, phthalo green, Payne's gray

1 Find the whites and mask them. Carefully observe the final image opposite before proceeding. This is treating space as an entity, often a dynamic one, and using it to create the painting. Carefully map out the sky around the chimneys and roofs in masking fluid. Mask the lower set of ripples and some lights representing the roofs. Next apply a pale mix of cobalt blue, Naples yellow and cadmium red over the whole painting. This wash should be redder higher up and blue/grey lower down.

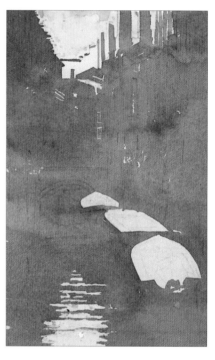

2 Mask the window frames and a straight edge above the bridge (see the final image), using masking fluid. Mix Naples yellow, cobalt blue and cadmium red. Brush this over the image, reserving the light grey boat tops. Notice how the masking channels the paint between the chimneys.

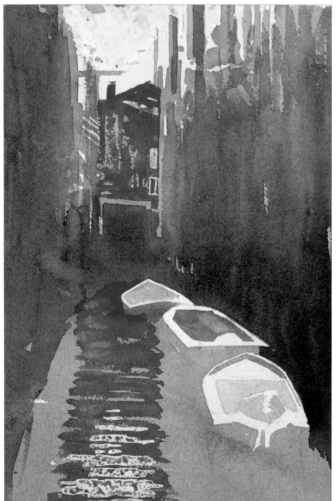

3 Brush on a darker mix of cobalt blue, Naples yellow and cadmium red, saving lighter facets of the chimneys and a few light streaks on the buildings. Brush a mix of cadmium red and Naples yellow over a central band in the water and up the centre of the painting, not trying to model any detail, simply allowing the masking to do the work. Model the boats' internal spaces with grey and grey-green with added phthalo green, reserving lights for the next stage. Add more dark grey to the central area of the painting and lower parts of the buildings.

4 Apply Payne's gray for all the remaining detail from the point of a brush, modelling the boat interiors, the windows and roof lines, bridge arch and coping, and the boat sides. The Payne's gray reflection is loosely brushed down in quick, rough, rippling strokes, leaving some spaces of the previous wash in between. Brush some darker green on to the boat tarpaulin before applying Payne's gray lines. When dry, remove all the masking fluid.

Venice, from Ponte de le do Spade

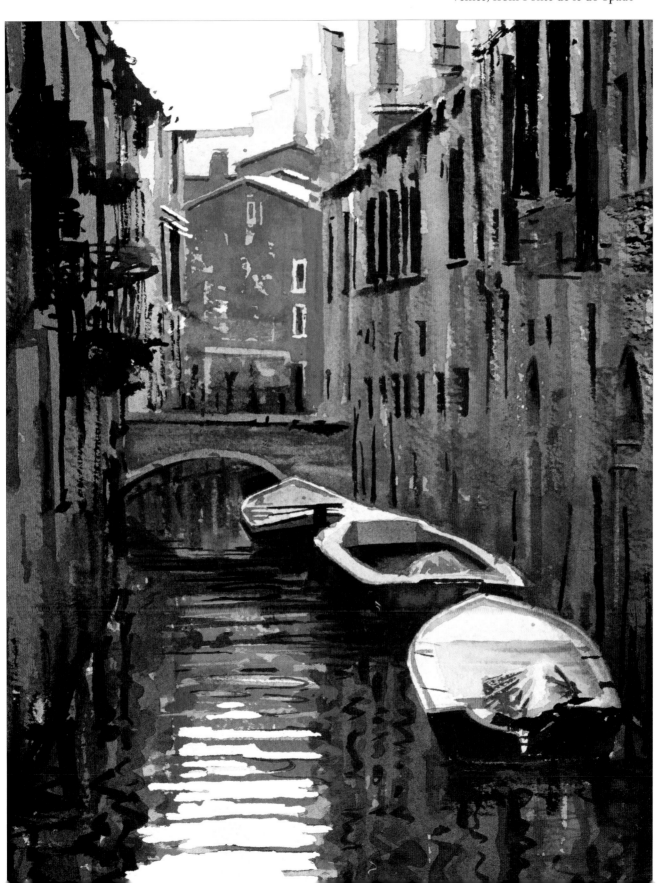

Waterfall

Combining techniques creates realism with ease. Keep it simple by painting the image one layer at a time, not expecting realism until the final stage. When complete, the layers combine to produce the painting.

Colours

Cobalt blue, quinacridone magenta, burnt sienna, cobalt turquoise light, Payne's gray, cadmium lemon, phthalo green

Tip

Before masking, see the finished image opposite and note that the falls were masked with diagonal streaks, spaced wider in rapid succession as they fall; a common visual feature of large waterfalls. Notice the semi-circular bands of masked foam in the lower pool.

1 Mask the waterfall highlights, a few horizontal markings in the pool above and more scattered and curved markings in the lower pool, using masking fluid. I applied this with a white synthetic round brush (see page 12). Dry brush a blue-grey mix of cobalt blue, quinacridone magenta and burnt sienna for the falling water.

2 Mix cobalt turquiose light with a little cobalt blue, quinacridone magenta and burnt sienna and carefully drag a dry brush over parts of the waterfall and the pool, reserving light areas. Notice the soft edge at the base of the lower falls, and the white light area below. Reserve this by not applying colour. Brush water in this area to soften the colour as it is applied to the base of the falls.

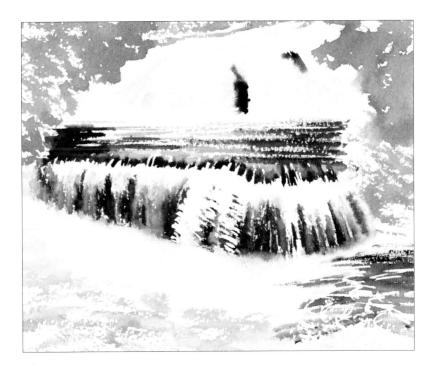

3 Use the water feathering technique, dragging clean water across the surface of the pools and brushing Payne's gray into the dragged water. Do the same in the waterfall, dragging water upwards and being careful to reserve dry white areas, creating dark vertical shadow for contrast. Brush green mixes of cadmium lemon, phthalo green and a little Payne's gray over the tree area. Allow to dry. Remove all the masking fluid. Start applying Payne's gray over the upper falls as with the lower ones.

4 Complete the upper falls by applying Payne's gray in dark patches of colour with soft and hard edges. Apply water where the soft edges are required, then apply paint so it blends with the water to produce soft edges. Criss-cross brush strokes of Payne's gray wet in wet into the tree area. The soft edge of the lower falls, where they drop into the spray, is achieved by always maintaining wetness in the white spray area before applying colour above it in the falls. This way the falls always have a soft or 'lost' lower edge. These lost edges can belong to washes which have hard or 'found' edges elsewhere, completing the effect of 'lost and found edges'.

Plitvice Falls, Croatia

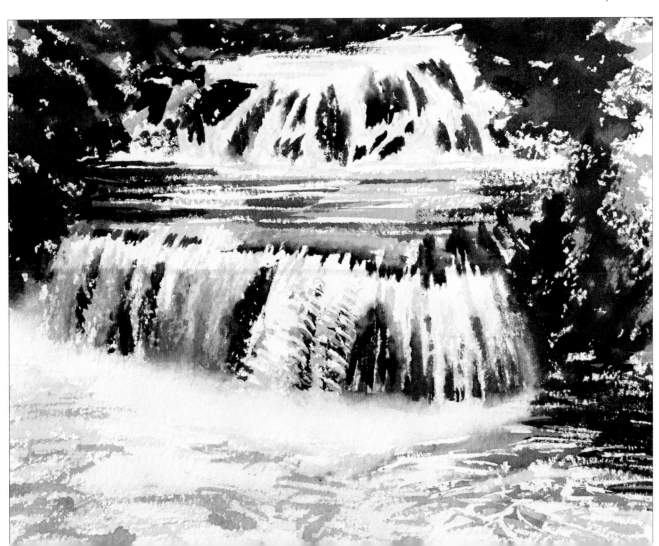

Wet pavement

In this painting, all whites are masked at the outset. Layers of colour are added one over the other, reserving unpainted light areas in the previous wash. Bright light is masked, then glazed over, then lights in the first wash are masked. Darks are added in the later stages – the 'handwriting' that says what the scene is. For final definition, masking fluid is removed and the black is applied. The distribution of colour is controlled with water from the first wash onwards. The colours are not as bright as they seem.

Colours

Quinacridone gold, burnt sienna, cobalt blue, quinacridone magenta, Payne's gray

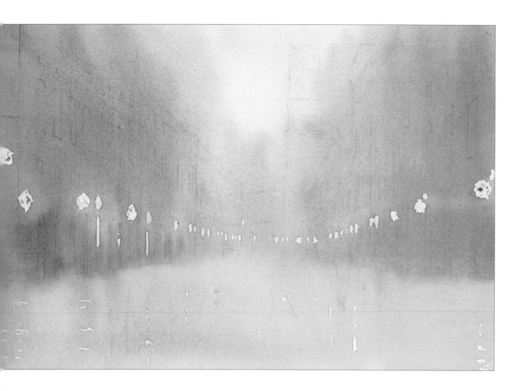

1 Using the final image as a guide, mask the whites only. These are the row of lights and some of the rippled reflections. Do not mask the tower. When the masking fluid is dry, wet the paper and brush a mix of quinacridone gold, burnt sienna and cobalt blue wet in wet over the painting. Add the broad, darker area wet in wet by adding more cobalt blue and burnt sienna to the mix, and make sure you keep the upper central area pale.

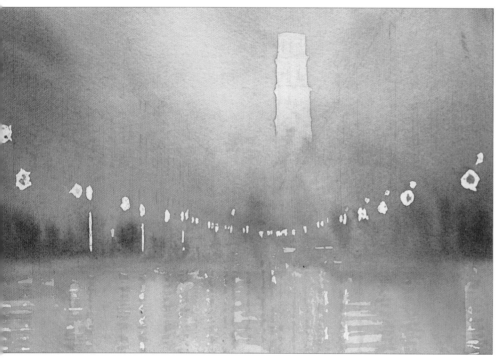

2 Mask more vertical rippling reflections on the pavement, observing the finished image for their appearance. When dry, brush a very wet wash of the previous colour carefully over the image, leaving a dry rectangle of saved light in the exact shape of the tower. Save a few horizontal lights on the pavement area. Observe and paint the darker band across the image using a mix of cobalt blue and burnt sienna. This helps to concentrate light on the pavement and in the tower.

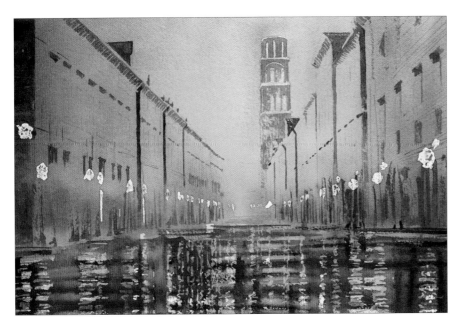

3 Carefully mask the lightest shapes in the masonry on the tower. These include the horizontal bands, the bow and arches around the windows, and the internal lights through the windows. When this is dry, dry brush a grey mix of cobalt blue and burnt sienna on to the tower for the masonry texture. Start applying detail on the buildings with a bold, warm grey mix of quinacridone gold, burnt sienna and cobalt blue. Apply horizontal and vertical streaks of this colour to the pavement.

4 Wet the sky area up from street level and almost up to the edges of the buildings and tower, being very careful not to go over these edges. Apply a rich, reddish-brown wash of quinacridone magenta, burnt sienna and a little cobalt blue up from street level. Above this, apply Payne's gray wet in wet to the sky, leaving a soft transition down to street level, but very strong and intense in the sky. Carefully take the colour up to the edge of the tower and buildings. Make sure the sky stays wet all over until you have finished. Using Payne's gray, define dark detail in the tower and on all the buildings. Place figures using mixes of cobalt blue and burnt sienna, and Payne's gray. Put in the dark reflections for the people. For 'scrubbed glare', use a clean, damp sable brush to rub the individual glare areas of the street lights and dab with kitchen paper or cloth to lift some colour from each. Finally allow to dry and remove all masking fluid. Notice there are a few lights in the sky where the paint has missed. I prefer to leave these rather than paint them out as they breathe life into a watercolour.

Stradun, Dubrovnik

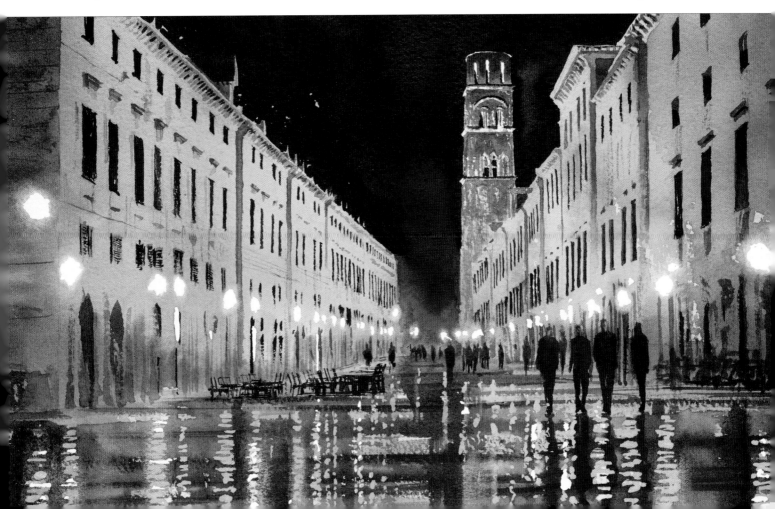

Children on Wet Sand

This painting is built with a special watercolour system. It involves painting layers, mostly of grey, one over the other. Use this technique and you can achieve many things. Do no more than is necessary at each step. The greys are applied first, and the bright colour at the end of the painting process. If you stick to this system, it becomes simple to create effects that you might think are difficult, like making the sand look wet.

You will need

Masking fluid, fine brush and dip pen
Masking tape
Brushes: 38mm (1½in) hake, no. 7 round, no. 4 round, small bristle bright
Colours: cobalt blue, burnt sienna, Naples yellow, quinacridone magenta, ultramarine blue, burnt umber, Payne's gray, light red, cadmium yellow

1 Draw the scene. I use a tracing which I refer to as required during the painting process.

2 Mask the two figures entirely with masking fluid and a brush. Apply masking tape round the edges of the picture area.

3 Use the 38mm (1½in) hake to wet the whole painting with clean water, then apply a wash of cobalt blue and burnt sienna from the top. Add more brown to the mix and apply this at the bottom with a little Naples yellow.

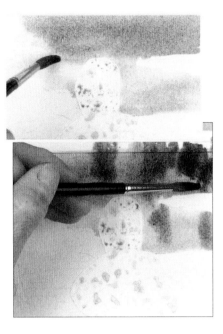

4 Paint a darker mix in the lower part of the painting and drag the paint down with vertical strokes.

5 Tilt the painting to concentrate the dark colour at the bottom. Change to the no. 7 brush and paint the browner mix with horizontal strokes up into the bluer part of the painting. Allow to dry.

6 Wet the area at the top of the painting. Paint on a wash of cobalt blue, burnt sienna and a little quinacridone magenta to create the area of wet sand at the top right. Paint vertical strokes of a dark mix of ultramarine and burnt umber down into this wash wet in wet.

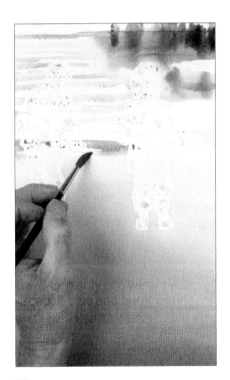

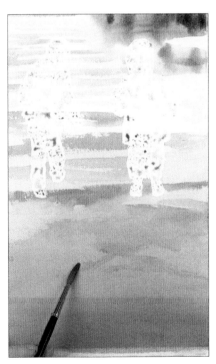

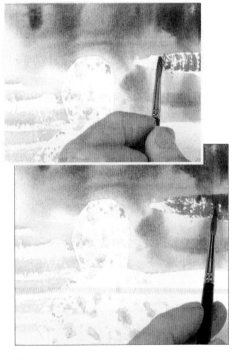

7 Paint horizontal lines of cobalt blue and burnt sienna over the top left-hand part of the scene, using a dry brush in places to create the effect of sparkling wet sand.

8 Use the water feathering technique in the foreground: brush water across parts of it in a criss-cross pattern, leaving parts dry. Brush Naples yellow, cobalt blue and burnt sienna into the water to create texture. Allow to dry.

9 Paint the same mix in vertical strokes of a dry brush into the puddle at the top right, then drop in a darker mix of ultramarine and burnt sienna at the top.

10 Suggest dark reflections in the pools of water slightly further forwards with cobalt blue, burnt sienna and a little Naples yellow.

11 Wet the foreground beach so that the reflections will fade into it. Begin the boy's reflection with horizontal strokes of the no. 4 brush with the same paint mix, with a little more Naples yellow added. Use the flat of the brush in places to create texture.

12 Use a darker mix of the same colours at the top of the reflection where there is also shadow. Drag a dry brush out from the edge of the reflection to suggest the texture of the sand.

13 Paint the reflection of the left-hand figure in the same way.

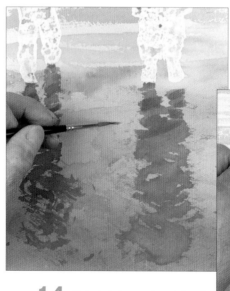

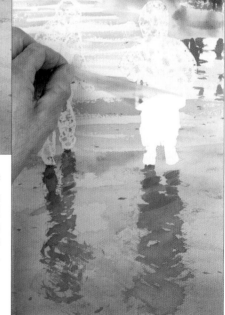

14 Paint dots and swirls of the same colour mix on the sand to create texture and suggest beach debris. Allow the painting to dry, then rub at the masking fluid and peel it off.

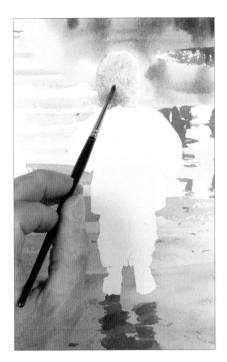

15 Mix cobalt blue and burnt sienna and paint a pale mix on to the hood of the right-hand figure, leaving white paper for the highlighted folds on the right.

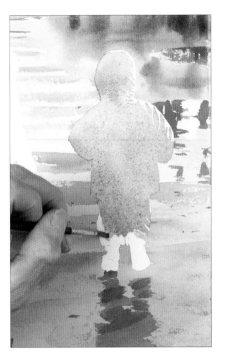

16 Continue down the coat, varying the colour and adding more blue on the left. Lift out any excess colour to avoid hard lines forming on the edges. Add more brown towards the bottom and leave highlights on the folds of the trousers white.

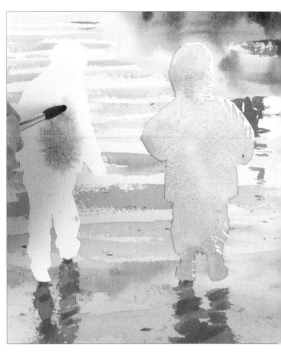

17 Wet the body of the girl figure, going carefully right to the edges and up to the collar top but keeping the feet dry. Drop in the grey mix of cobalt blue and burnt sienna with the no. 7 brush.

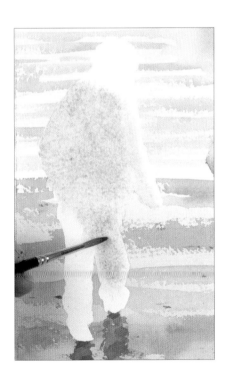

18 Leave the right-hand edge of the arm white, and add more blue to the mix to paint the jeans.

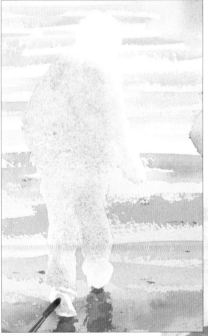

19 Leave white for highlights and for the soles of the shoes. Allow the figures to dry.

20 Make a stronger mix of cobalt blue and burnt sienna and begin to paint this on the right-hand figure, leaving the creases white.

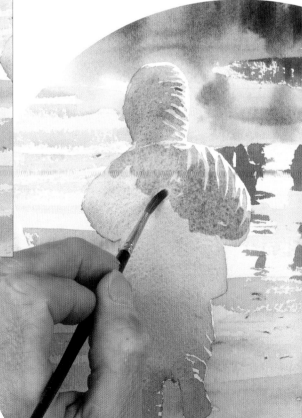

21 Paint on cobalt blue for the blue parts of the coat. As before, leave highlights. Allow to dry.

22 Mix burnt sienna and cobalt blue and paint a darker grey on to the upper part of the coat, wet on dry.

23 Darken the boy's jeans with a mix of ultramarine and burnt sienna.

24 Use a very strong Payne's gray mix to paint the shaded folds of the jeans, working wet on dry and leaving white highlights and some greys from the previous wash.

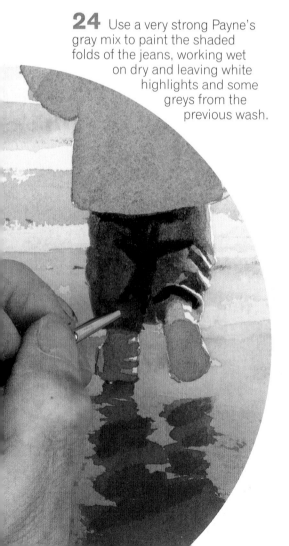

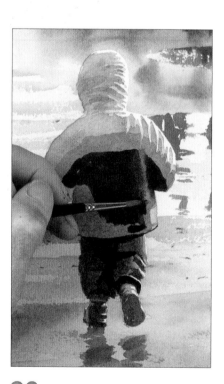

25 Model the boy's shoes with a dark mix of ultramarine and burnt sienna.

26 Paint the dark blue part of the coat with a bluer mix of ultramarine and burnt sienna. Wet the right-hand side and soften the paint in to create reflected light here.

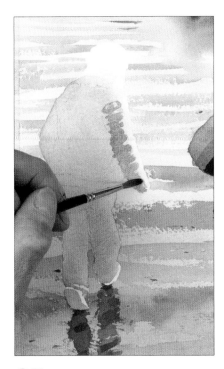

27 Add tone to the girl figure, leaving highlights on the right, with a mix of cobalt blue and burnt sienna.

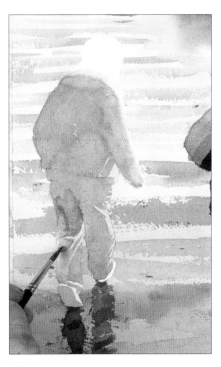

28 Paint the jeans with a bluer mix of the same colours, leaving highlights on the creases.

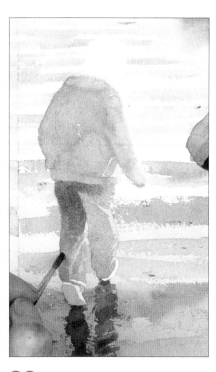

29 Wet the girl's jeans, leaving the highlights dry, and paint another layer of cobalt blue and burnt sienna into the wet parts.

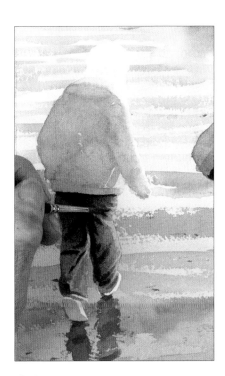

30 Paint the shaded parts of the jeans wet on dry with ultramarine and burnt sienna.

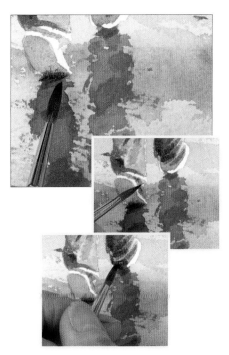

31 Shade the sole of the left shoe with ultramarine and burnt sienna, then model the top part with burnt sienna and cobalt blue. Shade the right shoe with ultramarine and burnt sienna.

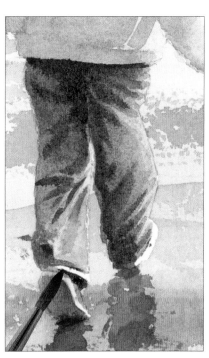

32 Allow to dry, then paint more shadow under the left sole with cobalt blue and burnt sienna, then darken under the jeans.

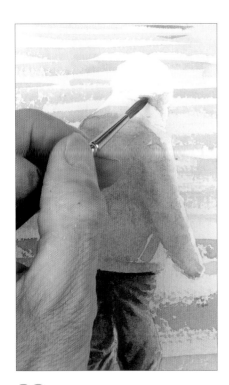

33 Wet the girl's face, leaving the right-hand edge dry. Drop in a mix of cobalt blue and light red.

34 Soften the right-hand edge of the colour, using a dampened small bristle bright. Touch in the eye with the no. 4 round and a darker mix of cobalt blue and light red.

35 Paint the shaded area behind the ear with the same darker mix, then model the front of the ear.

36 Mask the highlight on the hair with a dip pen and masking fluid. Allow to dry.

37 Wet the hair area with the no. 4 brush, then paint it with a pale mix of Naples yellow and burnt sienna, leaving light for the highlight on top.

38 Paint the darker parts of the hair with burnt sienna, cobalt blue and Naples yellow.

39 Mix ultramarine and burnt sienna and build up the darks in the hair. Add the pigtail with the same mix, then paint the shaded parts with ultramarine and burnt sienna.

40 Add the left-hand pigtail. Paint the tone in the headband with a pale grey mix of cobalt blue and burnt sienna.

41 Paint tone on to the scarf with the same grey mix, then paint cadmium yellow on top.

42 Wet the girl's coat and paint it with quinacridone magenta.

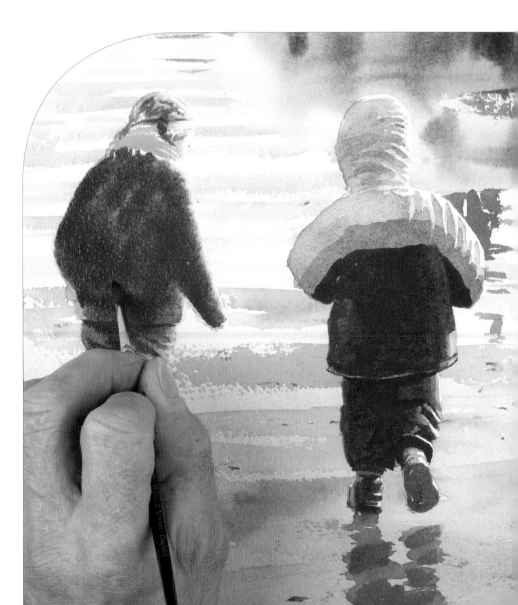

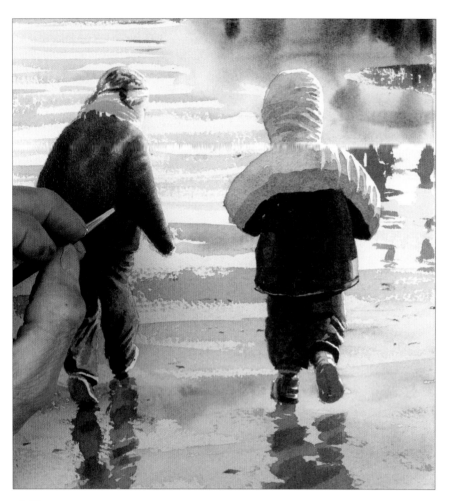

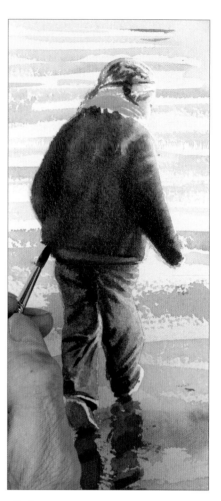

43 Mix ultrmarine and burnt sienna with quinacridone magenta and paint in the shaded parts of the coat.

44 Add the shadow above the trim at the bottom of the coat. Soften any hard edges with clean water.

45 Paint the girl's fingers with light red and cobalt blue and allow to dry.

46 Add dark details in the scarf and pigtails with burnt sienna and ultramarine.

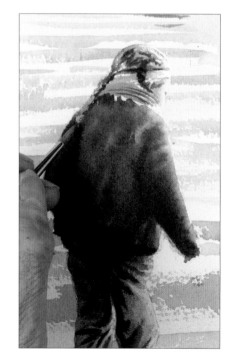

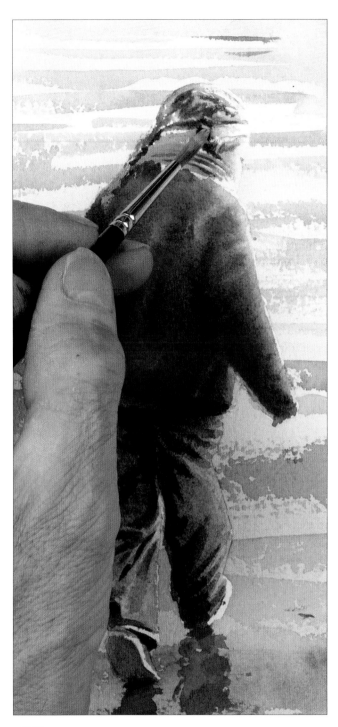

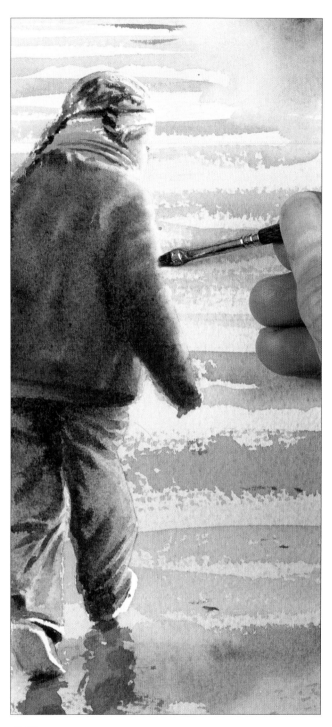

47 Use thick Naples yellow to paint the left-hand pigtail where it goes over the coat, and highlight the right-hand pigtail.

48 Use the small bristle bright dampened with clean water to soften the right-hand edge of the girl's coat.

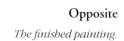

49 Add quinacridone magenta to the hairband with the no. 4 round brush.

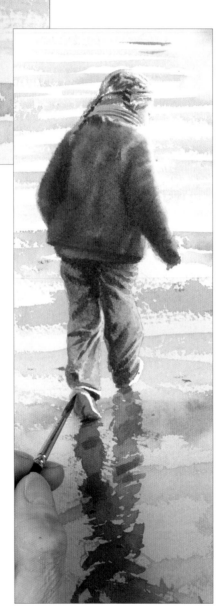

50 Paint details on the girl's shoes with the same pink.

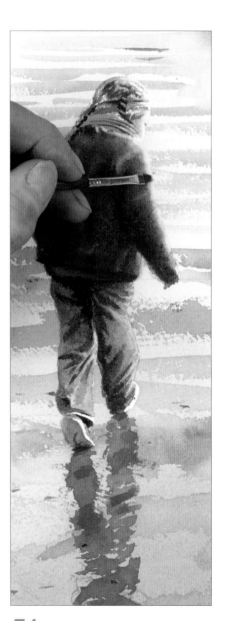

51 Finally use the small bristle bright dampened with clean water to lift out colour from the jeans and the right-hand edge of the coat.

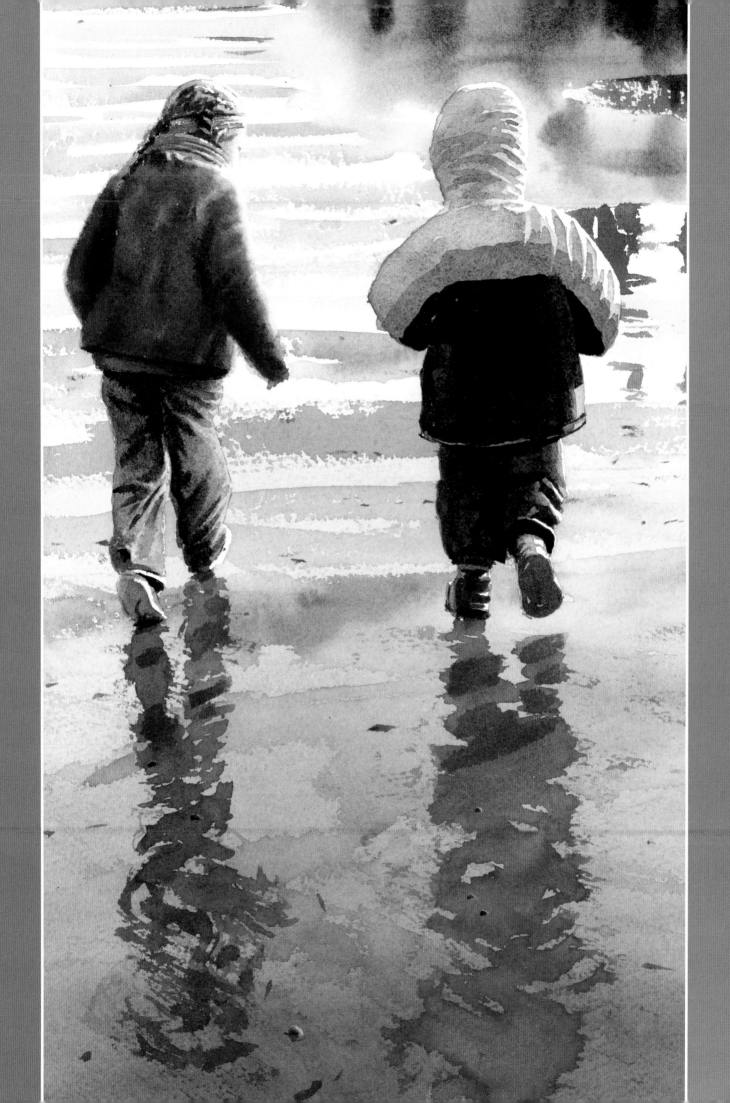

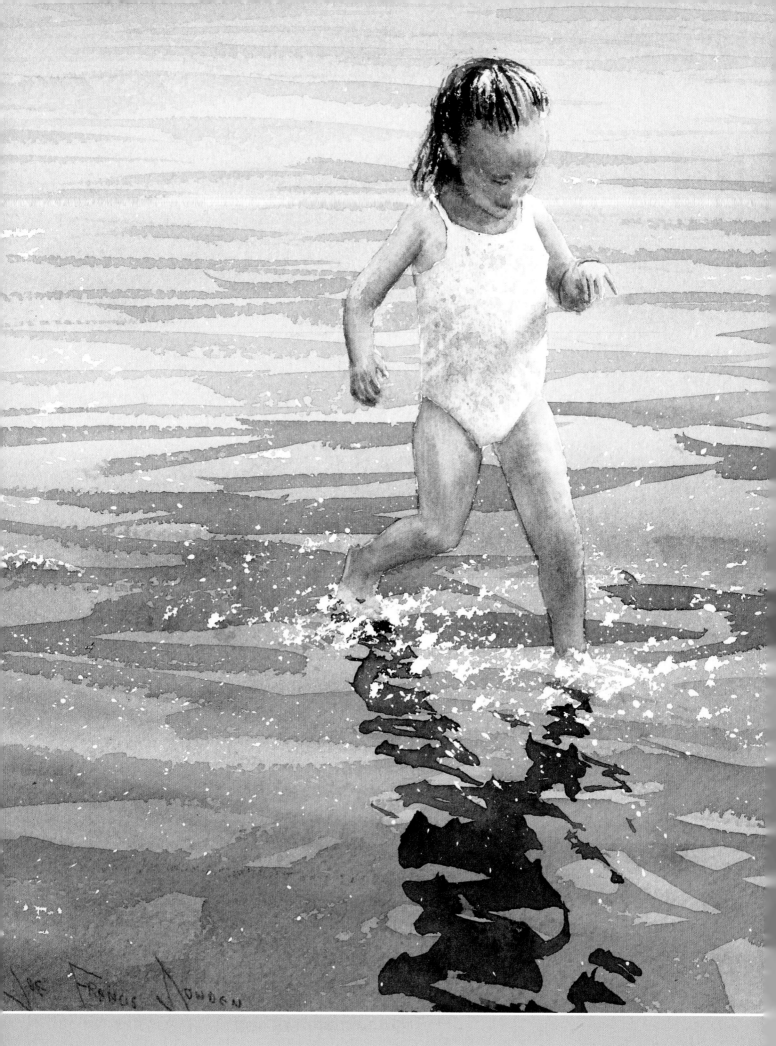

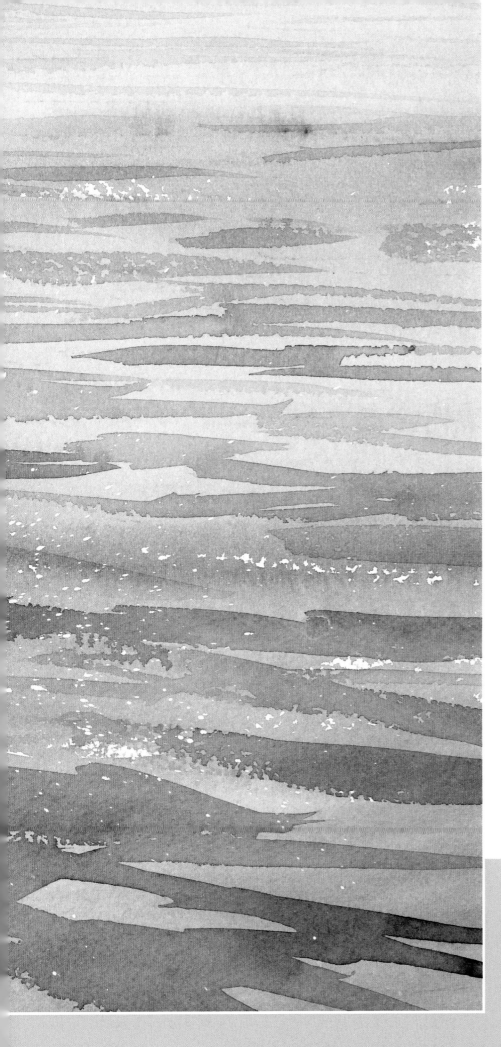

Girl on Beach

I masked the girl carefully, and created the splashes with a hog hair brush as on step 2 of the Sparkling Sea demonstration on page 110. Some droplets of masking fluid were also spattered off the brush by jogging the ferrule. When this was dry, I applied a blue-grey wash of phthalo blue, cobalt blue, quinacridone magenta and burnt sienna from top to bottom, brushing horizontally in the same direction each time from side to side, with each brush stroke lower than the last. Keep the board tilted when you do this and the colour flows down in a continuous veil. At the bottom more burnt sienna was added for the shallow, sandy water. When this was dry, I applied brush strokes of the same colour but stronger, wet on dry. The brush strokes get bluer, finer and paler further away.

I removed the masking fluid from the girl, but then masked highlights in her hair and her swimming costume. I painted her one limb at a time, in separate 'panels', rather than all at once. The flesh colour was made with cobalt blue, light red and yellow ochre. Make a neutral grey first with cobalt blue and light red. Add this to pale yellow ochre and light red. The flesh tone is actually very grey, more than an initial view might reveal. I painted this over the hair with a yellow ochre bias, and then more highlights were masked over this tone. I wet each limb and then 'let the colour in', carefully allowing it to flow from the point of the brush and spread across the damp paper for the fine skin effect. I then applied darker grey to the wet area on one side for shade spreading across. The pigment spreads or 'bleeds' over the damp paper, gradually diminishing and producing a tonal gradient or graduated wash, going evenly from dark to light. I painted the hair with ultramarine blue and burnt sienna, blending this with the forehead colour. A common mistake is to do a hard edge here.

Face detail is handled in tiny areas and allowed to dry before proceeding again. I removed the costume masking and water feathered a delicate violet texture of cobalt blue and quinacridone magenta, slightly greyed with burnt sienna. There is a slight linear effect on the limb edges where the masking has been removed but I see this as a style boost.

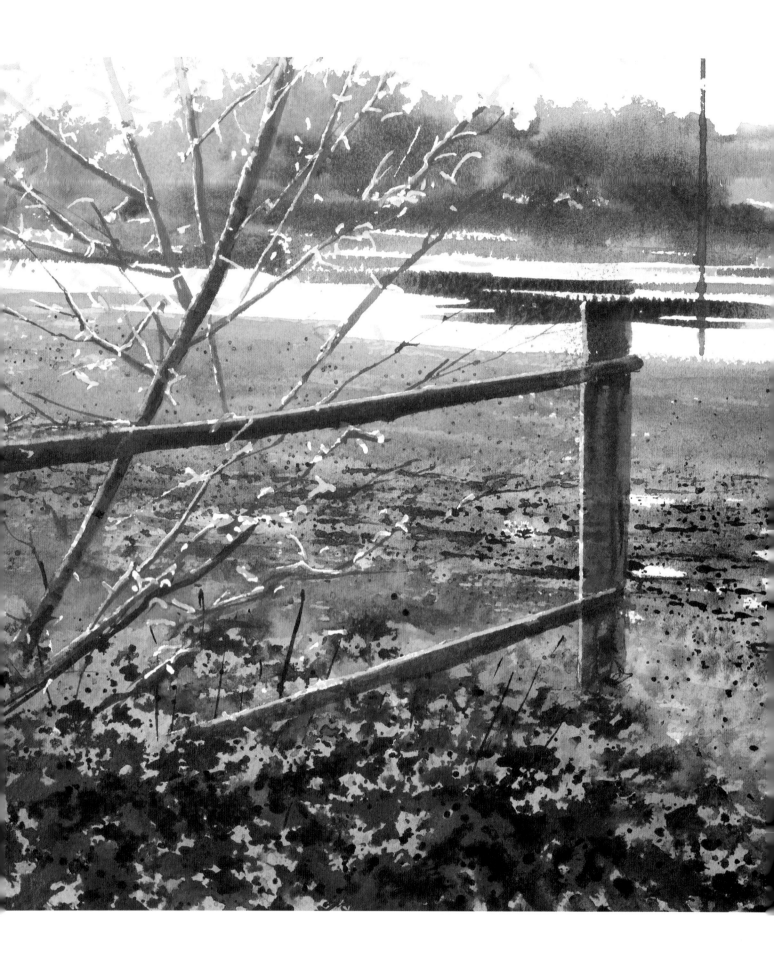

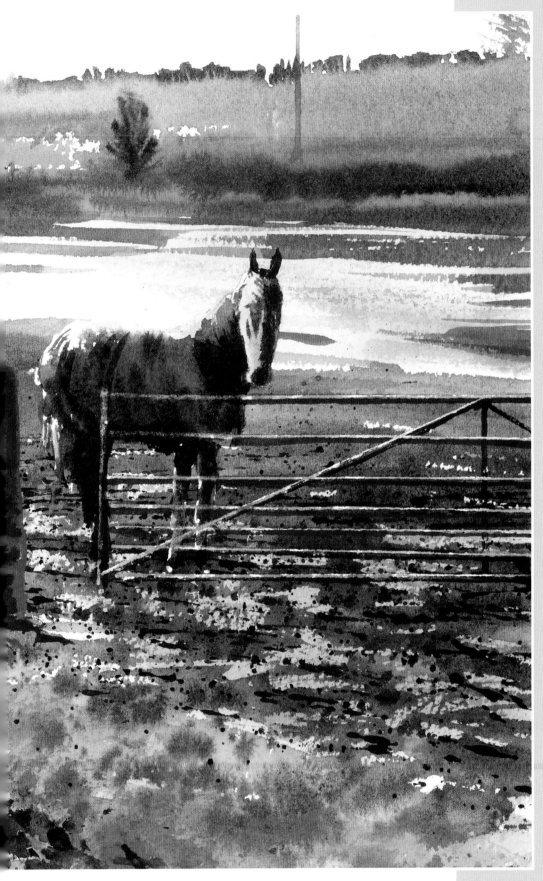

Watershed Studio and Fields at St Osyth

I demonstrated this one and a half hour sketch of the view outside the window to a group of artists at Watershed Studio. Masking was used extensively to get the rough edges of trees, lights on the gate and fence, leaves and the left-hand side of the horse's head. I mixed a large palette of colours at the outset: greys from cobalt blue and burnt sienna and dark greens from Payne's gray, phthalo green and burnt umber. Richness was added to the browns with quinacridone magenta. I like to make my paintings strong no matter how sketchy they are.

After masking, I wet the whole painting and gave it some intial tonal strength with grey doubling up as sky, underlying tone in the water, which was kept pigment free to the far left, and the ground, darker in the foreground. Then I mixed masses of quinacridone gold, green gold, burnt sienna, and greys and started applying them in broad swathes to the fields, right across the horse and everything else. The masking on the horse protected the head, the top of the body and some lights on the legs. As I dragged the wet colour across, I left out the wet ground flooded by the overflowing brook. I kept reserving the lights for the puddles and water while brushing and spattering more and more darks, of green gold, burnt sienna, cobalt blue, and then some Payne's gray.

The foreground green was of green gold, a little phthalo green, burnt sienna and cadmium lemon. The darks were phthalo green and Payne's gray mixed. I spattered water first, then spattered dark wet colour into it to create the 'leafscape'. I also applied colour from the tip of the brush into the wet wash – a process known as 'dropping'. I kept it wet and strengthened it with more and more colour, brushed, dabbed and spotted on.

I painted the darks on the fence and the horse, including ultramarine blue for the blanket with added Payne's grey dark. I removed all the masking, leaving the left-hand side of the horse's head, which was now white paper, and the lights on its top. I touched in the fence lights with quinacridone gold and used burnt sienna for the horse's head. Finally I remodelled over that with darks.

57

Swan on Rippled Water

This project is about working one piece at a time. You break the painting down into small areas which you can cope with. This even applies to the large area of water, because by working from top to bottom, and from one side to the other, you still only work one piece at a time. Instead of one big battle which you can't win, you have many small battles and you can win them all.

You will need

Masking fluid and fine brush
Masking tape
Brushes: 38mm (1½in) hake, no. 7 round, no. 4 round, no. 10 round
Colours: Payne's gray, cadmium orange, cobalt blue, burnt sienna, Winsor blue (red shade), burnt umber, quinacridone magenta, yellow ochre, white gouache
Kitchen paper

1 Draw the scene and tape the edges with masking tape. Mask the swan with masking fluid.

2 This painting begins with a light, subtle toning wash. Brush water all over the picture with a 38mm (1½in) hake brush. Have separate pools of Payne's gray, cadmium orange and cobalt blue ready. Brush on Payne's gray, very pale and wet.

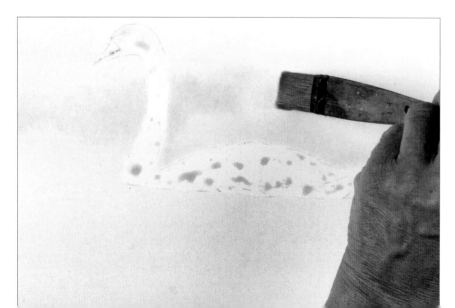

3 While this is still very wet, paint in cobalt blue.

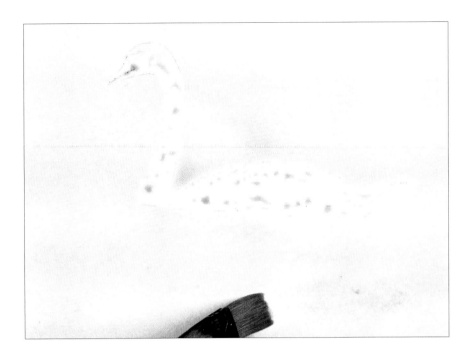

4 Paint in a tiny touch of cadmium orange.

5 Wash the brush and blot it dry, then use it to soak up excess colour from the surface of the painting. This completes the intial wash. Allow the painting to dry.

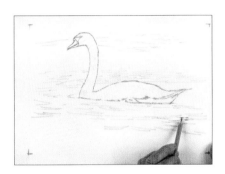

6 At this point, I used my tracing to help me work out where the highlights are in the painting. I transferred them lightly on to the image using pencil.

7 Mix plenty of a watery wash of cobalt blue and burnt sienna, as this should be painted on in one go, without the need for remixing colour. Use the no. 7 round brush and turn the board so that it is at a good angle for your arm movements: you are going to be making horizontal strokes across the picture. Paint the water in as shown, leaving patches of light where marked, and changing to the no. 4 brush when smaller marks are needed.

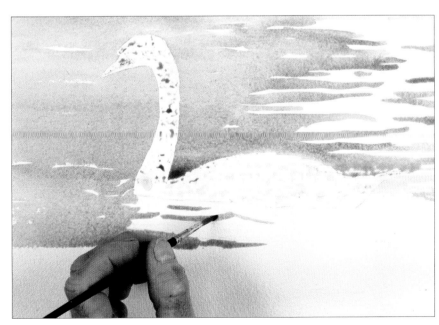

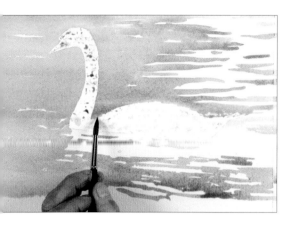

8 Lift excess paint if it has gathered on the surface with a 'thirsty' brush as before. Allow the painting to dry.

9 It is good to check the tonal values you are achieving in your painting as you go. A good way to do this is to isolate an area of tone by tearing a small aperture in a piece of paper, as shown. Here I was comparing the tones with the reference photograph.

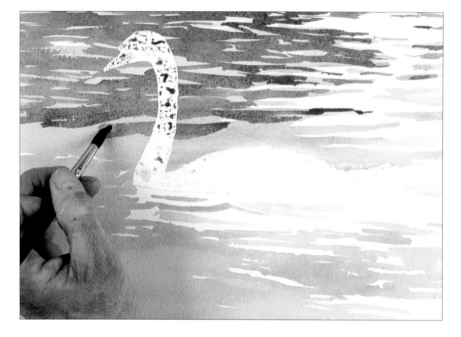

10 Mix Winsor blue (red shade) with cobalt blue and burnt sienna and use a no. 10 brush to paint ripples across the painting again, starting from the top. Paint quickly and fluidly, mostly inside the previous marks, and leave the white areas as before. Allow to dry.

11 Mix Winsor blue (red shade) with Payne's gray and paint in the mid-range darks in the water, using loose, fluid strokes as before.

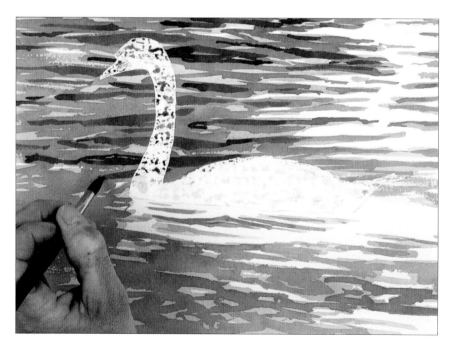

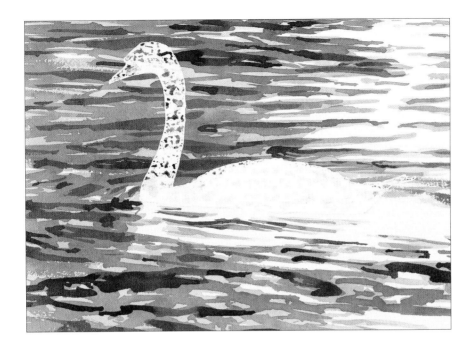

12 Continue painting the mid-range darks, then allow the painting to dry.

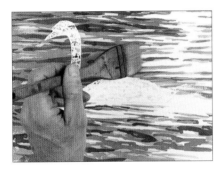

13 Soften the effect by applying clean water over the whole painting with the 38mm (1½in) hake. Tilt the painting so that the water runs away from the whites on the right. Lift out water with a thirsty brush. Allow to dry.

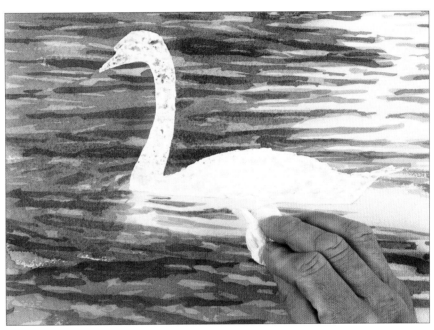

14 To re-establish the whites, brush them with water and then dab with a piece of kitchen paper.

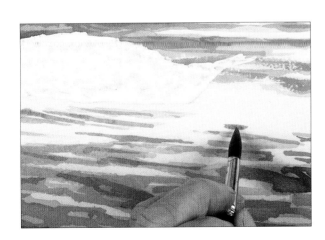

15 Mix Winsor blue (red shade), burnt sienna and burnt umber, and use the no. 7 brush to paint in little islands of colour.

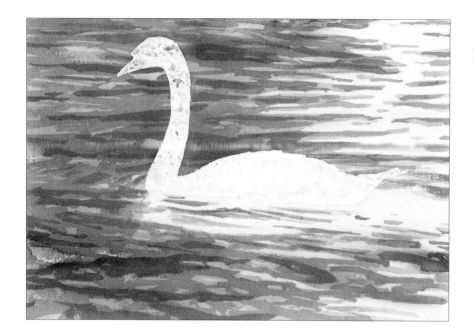

16 Complete the little islands of colour, mainly on the right of the painting.

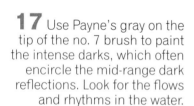

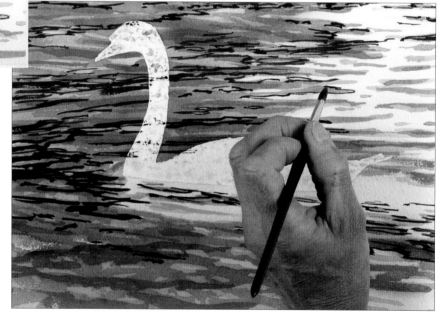

17 Use Payne's gray on the tip of the no. 7 brush to paint the intense darks, which often encircle the mid-range dark reflections. Look for the flows and rhythms in the water.

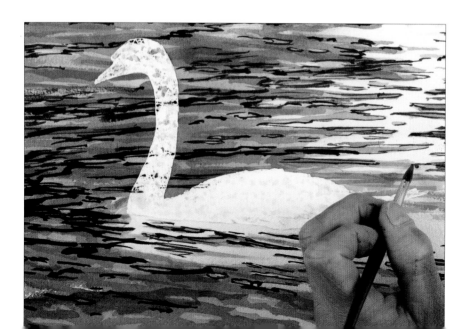

18 Mix burnt sienna with quinacridone magenta and moderate the brightness with a touch of Payne's gray. Use this to paint the reds that appear in the water in places, particularly on the right of the painting.

19 Use Payne's gray to paint the reflection of the shadow under the swan, breaking it up into ripples.

20 Use the dry brush technique and Payne's gray to paint texture in the highlight behind the swan. Drag the brush on its side over the surface of the paper to leave a speckled effect. Continue this technique in some of the other highlights.

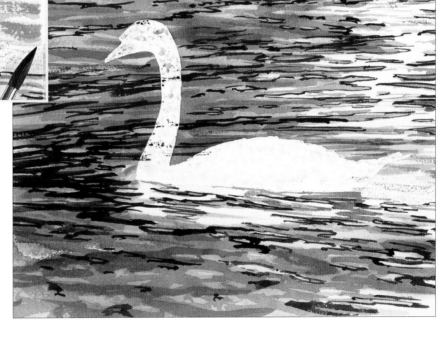

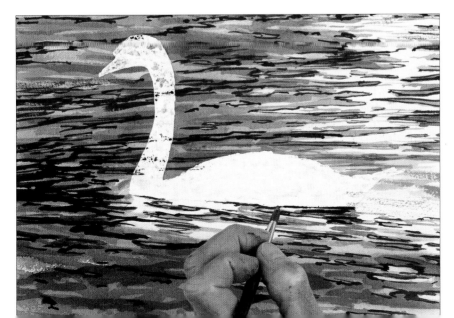

21 Paint intense darks under the swan with strong Payne's gray. Allow the painting to dry.

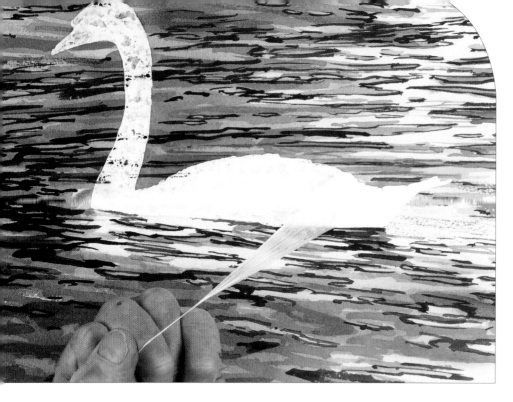

22 Peel the edge of the masking fluid, then pull it off in one piece. Keeping the beak dry, wet the head and neck with clean water and keep this area damp up to and including step 29.

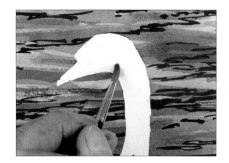

23 Use the no. 4 brush to drop a little yellow ochre into the area of reflected light under the swan's neck.

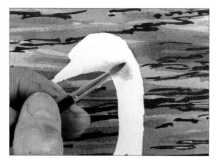

24 Drop cobalt blue into the shadow area.

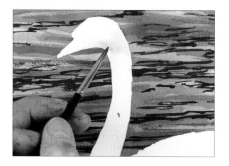

25 Drop burnt sienna into the reflected light under the neck.

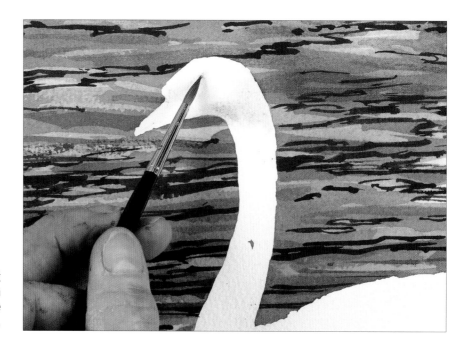

26 Mix a pale grey from cobalt blue and burnt sienna and touch this in round the back of the swan's eye.

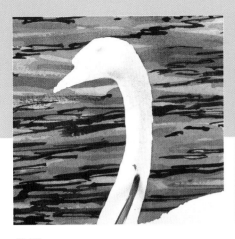 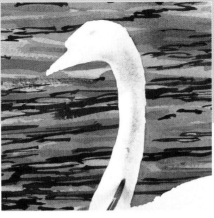 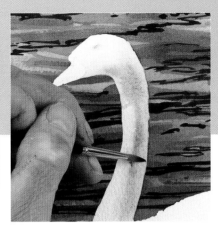

27 Touch the same colour into the neck, then drop in a pale mix of yellow ochre. Add a darker grey to build up the shadow, with a little quinacridone magenta added so that the yellow doesn't go green. Add water to soften he effect.

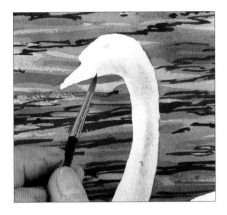

28 Drag the same colour across the face, to shape it.

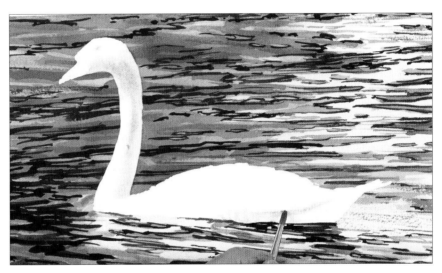

29 Paint clean water under the wing and drop in the same grey.

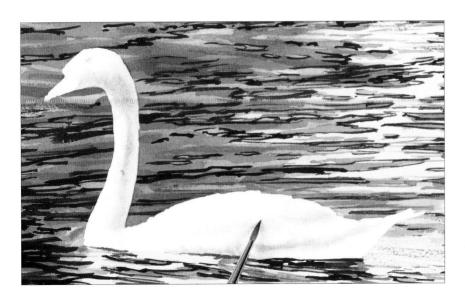

30 Add more water to the painting surface and drop in faint, feathery dashes of grey. Add a little yellow ochre if the colour looks too blue. Allow to dry.

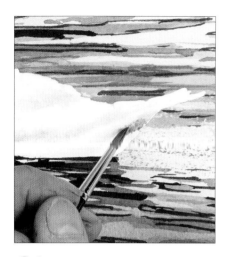

31 Wet the tail, leaving a tiny space at the edge, and drop in yellow ochre, then burnt sienna.

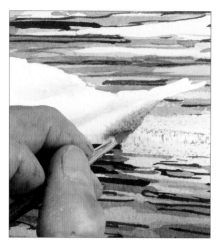

32 Drop in a mix of cobalt blue and burnt sienna to make the shadow blacker along the edge.

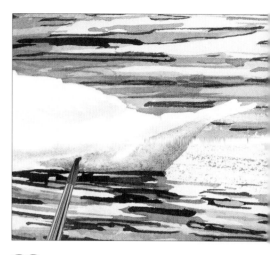

33 Add more cobalt blue and a little quinacridone magenta to the mix and shape under the tail.

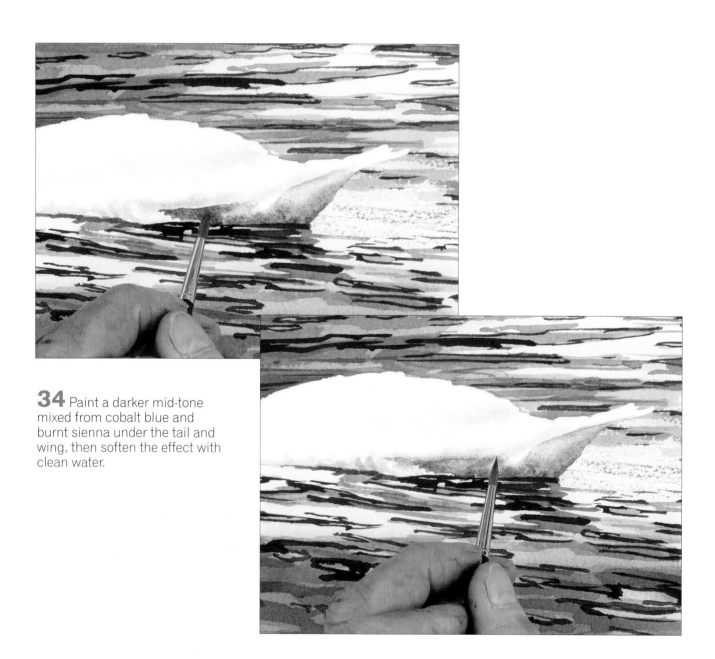

34 Paint a darker mid-tone mixed from cobalt blue and burnt sienna under the tail and wing, then soften the effect with clean water.

 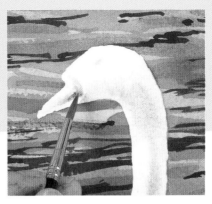

35 Mix yellow ochre and quinacridone magenta. Wet the beak and drop in the colour. Allow to dry. Add a little burnt sienna to the mix and paint another layer of colour on the beak. Allow to dry. Paint a shadow with burnt sienna and cobalt blue.

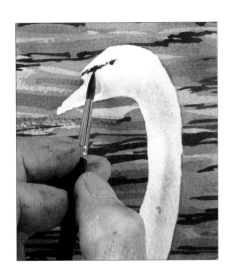

36 Paint the eye with the tip of the brush and Payne's gray, then continue to paint the facial markings.

37 Create the details of the face, making them all slightly smaller than in your reference material. You can always enlarge them later, but you can't reduce the size if they are too big. Details make all the difference to expression, which is vital to a swan portrait as well as for painting people.

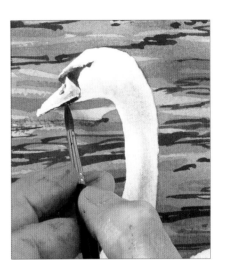

38 Finally I noticed a fleck of dark on the neck that had got through the masking fluid. If you find any marks like this, take a little white gouache, add a tiny bit of the grey mix of cobalt blue and burnt sienna, and apply this over the mistake.

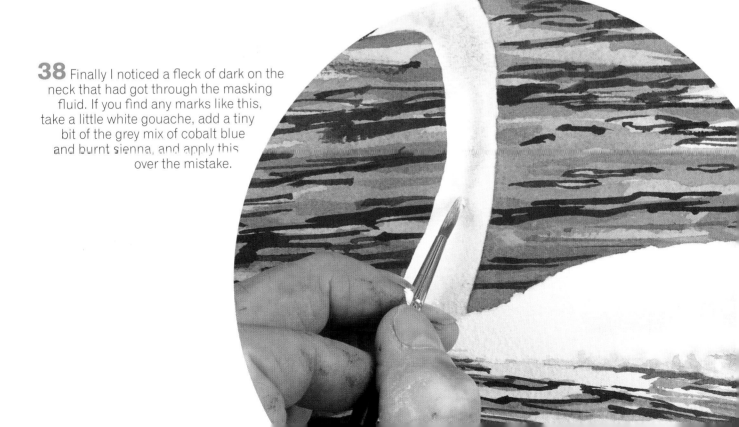

The finished painting.

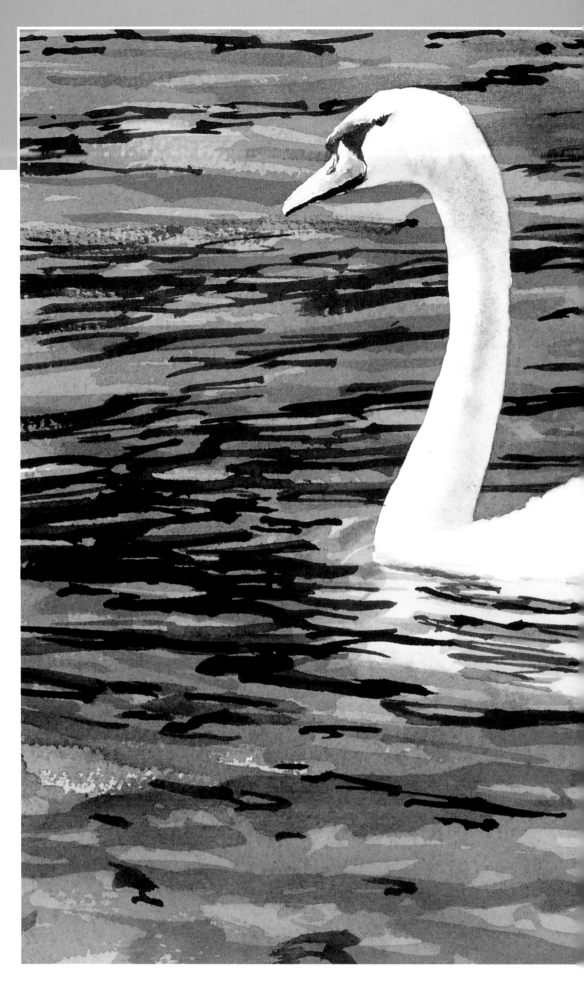

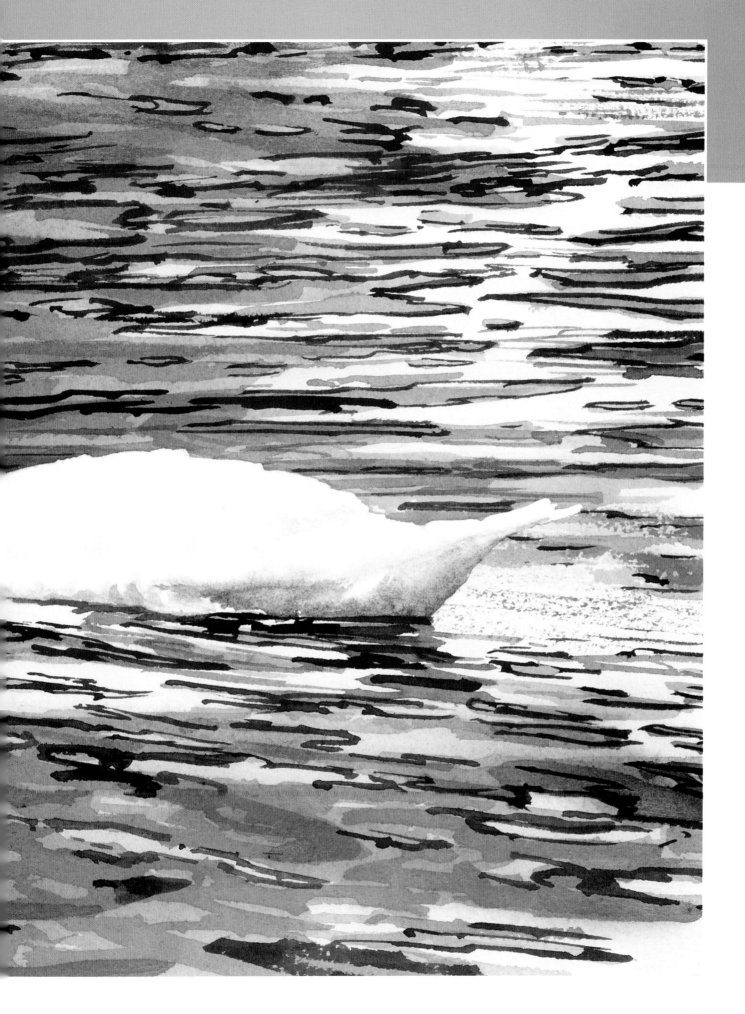

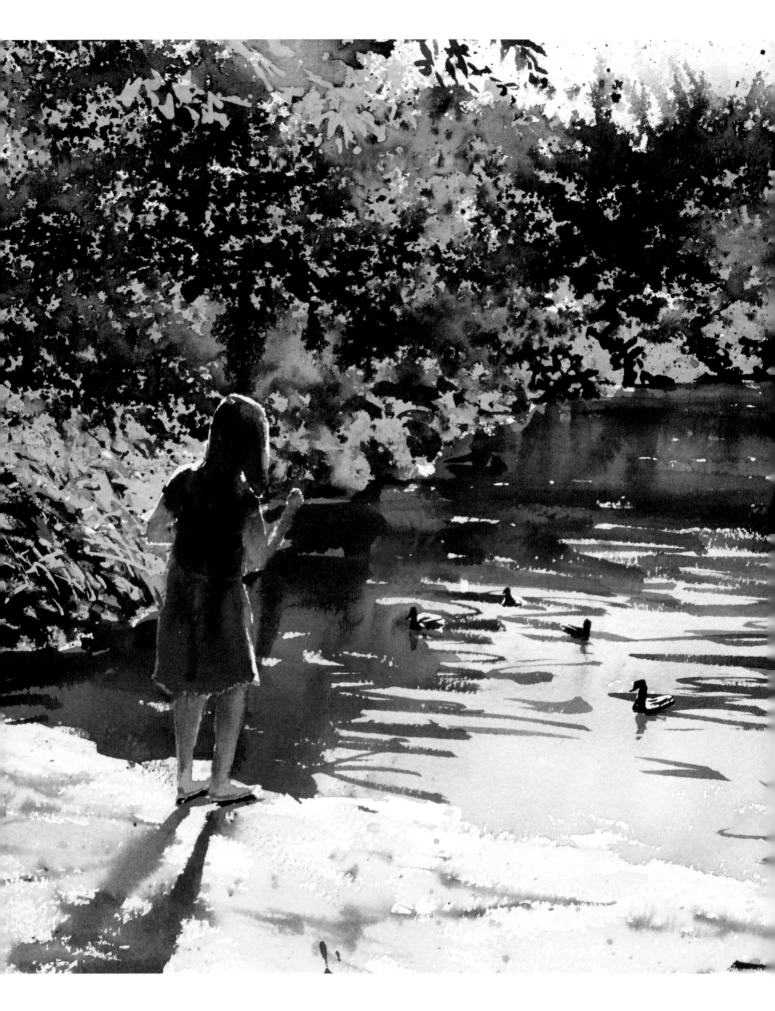

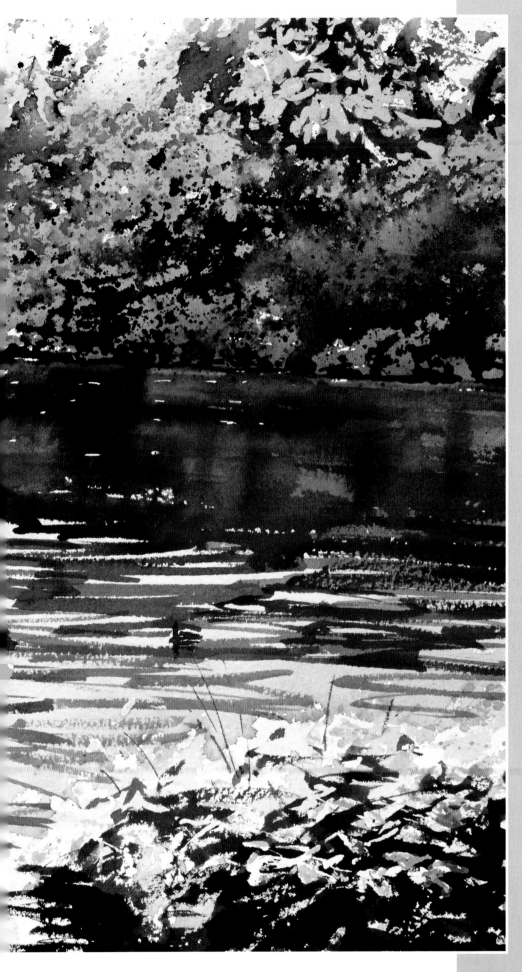

The Pond at Roskilly's, St Keverne, Cornwall

Demonstration paintings can have vibrancy because artists have to work fast. Having a generous palette is the key, and plenty of dark grey and dense colour for contrast. You can use bright colour if you also use strong darks. I use a lot of black from Payne's gray to get these.

The girl and some foreground leaves were masked, and so were the ducks. Starting from the top, I brushed many different greens: one mixed from cadmium lemon, phthalo green and burnt sienna, one from green gold, cobalt blue and burnt sienna and one from phthalo green and Payne's gray, to create a vast variegated mass of greens.

The first layer had numerous colours spattered, brushed and dropped, and then it was dried. I masked leaves over the dry wash and started again, spattering water from a large sable brush with a good point, and spattering colour into the water. The technique is simple. Load a well pointing sable round brush from size 7 to 16 with water. Bang the brush down firmly on to the palm of your hand or a roll of tape, so that droplets fly off on to the paper. Work from the bottom upwards so the droplets get smaller as they get more distant. Before you start at the bottom again, always recharge the brush so the droplets are larger at the bottom than the top. Repeat the process with rich, wet, strong paint mixed on a large flat palette. The paint droplets go into the water spatter. Some hit spatter, some go on dry paper. The many star-shaped spatters of colour and water start to link up and produce a very complex mass of dark shadow, revealing the light leaf shapes. This technique spatters the internal shapes or in-between spaces, sometimes called the negative space. Spattering like this works for quick, sketchy styles, or for photographic realism.

The pond has a loose, upside-down sky as shown on page 34. I brushed the rippled brown reflection loosely, with very wet paint. I brushed the foreground with water to give wet/dry patterns when the shadows and textures were applied. When the painting was dry, I removed the masking fluid, then painted the girl in a single wet wash of dark grey with added deep browns, leaving a glint of light, a 'silver lining' round her edges.

71

Venice, View from Ponte de le Balote

People will need to be featured in Venetian scenes so here is how to paint a gondolier. Work out exactly where the head is. Place the head over one heel, here it is his right. People nearly always stand with their weight over one foot. Heads are often painted too big. A male head goes 7 to 7½ times into the body. Drawing a scale down the side, I start with the head, count one space for this head and 6 to 6½ more down to the feet. If the figure is at my level, I place the head at my level. Here he is slightly below but the principle still applies, counting head lengths down finds the feet. Sideways, the head forms a small, almost square projection from his shoulder with the neck hidden by the coat collar. Painted from the front or back, a head is slim, but from the side it looks broader.

Draw the outline and fill in with paint, keeping the figure slim. Drag brushstrokes outwards in the limb directions. Some artists like to ignore the feet. I put them in if I can. I painted the trousers flaring for his boot tops. Paint figures loosely or they will be stiff, like a post. Don't worry about features. Think of a visor with an upward dent for the nose, like sunglasses. A faint shadow under the nose and cheeks is enough. Hair should blend or it will look like a wig. It is a common mistake to put the eye line too high; eyes should be half way.

The people in the boat are only hinted at. For distant people, paint clothes in bright tertiary colours (those between primary and secondary), such as turquoise, lavender, orange-red or apple-green. Small splashes of red often read well as clothing.

I applied broad, warm washes of yellow ochre, light red and burnt sienna to the painting vertically, leaving whites for arches and windows. I greyed subsequent washes with cobalt blue. I wet the arches and touched Payne's gray into the tops for a perfect shadow effect. I applied dark paint as the 'handwriting' in vertical lines and marks.

After I painted the sky reflection, I washed in the water area with plenty of rich, wet burnt sienna and cobalt blue pigment, tossing the brush loosely from side to side, making larger marks further down the paper. I brushed a tracery of dark squiggles over this with Payne's gray. I applied two washes of Payne's gray to the gondola, leaving many lights. The pole was lifted out against the dark and brushed in against the light. Lights were reserved on the gondola during two applications of Payne's gray. The key to painting the water is having more colour than you need and plenty of excess paint for the last few strokes. The waste of paint at the end may be a necessary sacrifice for a good painting.

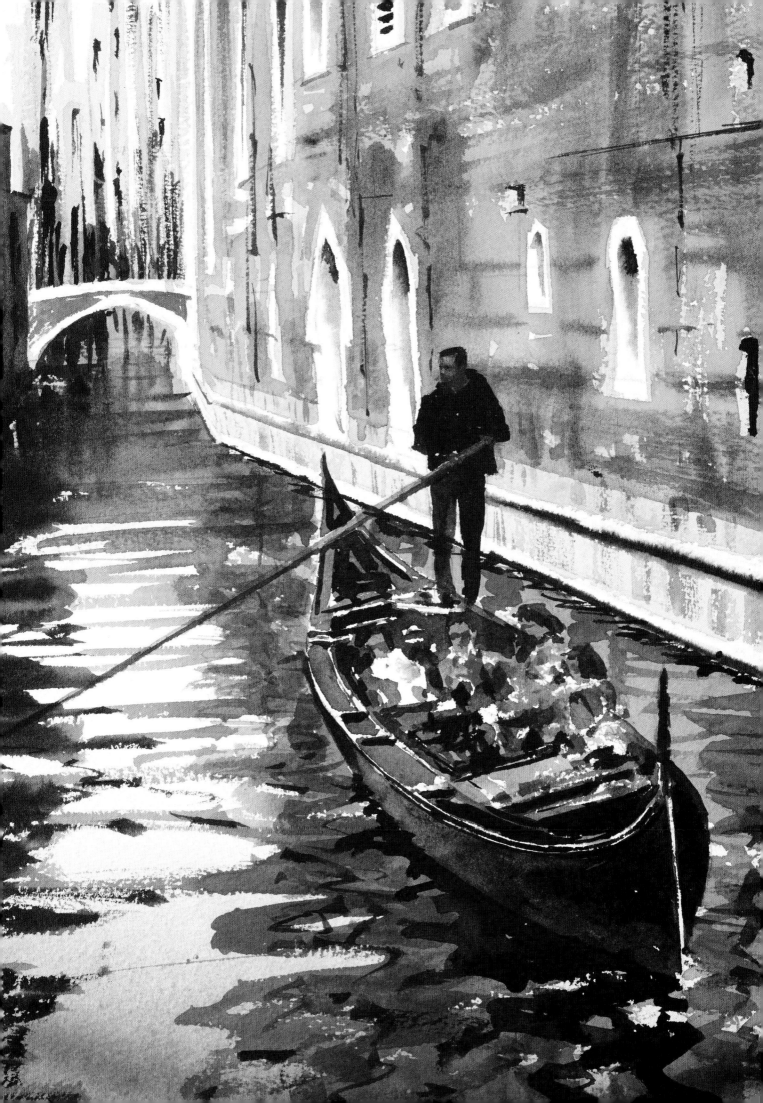

Lake and Mountains

This project is about making mountains look big, and water look deep and tranquil. It can solve many painting challenges. Mountains will look massive if they seem distant. For distance, paint them pale, with transparent veils of pigment. This mountain range, the Northern Fells in the Lake District of the UK, with Skiddaw in the centre, looks solid, but much of it is not painted at all, with many gaps in the washes going right through to the sky behind. To get the pattern of light and shade, I chose not just the location, looking across Derwent Water, but the time as well. The moment was early on an October morning, when the stunning light casts a pattern of sunshine and shadow to reveal flowing contours and the beauties of the long English autumn. All this is reflected in the still water of the lake, which has only the gentlest of ripples.

1 Apply masking tape to the edges of the scene. Draw the scene and paint water over the whole painting, apart from the buildings and their reflections, using the 38mm (1½in) hake brush.

2 Take the no. 12 round brush and paint yellow ochre where the mountains and their reflection will go. Leave white gaps for the buildings and their reflections.

3 Working wet in wet, paint quinacridone magenta around the yellow ochre, in horizontal strokes across the painting.

4 Change to the 38mm (1½in) hake brush and paint yellow ochre in at the top and half-way down.

5 Paint on a grey mix of cobalt blue and burnt sienna, with horizontal strokes as before, from the top and working your way down. Throughout this wet in wet stage, avoid painting the parts you have left white.

6 Add quinacridone magenta to the grey and paint this across the bottom of the painting, allowing all the colours to merge in the water. Add more cobalt blue to the mix and paint this at the top in the same way. The mountain area should merge with the sky.

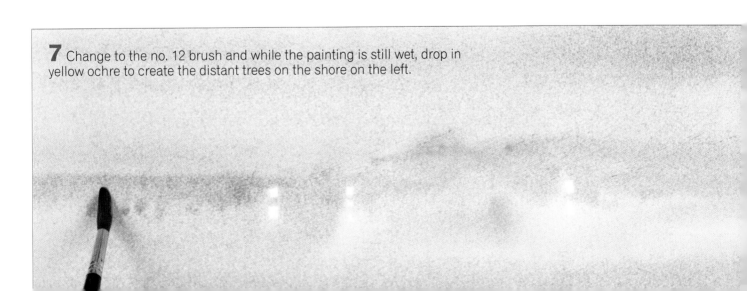

7 Change to the no. 12 brush and while the painting is still wet, drop in yellow ochre to create the distant trees on the shore on the left.

8 Paint more yellow ochre in the area of the mountains and their reflection, going carefully round the white areas.

9 Still working wet in wet, paint Payne's gray across the bottom of the lake area.

10 Paint a grey mix of cobalt blue and burnt sienna over the tree area.

11 Paint the same grey below the waterline and pull it downwards with vertical strokes. Paint the grey across the painting just above the bottom.

12 I used a fan blender to paint the same grey beneath the mountains, but use the no. 7 round if you do not have one. Use the no. 7 brush to paint a bright mix of burnt sienna with a little cadmium orange across the mountains.

13 Paint more Payne's gray across the bottom of the painting, then strengthen the colour in the distance with cobalt blue and burnt sienna, using the no. 10 brush. Paint vertical strokes downwards from the waterline, continuing to work wet in wet.

14 Paint soft ripples across the foreground water with Payne's gray, and soften them further with the fan blender.

15 Paint on more Payne's gray at the bottom to keep the colour strong. Remember that watercolour dries much lighter, and there is a lot of water on the paper to dilute the colour. Allow to dry naturally. When the painting was dry, I used my tracing of the scene to help me reinstate the hills that had been painted over.

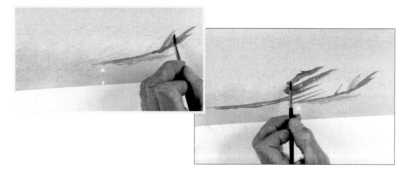

16 Apply the darks of the mountains with the no. 4 brush and a mix of ultramarine, a touch of burnt sienna and a little quinacridone magenta. Paint the lines in using the shape of the brush and soften the lower edges with water.

17 Continue into the left-hand side of the mountains, using paler paint and softening the lower edges of the applied darks with clean water for lost edges.

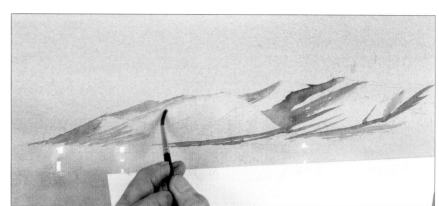

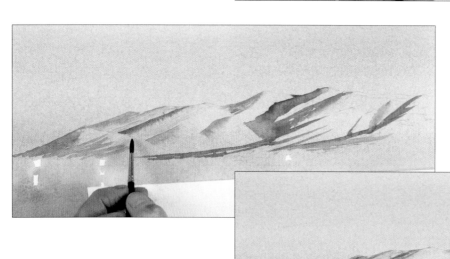

18 Allow the painting to dry, then build up a second layer of paint to strengthen the colours and create dimension. Use the dry brush technique on the right.

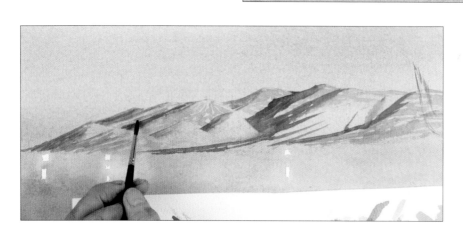

19 Mix pale quinacridone magenta with a touch of burnt sienna and paint the sunlit parts of the mountains, making the colour a little stronger as you come forwards. Leave patches of the underlying wash as though the sky is showing through.

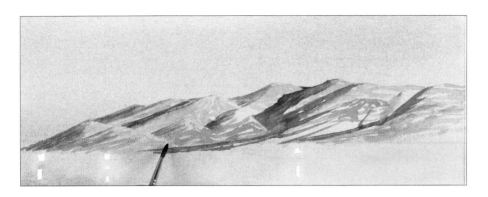

20 Paint a stronger mix further forwards with burnt sienna and a little quinacridone magenta.

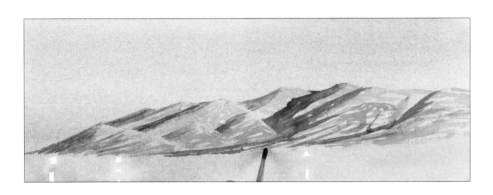

21 Mix burnt sienna with a little cadmium orange and paint this down the slopes towards the lake.

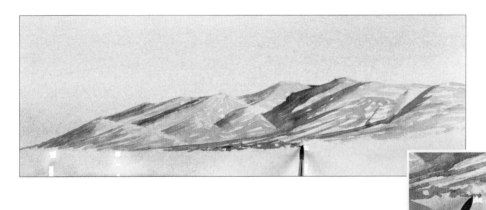

22 Build up shapes suggesting buildings on the lakeside with ultramarine and a little burnt sienna. Make a tiny mark suggesting a roof and gable front for one of the highlighted white buildings, with burnt sienna and quinacridone magenta.

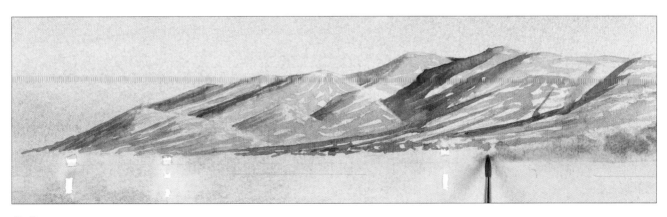

23 Wet the area of lakeside trees on the right of the painting, and drop in quinacridone gold.

24 Drop in burnt sienna wet in wet.

25 While the paint is still wet, drop in a dark mix of ultramarine and burnt sienna.

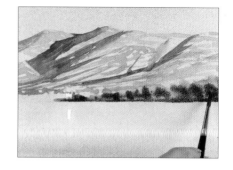

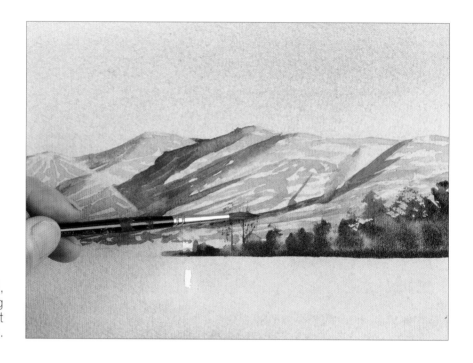

26 When the paint has dried, paint some individual trees using the point of the brush, and suggest foliage using dry brush work.

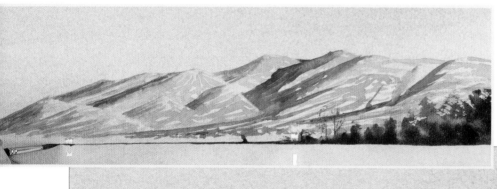

27 Paint a dark line for the shoreline right across the painting, using the point of the brush. Above the shoreline, paint a band of quinacridone gold.

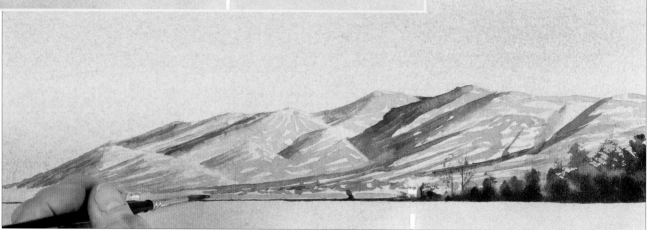

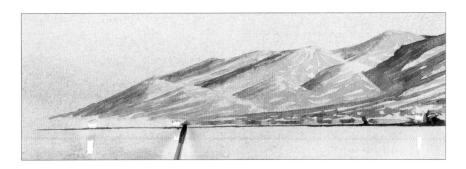

28 Drop in suggestions of detail on the shoreline with ultramarine and burnt sienna.

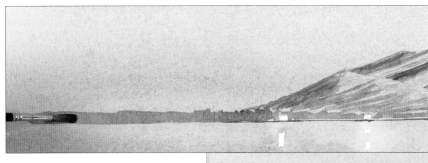

29 Paint the left-hand side of the shoreline with quniacridone gold. Drop in burnt sienna wet in wet.

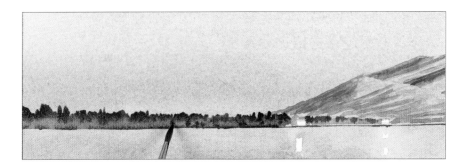

30 Drop in tiny marks with ultramarine blue and burnt sienna, suggesting tree detail on the left of the painting. Pant a dark line at the bottom, with a few breaks in it, then make vertical marks.

31 Use the dark mix to make the trees slightly larger, then allow the painting to dry.

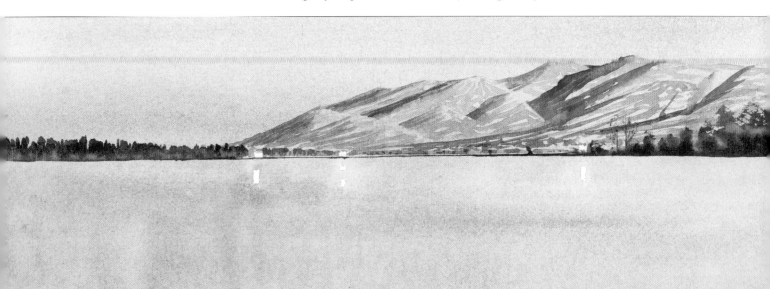

32 Mark the various heights of the mountains on a piece of paper and measure the same depth down into the water, then make a pencil mark to show the depth of the reflections. You can create an outline of the reflections by joining the dots.

33 Wet the right-hand side of the reflection area and use the no. 10 brush to drop in a mix of ultramarine and burnt sienna. Notice the colour spreading downwards as it blends with the clean water.

34 Drop in yellow ochre to the left.

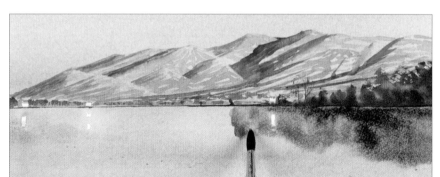

35 Drop in burnt sienna with vertical strokes.

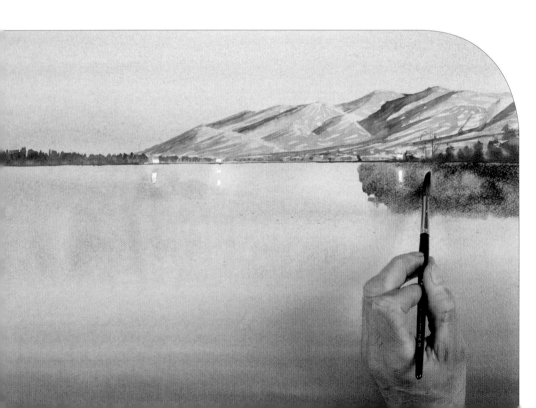

36 Add more water to keep the area wet down to the limit of the rippled reflection, then drop in more ultramarine and burnt sienna without going to the edge of the wet part.

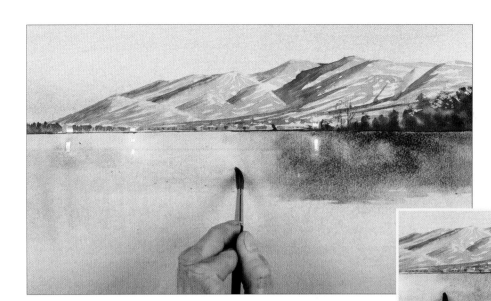

37 Drop in yellow ochre and soften the edges with clean water. Drop in quinacridone magenta.

38 Paint vertical strokes of ultramarine and burnt sienna on the right, then use a paler mix to paint uneven strokes on the left-hand side, wet in wet.

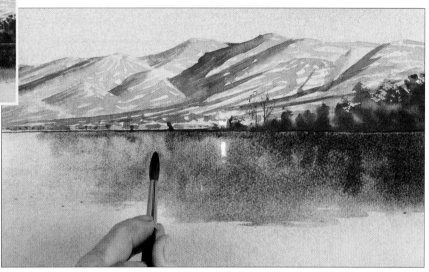

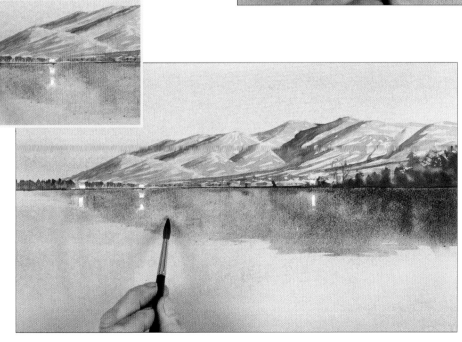

39 Wet the far left of the reflection area again and drop in pale ultramarine and burnt umber, then yellow ochre.

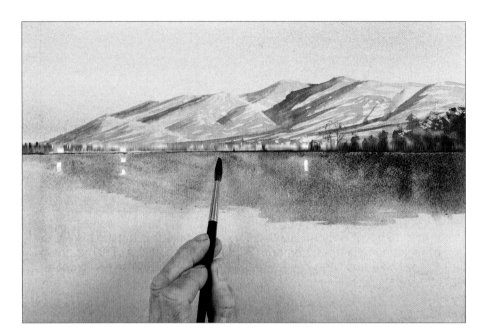

40 Suggest faint directional lines in the reflection with ultramarine and burnt sienna.

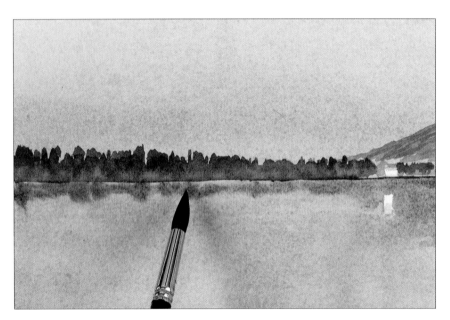

41 Wet the area below the shoreline on the left of the painting. Drop in quinacridone gold mixed with a little yellow ochre. Keep the colour well within the wet area so that the lower edge of the reflection remains soft focus with a lost edge.

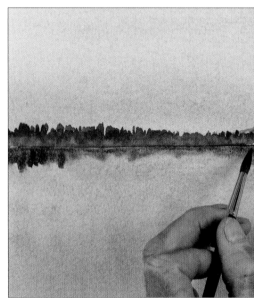

42 Drop in darker parts of the reflection with ultramarine and burnt sienna, and add a dark line for the shoreline. Allow to dry.

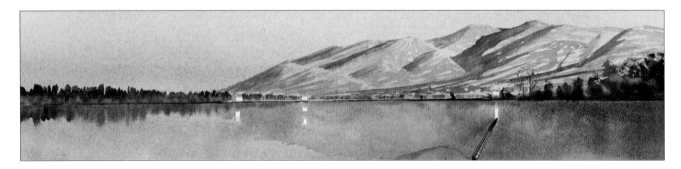

43 Mix ultramarine, quinacridone magenta and burnt sienna and use the no. 4 brush to reduce the white reflections.

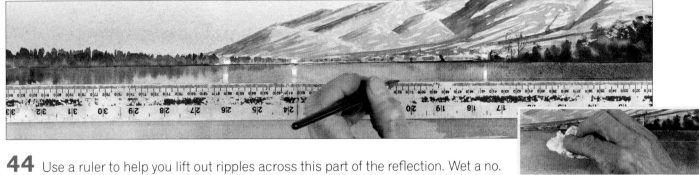

44 Use a ruler to help you lift out ripples across this part of the reflection. Wet a no. 7 brush and take off the excess water before dragging it across the edge of the ruler, making absolutely sure the ruler is parallel with your horizon. Blot with kitchen paper to lift out the ripple. Repeat to make a wider ripple further forward.

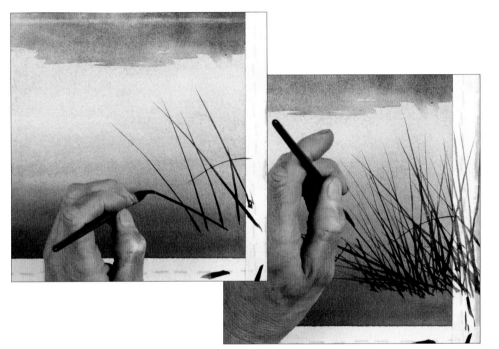

45 Use a sword liner brush and Payne's gray to paint reeds coming out of the water. Paint with long sweeps of the brush, beginning on the masking tape outside the picture area for a natural look. Start each stroke with the fat side of the brush, then rotate as you go, drawing out to a thin, tapered line.

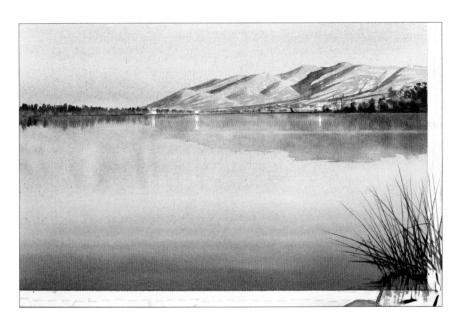

46 Use the no. 4 brush to drag stalks down to the water and to paint their reflections with downward strokes and squiggles.

Overleaf

The finished painting.

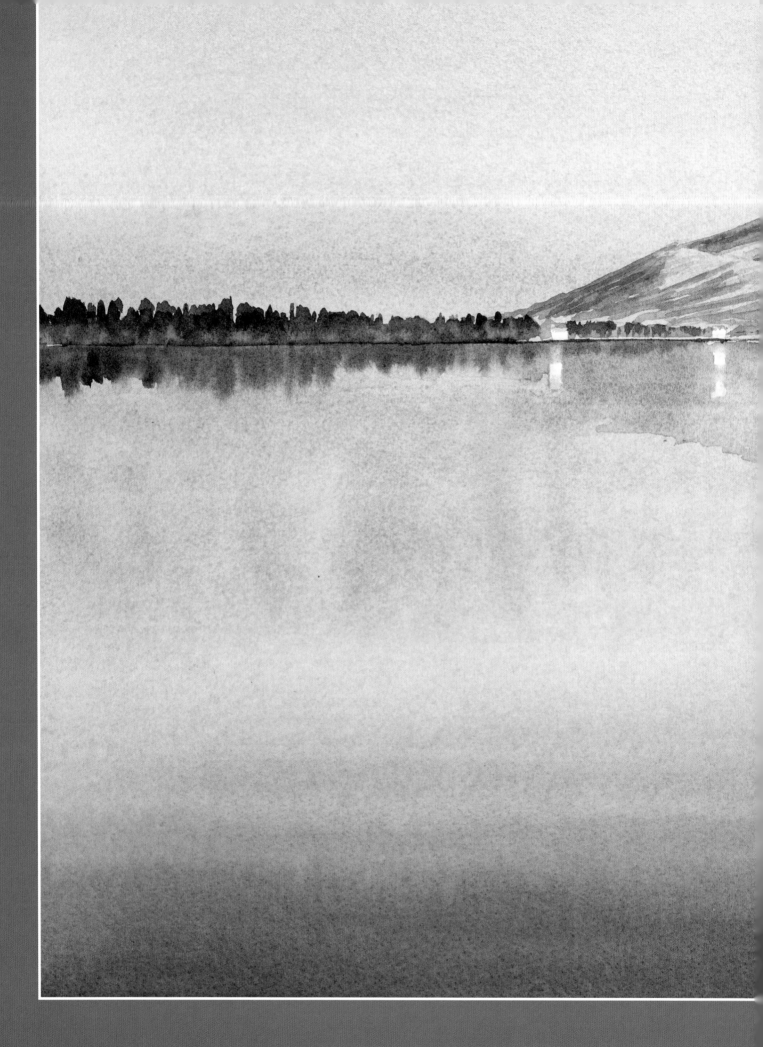

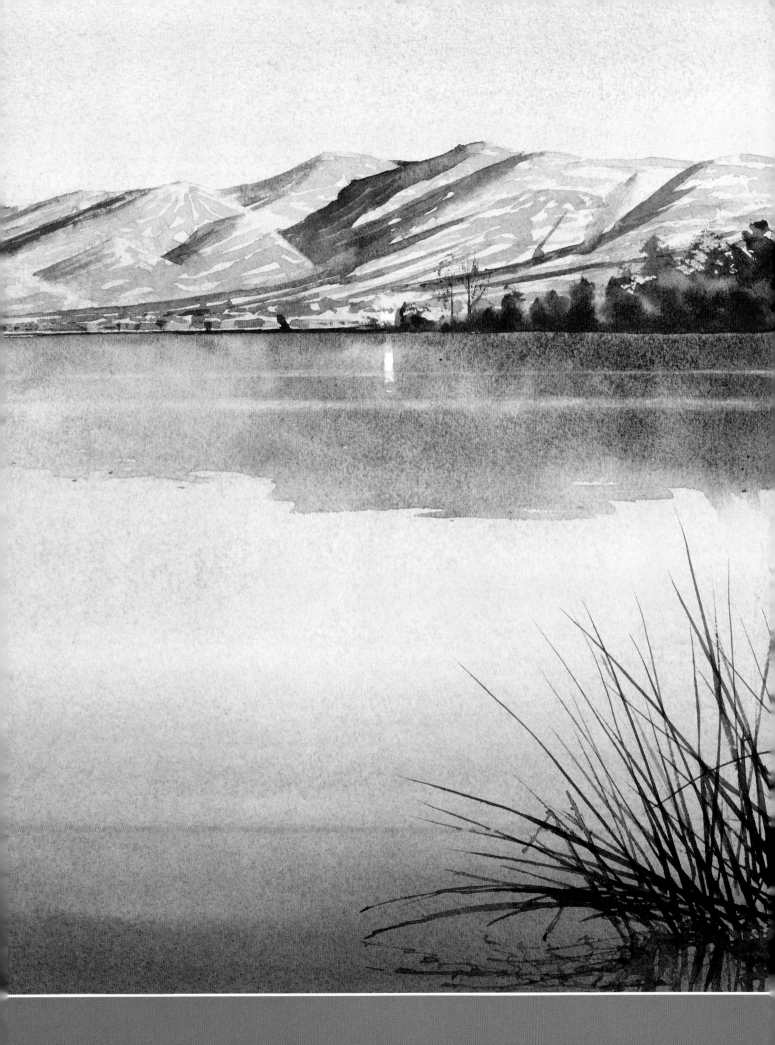

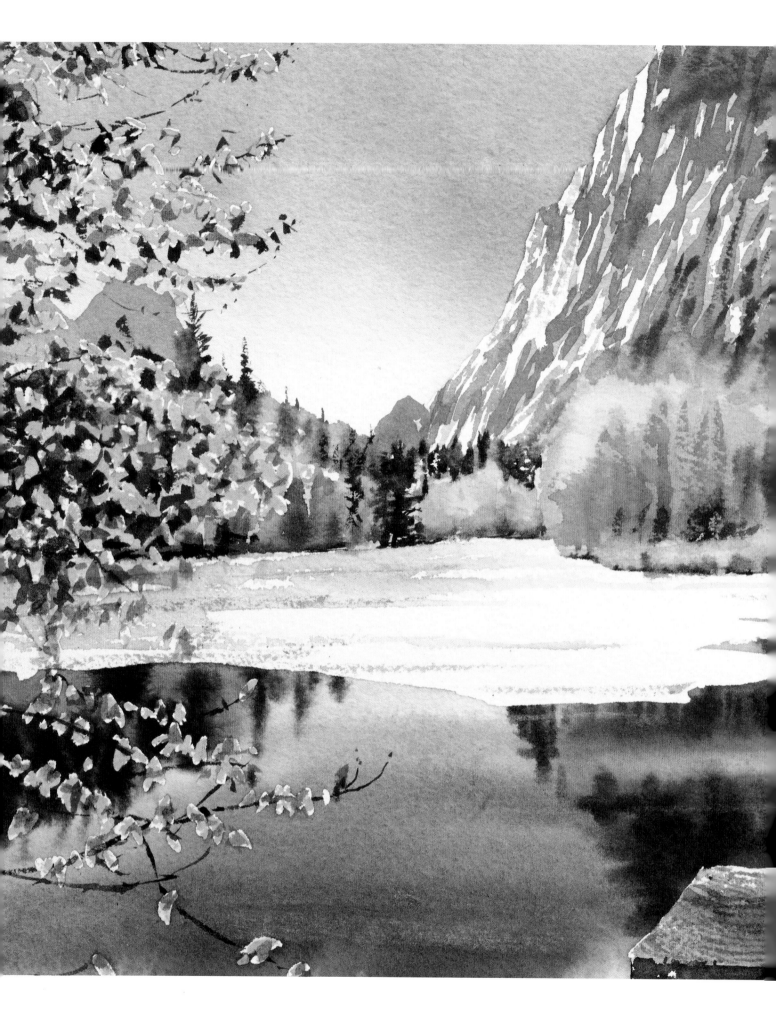

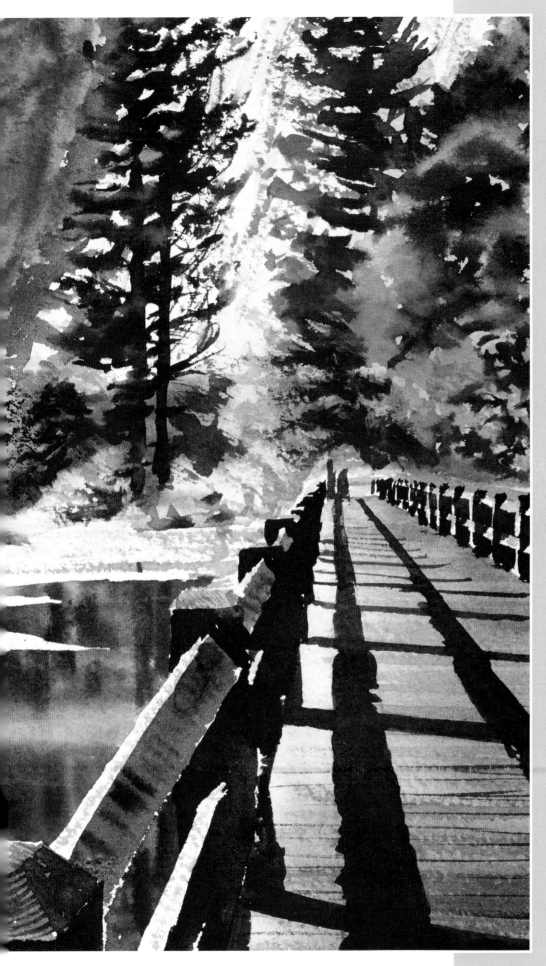

Yosemite Walkway

This scene is based on a Richard Thaxter shot, and the walkway adds depth and scale and leads you into the image. Some artists might have removed it from this natural scene but I tend to keep things the same and use a more subtle approach of exploring what is there. Here I liked the geometric lights, which I masked, the wood-grain and the blue-orange variations.

Before masking, a slightly warm grey was brushed all over the painting, leaving no white at all. I masked the foreground leaves and the beach. When the grey wash over this was dry, I painted the sky phthalo blue, avoiding the mountain shape in the light grey under-glaze.

I applied dragged streaks of blue-grey on the mountain with a phthalo blue, cobalt blue and burnt sienna mix and when this was dry, I added a darker layer. Both washes were applied with a 'lost' lower edge by wetting the paper below and letting the colour bleed in. The second time I did this, I applied green gold, new gamboge and quinacridone gold to the autumnal aspen forest below. Darker greens were applied with Payne's gray added, then the big trees with quinacridone magenta and phthalo green mixed into a nearly black green, a useful combination for pines and other evergreens.

The distant mountains on the left were brushed with ultramarine blue and burnt sienna.

I applied deep phthalo blue, darkened with Payne's gray to the water, and brushed the reflection darks wet in wet, dragging them down vertically. This gave a great contrast when the masking for the beach and the lights from the walkway was peeled off.

I left the masking in place on the right of the walkway and brushed Payne's gray over it before removing it. I painted a light wash on the walkway deck, strong mid-tones and darks on the posts and rails and light dry brush along the rail tops. The masking also allowed me to paint the water loose and wet for a much better effect of depth, because I did not have to go carefully round the edges.

With the masking fluid removed, the foreground leaves were painted with new gamboge and quinacridone gold, with dark greys added when dry.

89

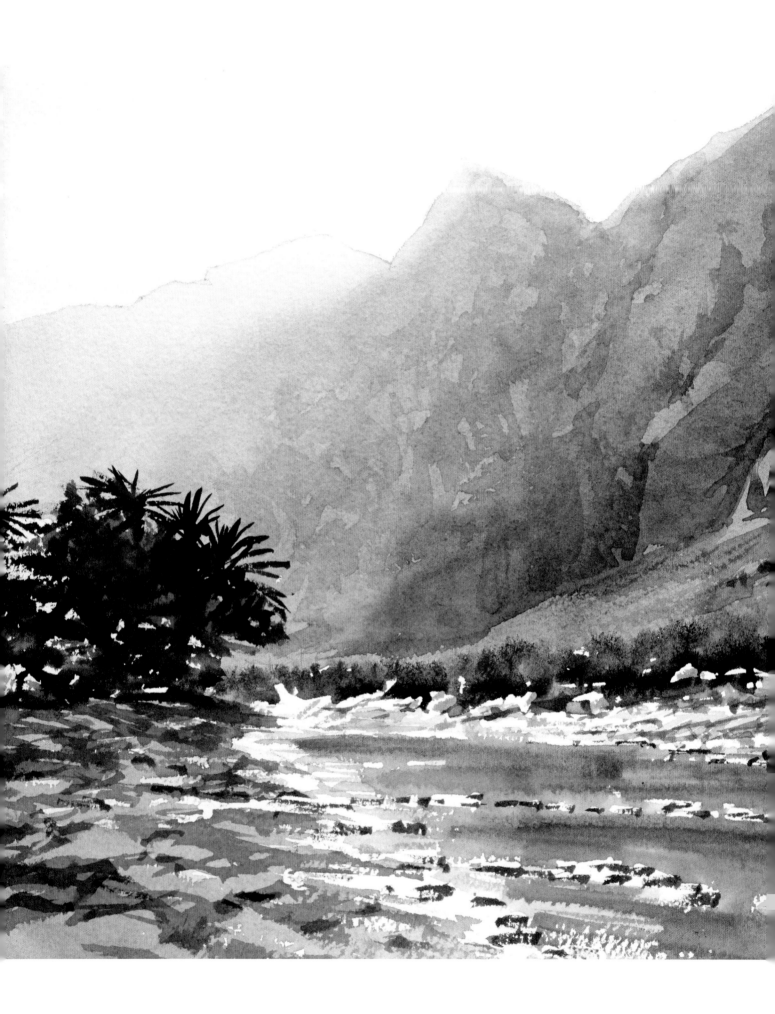

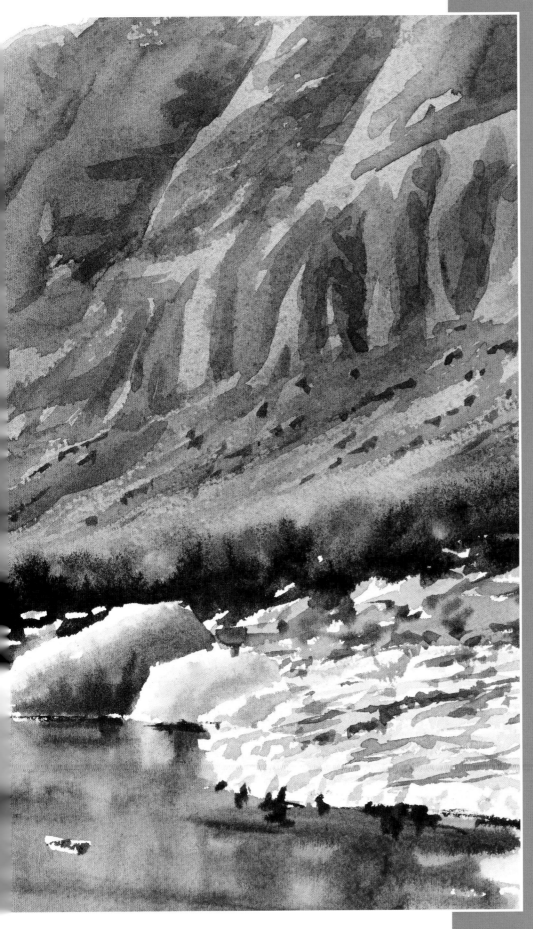

Al Hajar Mountains

Great ravines and jagged mountains soar above date palm plantations running along the water's edge. This was painted as a demonstration watercolour for a group of artists at Cheddar Gallery in the UK.

I masked rocks in the water and reserved others as I painted. The mountains and their reflections were painted with cobalt blue, burnt sienna and quinacridone gold, becoming warmer nearby with more quinacridone gold added. To achieve the atmosphere, I wet the mountains and applied greys, keeping away from the mountain ridge and allowing the paint to find its own way there. While the first wash was still wet, I applied green gold with burnt sienna to the date palms, with Payne's gray to darken them. When this was dry, I loosely brushed a second mountain wash for the crags and gulleys, creating a web of texture receding into nothing in the distance.

I brushed greys over the flat riverside rocks, then painted the date palms on the left and a few dark rock accents. Next I applied a strong, wet wash of cobalt blue, burnt sienna and quinacridone gold over the water, adding darks while this was still very wet. I brushed a little water for the light reflections below the large white rocks. I brushed some darks along the water for the dark river bed.

When this was dry, I removed all the masking and touched in rocks. I wet the larger rock, which had not been masked, and applied colour to the lower half, letting it spread through.

91

Autumn River: Still Water

This project is about using techniques to help you paint things that seem impossible. I show how to get masses of leaves with convincing landscape and trees behind and between them, and how to paint detailed foregrounds. You can use these methods to make your water look still, wet and deep, in blazing colour and bright light.

You will need

Masking tape

Masking fluid, fine brush and dip pen

Brushes: cheap hog hair, no. 12 sable round, no. 7 round, no. 4 round, sword liner, small chisel-ended brush

Colours: quinacridone gold, green gold, new gamboge, burnt sienna, cadmium lemon, Winsor green, cobalt blue, ultramarine blue, burnt umber, Naples yellow, Winsor blue (red shade), neutral tint, quinacridone magenta, quinacridone gold, cadmium lemon, Payne's gray, cobalt turquoise

Scrap paper

Kitchen paper

Gum arabic

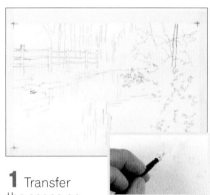

1 Transfer the scene on to watercolour paper using a tracing, which I refer to throughout the painting process, as some of the pencil drawing gets covered in paint. Tape the edges of the image with masking tape. Apply masking fluid with a fine brush to some highlighted leaves in the right-hand foliage and to some branches, and the distant trunks.

2 Take a cheap hog hair brush, crush the end to spread the bristles, pick up masking fluid and dab it on lightly. As you proceed, rotate the brush between each dab, so each time it touches it applies different shapes rather than identical ones. Dab on more solid blocks of masking fluid in the sky area to protect sky holes. Spatter some masking fluid with the same brush to create more highlights.

3 Tear up pieces of scrap paper to create a paper mask with jagged edges to cover the water area of the painting. Tape them together with masking tape. Take a no. 12 sable round and spatter clean water over the foliage area.

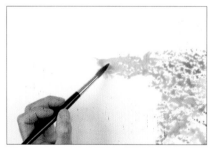

4 Mask the left-hand side of the painting. Prepare watery mixes of paint and spatter quinacridone gold and then green gold.

5 Continue spattering with more green gold added to the quinacridone gold. Use the tip of the brush to paint the area where the bright leaves will go against the dark background.

6 Continue spattering, then drag the colour with the brush on its side.

7 Use the no. 7 round and a mix of new gamboge and quinacridone gold to paint a layer of colour as an undercoat for the foliage area and its reflection.

8 Mix new gamboge and cadmium lemon and paint some of the distant trees with a yellow undercoat. Drag colours across between them for a speckled effect. Spatter on colour for foliage. Allow to dry.

9 Put the masks in place again and spatter on burnt sienna in the right-hand foreground with the no. 12 sable round. Allow to dry, then use the fine brush and masking fluid to mask tiny twigs and dabs to preserve the yellow leaves (refer to the finished painting). Continue masking with the bristle brush as before. Layering the spattering and masking fluid in this way helps to create depth in the foliage.

10 Spatter strong burnt sienna in the foreground with the no. 12 round brush. Larger spatters here and smaller ones in the background will help to create perspective. Using the no. 7 round brush, dab the spatter to adjust the shapes. Try to avoid leaving lines of spatter.

11 Spatter green gold, then Winsor green with cadmium lemon. Allow to dry.

12 Mix burnt sienna with a little cobalt blue. Spatter water first, then spatter the brown mix. Notice how the jagged, torn stencils are used to mask natural-looking edges.

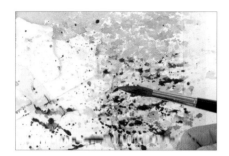

13 While the paint is wet, spatter water on top. This spreads the colour and the dark pigment, giving the patterns of shadow around the leaves.

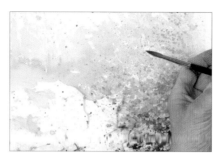

14 Mix a more muted green from cobalt blue, Winsor green and cadmium lemon, and spatter with the no. 7 brush to create smaller spatters in the distance. Add more cobalt blue to the mix to make a darker green and continue spattering.

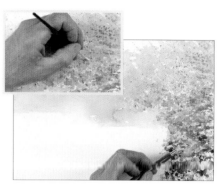

15 Use a fine brush and masking fluid to mask the light on the edge of the tree at top right. Change to a dip pen to apply masking fluid to create fine lines in the foliage, in areas that will be dark.

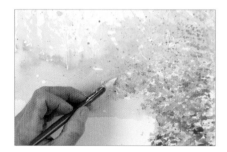

16 Use the dip pen to mask the area of the very bright leaves over the dark water, to preserve the yellows and bright greens. There is already masking fluid in this area preserving whites, for a multi-layered effect. Allow to dry.

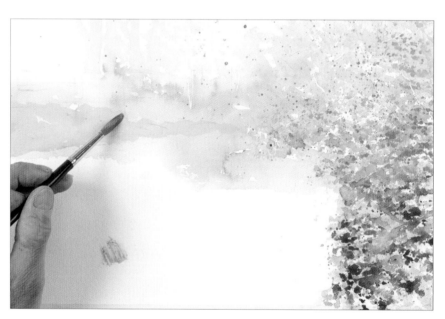

17 Mix new gamboge, cadmium lemon and a little Winsor green and use the no. 7 brush to put in the mid-greens for the riverbank on the left of the painting.

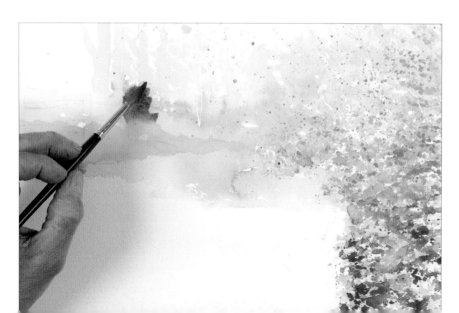

18 Mix burnt sienna and a little quinacridone magenta to paint the bright warm area on the left.

19 Soften the edges of the area with water, then add green gold to calm down the red.

20 Paint more green gold into the riverbank area, and over the trees.

21 Mask a few reeds on the left, and the left-hand sides of two trees, with the dip pen and masking fluid. Allow to dry.

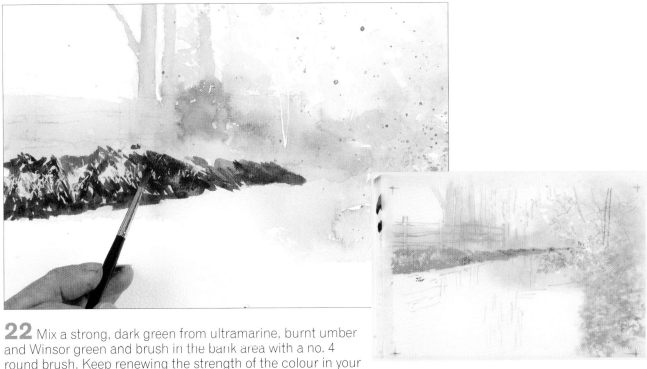

22 Mix a strong, dark green from ultramarine, burnt umber and Winsor green and brush in the bank area with a no. 4 round brush. Keep renewing the strength of the colour in your palette and paint a darker band at the top and bottom of the bank, to create form. At this point I needed to reinstate elements of the drawing that had been painted over, so I used the tracing again.

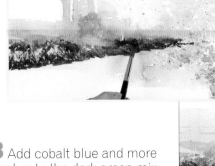

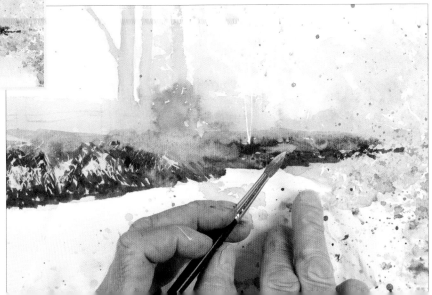

23 Add cobalt blue and more burnt umber to the dark green mix and paint the darker parts of the riverbank. Drop opaque Naples yellow into the dark mix.

24 Spatter water, then darks mixed from ultramarine and burnt umber, at the bottom right of the painting with the no. 7 brush.

25 Change to the no. 12 brush and continue spattering with thick paint, changing the direction of the brush as you go. Add the dark green mix at the top of the painting.

26 Return to the browner mix in the centre of the painting and continue spattering.

27 Use the no. 4 round brush to draw through the dark spatter, creating distant tree trunks. Spatter water across the area. This helps to join up the marks you have made. These steps follow exactly how the painting was done, but you only need to keep to the general principles in this section.

28 Continue drawing trunks, using a sword liner brush.

29 Use the no. 7 brush to spatter quinacridone gold and Naples yellow.

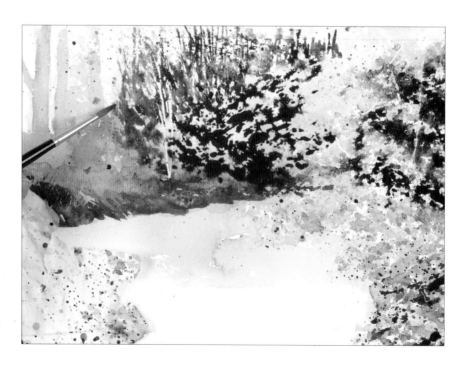

30 Drag the colour and use the dry brush technique with the no. 4 round brush to create distant darks.

31 Spatter more water on the distant foliage area, then ultramarine and burnt sienna.

32 Mix quinacridone gold and Winsor green with a little of the brown mix and spatter this on.

33 Spatter on intense darks mixed from ultramarine and burnt sienna.

34 Add more cobalt blue, burnt umber and ultramarine to the mix to make a very intense dark, and spatter this around the light area of foliage at the centre right.

35 Use the dip pen and masking fluid to mask another layer of grass on the riverbank. Allow to dry.

36 Spatter water, then burnt umber and ultramarine, then more water on the right-hand side of the painting. The water helps to join up the spatters so that they do not make separate spots of colour, but create the impression of the shadow between bright leaves. Use the no. 7 brush to tease out the shapes, removing anything that looks too directional.

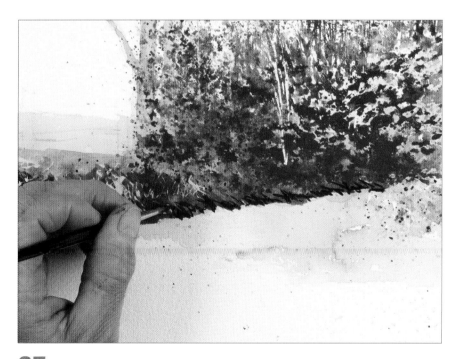

37 Use the point of the no. 4 brush and the intense dark mix of ultramarine, burnt sienna, burnt umber and cobalt blue to paint the darks at the bottom of the riverbank.

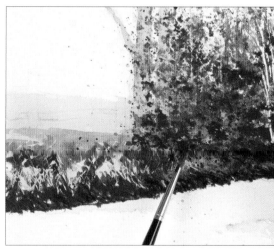

38 Paint dark shadows over the bank to complement the masked grass when it is revealed. Use dry brush work to soften any neat lines.

39 Wet the distant field with a no. 4 brush. Spatter water over the surface to leave a wet and dry pattern. Drop in a mix of quinacridone gold and green gold to create texture.

40 While this is wet, drop in a grey mix of cobalt blue and burnt sienna. This will spread through the wet paint, suggesting distant trees.

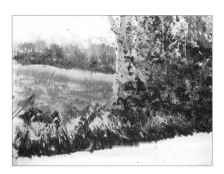

41 Mix cobalt blue, burnt sienna and a little Winsor green and paint the shadow in the grassy area.

42 Add strength to the shadow using a mix of ultramarine and burnt sienna, dragging the colour towards the foreground.

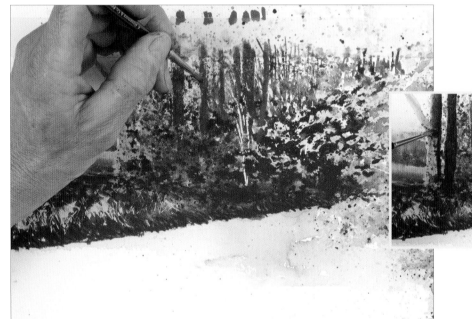

43 Mix a lighter grey from cobalt blue, burnt sienna and Naples yellow, and paint the distant tree trunks, taking care to paint against their masked edges. Paint the darker tree trunks with ultramarine and burnt umber.

44 Wet the branch of the backlit left-hand tree and the left-hand side of the trunk and drop in quinacridone gold. While this is wet, drop in the dark mix of ultramarine and burnt umber. Add branches with the tip of the brush and a pale mix of cobalt blue, burnt sienna and Naples yellow.

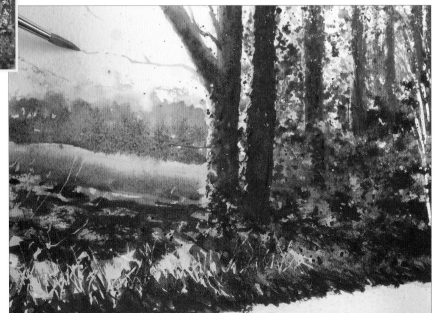

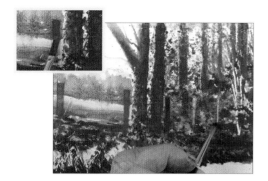

45 Use a small, chisel-ended brush and a mix of cobalt blue and burnt sienna to paint the uprights of the fence, then lift out the sunlit parts with a damp brush and dab with kitchen paper.

46 Paint the shadows under the horizontal bars of the fence with the same paint mix, and lift out highlights in the same way.

47 Change to the no. 4 brush to lift out the horizontal bars of the fence on the left, then paint the shaded parts with cobalt blue and burnt sienna.

48 Paint the darks of the fence uprights, then use the chisel-ended brush to lift out highlights where the horizontal bars cut into the uprights.

49 Use the no. 4 brush to paint quinacridone gold into the grass on the riverbank.

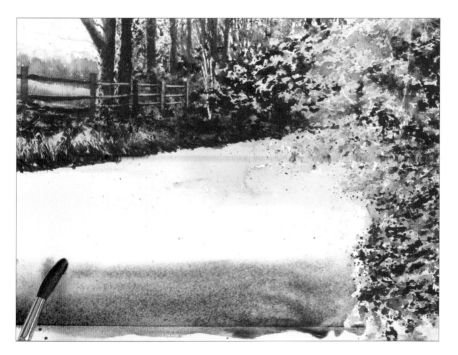

50 Mix a blackish blue from Winsor blue (red shade) and neutral tint. Wet the water area with clean water on the no. 12 brush, then brush in the mix from the bottom, so that it gets lighter coming up as it mixes with the water. Apply more dark paint along the bottom. If necessary, tip the board up, raising the top of the picture so that the watercolour spreads downwards. Allow to dry naturally.

51 Paint the tree trunk in the foliage on the right with the no. 7 brush and a mix of ultramarine and burnt umber, then change to the no. 4 brush to paint fine branches and twigs.

52 Apply clean water to the whole water area with the no. 7 brush. Some of the reflection will be done wet in wet, some wet on dry. Paint a little gum arabic on to the area shown (currently yellow), which will be painted wet in wet.

53 Paint cadmium lemon into the same area.

54 Working wet in wet, paint vertical streaks of burnt sienna, then strengthen this colour by adding quinacridone magenta. Brush down quinacridone gold further along.

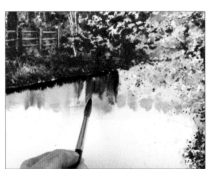

55 Still working wet in wet, paint Payne's gray under the waterline, then take it down in vertical strokes through the wet paint.

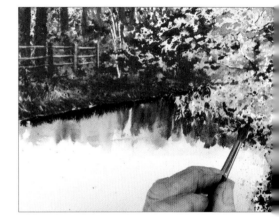

56 Mix burnt sienna and ultramarine and paint round the bright foliage over the water to create the pattern of leaves by negative painting.

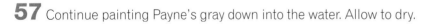

57 Continue painting Payne's gray down into the water. Allow to dry.

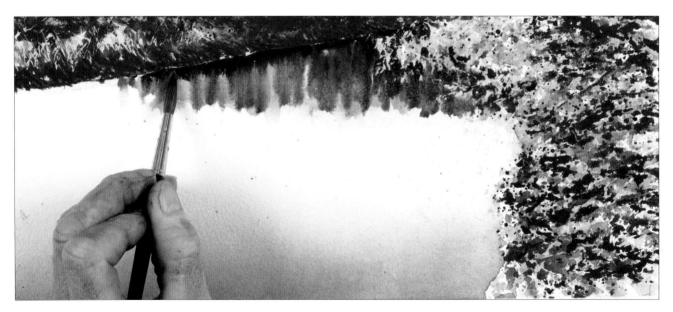

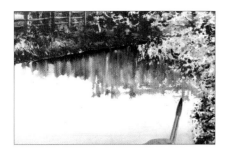

58 Painting wet on dry, drag down a mix of burnt sienna and ultramarine below the area of wet reflection.

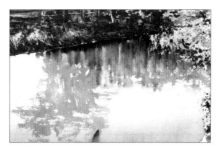

59 Mix quinacridone gold and cadmium lemon and drag this in on the left, using the rough surface of the paper. Add a little burnt sienna in places and continue with quinacridone gold.

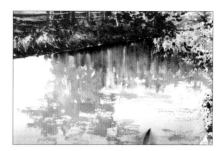

60 Mix ultramarine blue and burnt sienna and paint dry brush work in the foreground water.

61 Paint under the waterline with intense dark Payne's gray, using the dry brush technique.

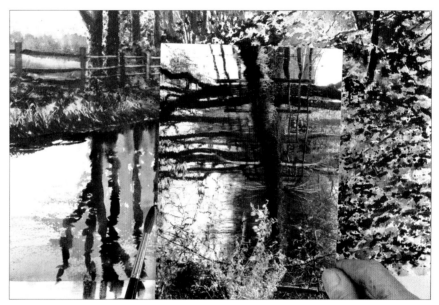

62 Wet the left-hand side of the water and use Payne's gray to paint the tree reflections. You can use a straight edge to help you get the angles right – here I am using the reference photograph.

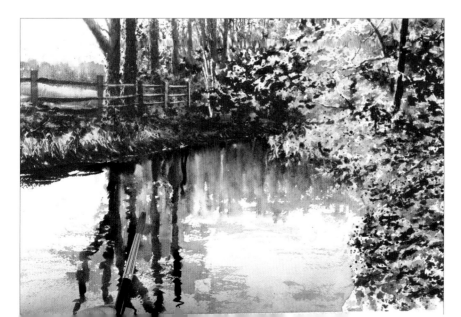

63 Drop in cadmium lemon over the top of the tree reflections.

64 Rewet the wet in wet area and paint trunks down into it with Payne's gray. Merge the shapes together.

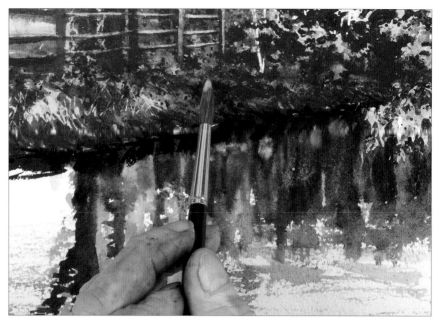

65 Paint dabs of cobalt turquoise into the water and on the bank.

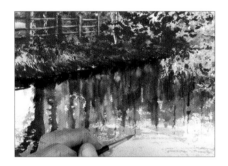

66 Use the no. 4 brush to paint small vertical reflections with Payne's gray.

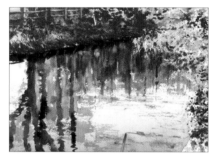

67 Scrub ultramarine and burnt sienna into the foreground water, then add more vertical tree reflections.

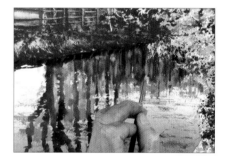

68 Drop a mix of cadmium lemon, Naples yellow and burnt sienna into the wet reflection to create warm lights in the water.

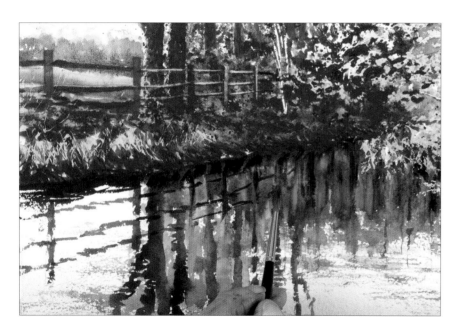

69 Paint the reflection of the fence with ultramarine and burnt sienna. Change to Payne's gray and the no. 7 brush for darker parts of the reflection in the centre of the picture.

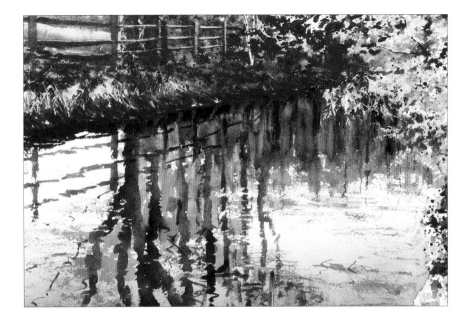

70 Continue adding detail to the reflections with the no. 4 brush, scrubbing in areas of tone where necessary.

71 Drag down a mix of quinacridone gold and cadmium lemon as reflections of the grasses on the left. Add a little more tone with burnt sienna and ultramarine.

72 Mix burnt umber and Payne's gray and paint long sticks protruding from the river bank on the right. When dry, mask the bank area with paper and paint off the paper so that some of the sticks appear to come out of the unseen area of the bank. Allow to dry.

73 Remove the masking fluid with clean fingers. Go over the reed leaves with Winsor green and cadmium lemon.

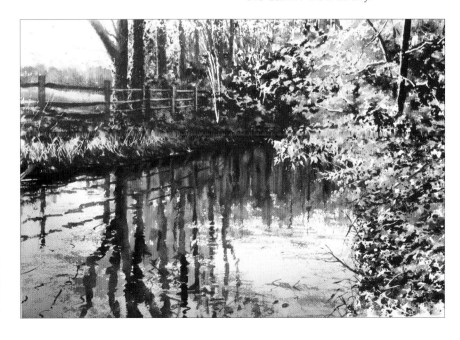

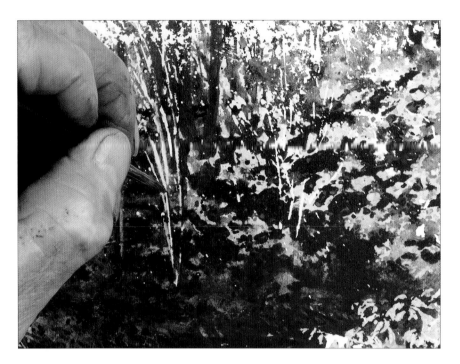

74 Wet the sapling trunks that were masked and paint a little burnt sienna in to reduce the highlights.

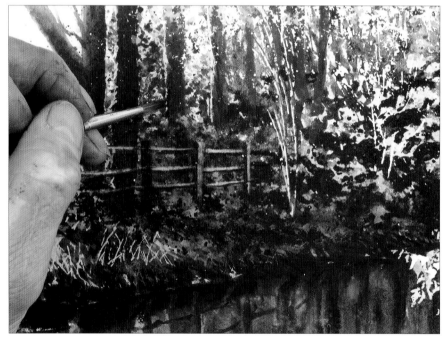

75 Paint a little green gold into the leaves in front of the distant trees. Break up highlights with a dark mix of burnt sienna and ultramarine.

76 Break up the masked lights with the same dark mix, moving across the painting.

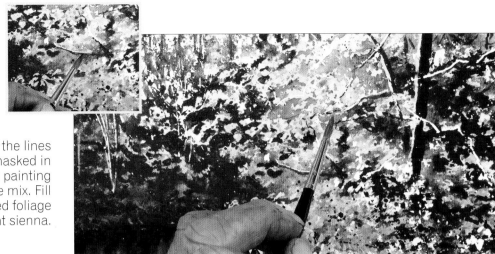

77 Thin down some of the lines of highlight that were masked in the right-hand foliage by painting shadows with the same mix. Fill in some of the highlighted foliage with burnt sienna.

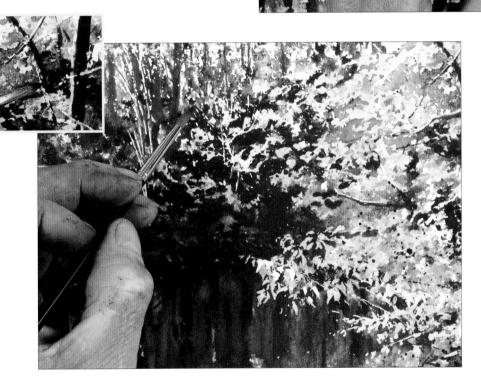

78 Continue modifying the previously masked foliage area to reduce any harsh highlights. Paint burnt sienna into some of the light areas so that they are not all sky holes.

79 Mix quinacridone gold and green gold and paint a little on the brightest area of foliage, leaving some leaves half white.

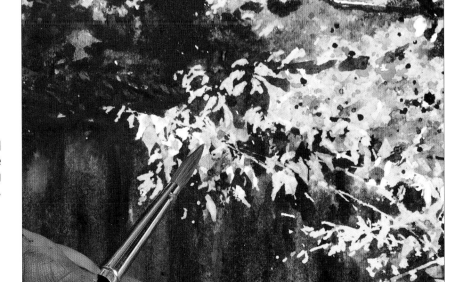

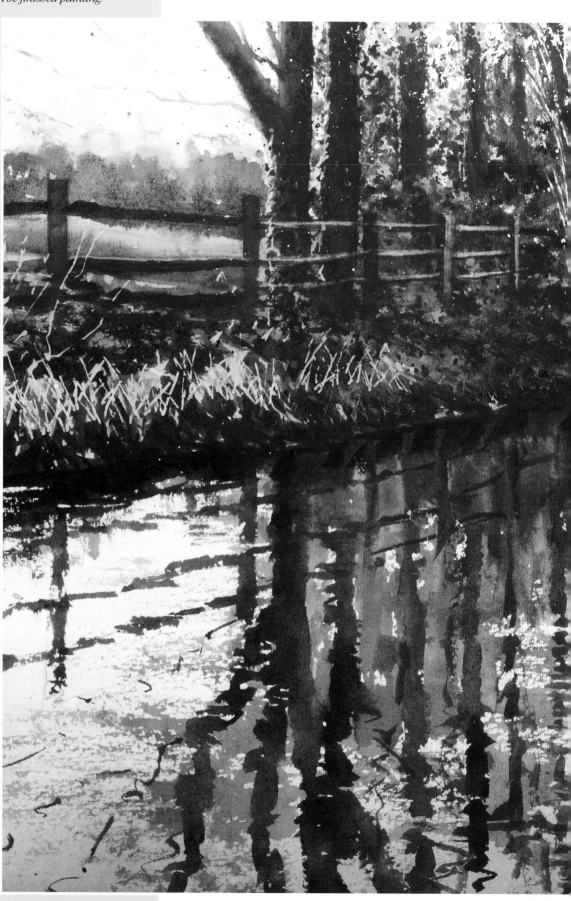

The finished painting.

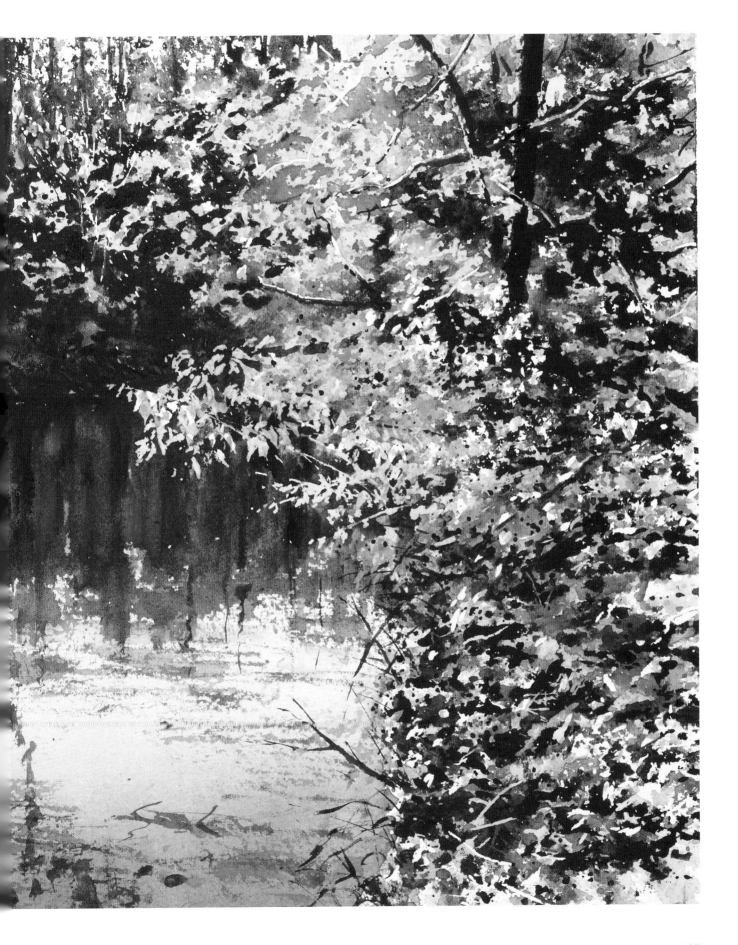

St Ives Farm Lakes

The key here is the loose approach and large quantities of paint and water. Demonstration paintings such as this one, done for Battle Art Group in Sussex, have loosened up my work because of the need for speed. Work can benefit from being untidy. With multi-layered watercolour it tends to tidy itself up a bit when the final elements go in.

I used a light green of cadmium lemon with a little phthalo green added and then burnt sienna to warm it. I mixed phthalo green, burnt umber and Payne's gray for a very dark green. I prepared a mix of quinacridone gold and some green gold. I masked all the lights on the chairs, the light edge of the fisherman and a highlight on the edge of the tree. Then I used a rough old brush messed up with dried masking fluid to mask ragged-looking oak leaves.

I loosely brushed water across the forest on the opposite side all the way across the painting. I spattered and brushed the quinacridone gold and green gold, then brushed in the phthalo green mix. After letting this dry, I spattered water, then dark green.

I brushed the right-hand foreground with burnt sienna, quinacridone gold and quinacridone magenta, greyed with a little cobalt blue. When this was dry, I brushed in violet shadows of cobalt blue and quinacridone magenta. I painted the grass with green mixed from cadmium lemon, phthalo green and burnt sienna, dropping in darks wet in wet. When the painting was dry, I dry brushed in more darks.

I painted an upside-down sky for the reflection, as on page 34. Once this was dry, I brushed plenty of wet tree colour down into the water, leaving ragged vertical lights for the reflected gaps of sky between the trees. I then brushed darker colour from the tree mixes down into the water. I let this dry before applying the foreground stump in two very dark washes of burnt umber and ultramarine blue, applying ripples at the same time.

The trees were painted very dark with the same mix, then Payne's gray was added wet in wet. I dragged out some branches and merged them with the leaf mass by spattering water and then colour. When this was dry, I removed all the masking. The leaves on the right resulted from spattering. The left-hand ones had been masked and I touched them in with green gold and quinacridone gold, and the highlight with burnt sienna. The reds of the chairs were from quinacridone magenta and cadmium lemon, and the blue was ultramarine.

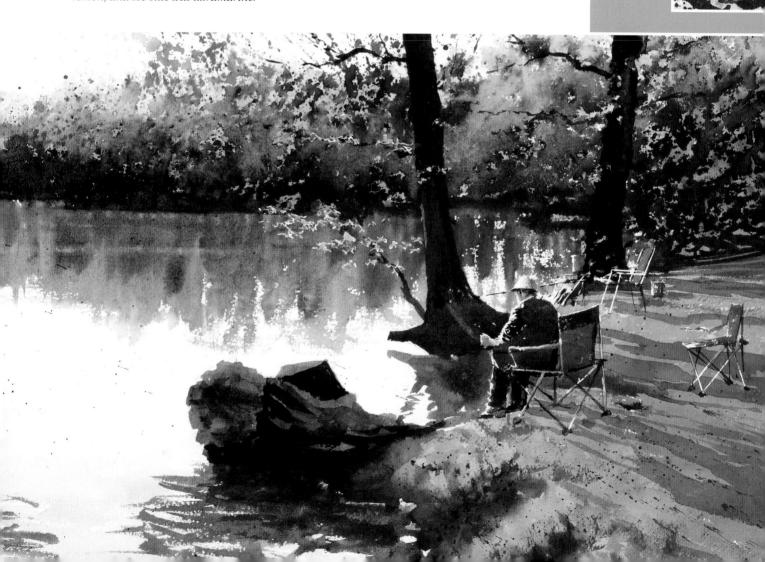

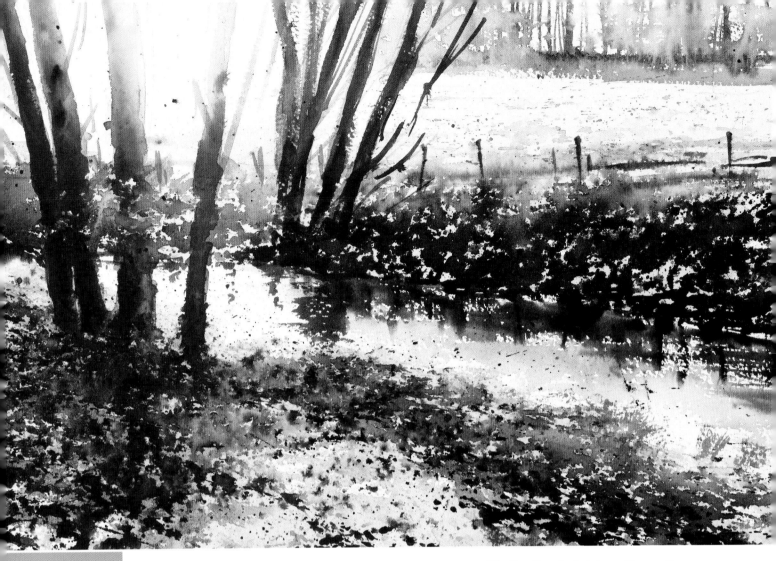

The Lye Brook, Ashdown Forest, Sussex

Success with bright, sunlit paintings comes from splitting tone and colour into extremes, with strong contrasts. The greens here are divided into a light, sunlit yellow-green and a dark, cool blue-green. The key was to reserve a large white area and to keep the colour here pale and warm. This is the glare zone. The sunny green is caused by low sun ahead. Light passes through translucent blades of grass and leaves as through coloured glass, in this scene producing light yellow-green. This is contrasted with the dark, cool blue-green in shadow.

I mixed several greens, starting with plenty of cadmium lemon and some phthalo green warmed with burnt sienna, and then some dark greens from phthalo green, burnt sienna and Payne's gray. I wet the glare area with clean water, brushing it well into the paper so it was damp without too much surface water, allowing colour to spread smoothly. I applied a pale layer of yellow-green on the ground, then spattered and brushed darker green in.

When this was dry, I used the water feathering technique for distant woodland. With plenty of water on a sable brush, I dragged the 'belly' across the rough surface of the paper, leaving a speckled wet-dry texture. This is a little like dry brushing, but with water on a well-loaded brush. While this was still wet, I brushed trees up into the water-feathered area with a grey of cobalt blue and burnt sienna. The trees form an intricate pattern as they 'feather' through the water. I then spattered and brushed water and dark greens for contrast.

The distant woodland grey was then applied to the brook, and a few darks were roughly brushed down into this. I brushed the trees in the glare zone with water using a sword liner, then applied a pale mix of cadmium lemon and burnt sienna, moving to burnt sienna, then Payne's gray further down.

Sparkling Sea

This project shows the sparkling sea at Mlini, Croatia, and demonstrates methods for painting a blaze of sunshine. To achieve this, everything must contribute to the effect. Every area of this painting stands on its own: the left-hand side, the right-hand side, the foreground and the sea – each will function as a painting. There is even a painting within a painting, by the artist Phil Kingsbury, at this idyllic location. I have taken artists to this perfect place for many years. Here is how you can use the elements from this scene and make it shine.

You will need

Masking tape

Masking fluid, fine brush, gummed-up brush, dipping pen and scrap paper

Brushes: cheap hog hair brush, no. 12 sable round, no. 7 and no. 4 round, small, stiff flat brush, fan blender

Colours: Winsor blue (red shade), Winsor green, quinacridone magenta, quinacridone red, cadmium lemon, cobalt blue, quinacridone gold, ultramarine blue, burnt umber, yellow ochre, burnt sienna, green gold, cadmium orange

Kitchen paper

Old toothbrush

1 Draw the scene and tape the edges with masking tape. Use a fine brush to mask the rocks, easel, bag, hat and boxes with masking fluid.

2 Take a cheap hog hair brush and crush the end to splay the bristles. Pick up masking fluid and dab on to the sea area where you want sparkles. Turn the brush before each successive dab to vary the marks. Dry and continue with a second layer.

3 Tear a piece of scrap paper and twist it as shown. Dip it on its side in masking fluid and use it to mask sparkles. This creates a different, irregular print. Dry the twist of paper, covered in masking fluid, with a hairdryer, then continue using it to vary the marks.

4 Use a gummed-up old brush to mask small sparkles further out to sea.

5 Spatter masking fluid using an old toothbrush, tapping it against your hand. Flick the bristles with your thumb for a finer spatter. Allow the masking to dry thoroughly.

6 Use a no. 12 round brush to paint clear water over the sea. Paint a pale wash of Winsor blue (red shade) from the top left.

7 Add Winsor green to the wash and paint it from the bottom of the sea area up.

8 Mix a pale wash of quinacridone magenta and Winsor blue (red shade) to paint at the bottom right.

9 Change to the no. 7 brush and paint a grey mix of quinacridone magenta, Winsor blue (red shade) and Winsor green to paint the darker part of the sea.

10 Paint directional strokes across with this mix using the no. 12 brush, keeping the paper wet, to create soft waves coming in to shore. Continue these strokes across the painting over the sparkles on the right.

11 Continue with the grey mix over the sparkles at the bottom right of the sea area. Make a stronger mix of the grey and reinforce the lines of waves coming from the left. Continue to work with wet paint on wet paper, or wet in wet, until the end of step 16.

12 Use more water and less paint to paint the paler wave lines on the right.

13 Wet the bottom right-hand area again and add more of the strong-toned grey mixed from quinacridone magenta, Winsor blue (red shade) and Winsor green, over the sparkles.

14 Make a very dark mix of quinacridone magenta and Winsor green and paint the wave lines on the left.

15 Paint more Winsor green at the top left of the painting.

16 Use the grey mix to paint directional lines across the painting. Allow the painting to dry.

17 The colour around the sparkles should be fairly washed out to create a dazzle effect. If there are any hard lines around the masked sparkles, soften them with a damp brush and lift out colour with kitchen paper.

18 Use a damp no. 4 brush to lift out lighter areas and dab with kitchen paper.

19 Mix Winsor green and Winsor blue (red shade) and break up the ranks of waves with smaller ripples.

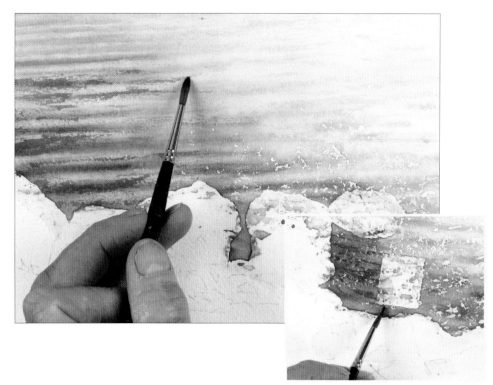

20 Use the darker variant mixed from quinacridone red, Winsor green and Winsor blue (red shade) to paint ripples on the left with the dry brush technique. Continue in the same way around the easel in the foreground.

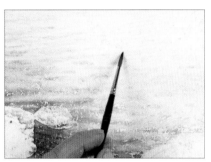

21 Dry brush a pale mix of Winsor blue (red shade) and Winsor green on the right of the sea area.

22 Take a small, stiff flat brush, wet it and scrub over some of the masking fluid sparkles to create a dazzle of light around them. Dab with kitchen paper to lift out colour. Allow to dry.

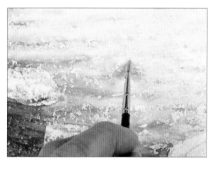

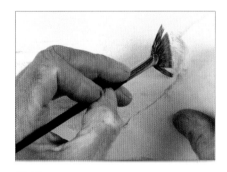

23 Remove all the masking fluid from the sea, leaving it on the land and rocks. Mix a bright green from cadmium lemon, cobalt blue and quinacridone gold. Make a paper stencil so that you only paint greenery in the top right-hand corner, and use the edge of the fan blender to gently touch in texture, leaving daylight showing through. Allow to dry.

24 Use the cheap hog hair brush to dab masking fluid over the dried bright green, to create light gaps in the foliage when the darker colour is applied later. Create larger holes using a brush already gummed up with masking fluid. When this is dry, spatter more masking fluid over the area with a toothbrush.

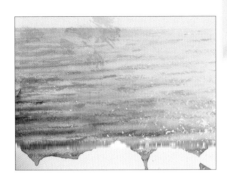

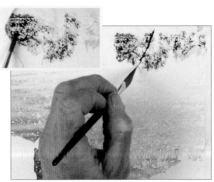

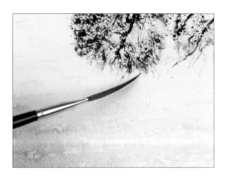

25 Remove the masking fluid from the rocks. Use the no. 4 brush to paint foliage at the top left-hand side of the picture with the same bright green.

26 On the right, paint an intense dark green mixed from ultramarine, burnt umber and Winsor green over the masking. Use a sword liner brush with the same mix to paint branches.

27 Use a pale mix of ultramarine and Winsor green to paint tiny branches. Suggest dried greenery with dry brush work.

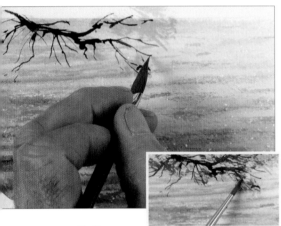

28 Paint the branches in the greenery on the left with the intense dark green. Change to the no. 7 brush, mix a little of the intense dark green into the bright green, and suggest foliage with dry brush work.

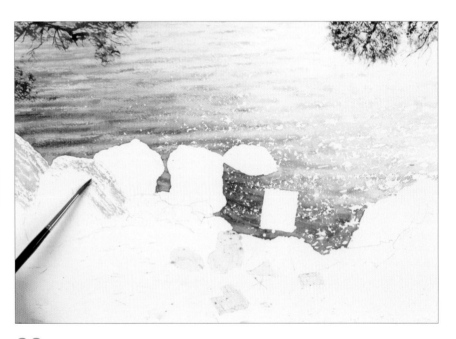

29 Drag clean water over the rocks with the no. 4 brush, then drag a pale mix of cobalt blue and burnt sienna over them, leaving white highlights.

30 Add yellow ochre to the mix and continue, creating the shapes of the rocks.

31 Drop in a little cobalt blue while the rocks are wet, then begin to add dark shadows with ultramarine and burnt sienna.

32 Continue dry brushing rock texture with the paler cobalt blue and burnt sienna mix.

33 Build up the tones and colours of the rocks with the same mix with yellow ochre added.

34 Continue painting the rock texture with the lighter mix, then dropping in the ultramarine and burnt sienna mix for the darks.

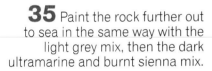

35 Paint the rock further out to sea in the same way with the light grey mix, then the dark ultramarine and burnt sienna mix.

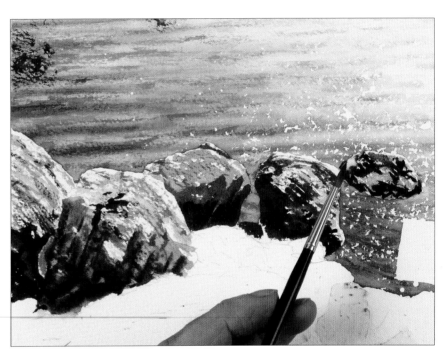

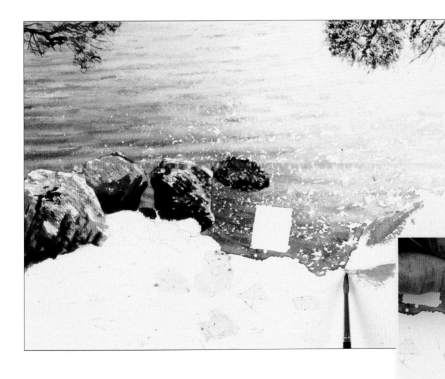

36 Paint on a mix of yellow ochre and burnt sienna on the rock on the right. Continue creating the form of the rock with a cooler mix of cobalt blue and yellow ochre.

37 Paint in the dark crevices with ultramarine and burnt sienna.

38 Add texture with dry brush work and continue adding cracks and crevices.

39 Use a dip pen and masking fluid to mask lots of sticks and twigs in the foreground.

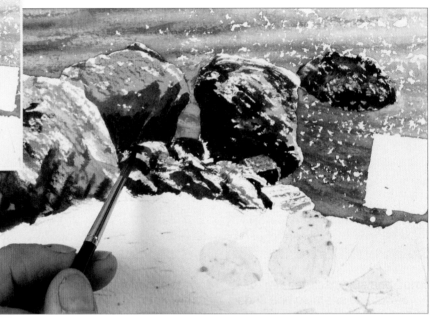

40 Paint more rocks just beyond the shore with cobalt blue, burnt sienna and yellow ochre and the dry brush technique, using the no. 4 brush. Add the lower, shadowed parts of the rocks with the dark mix of ultramarine and burnt sienna.

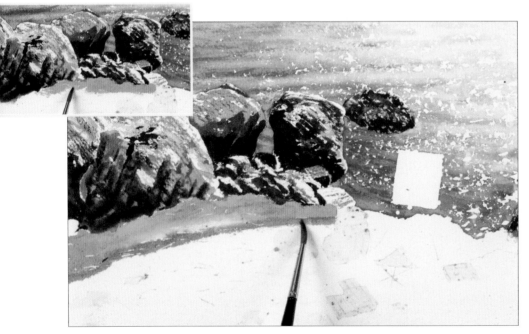

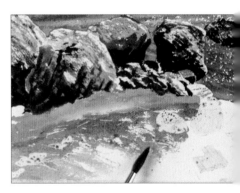

42 Use the no. 7 brush and burnt sienna to create texture in the foreground.

41 Block in the foliage at the edge of the land with green gold. Soften with water at the bottom, then paint burnt sienna below so that it blends in.

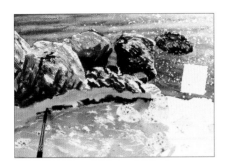

43 Paint in intense shadow under the foliage wet in wet with a mix of ultramarine, burnt sienna and a little Winsor green on the no. 4 brush.

44 Mix Winsor green with a tiny bit of cadmium lemon and dot this into the foliage, wet in wet, then dot in pure cadmium lemon.

45 Paint the small rock on the far left with the pale mix of cobalt blue and burnt sienna, then add darks with ultramarine and burnt sienna.

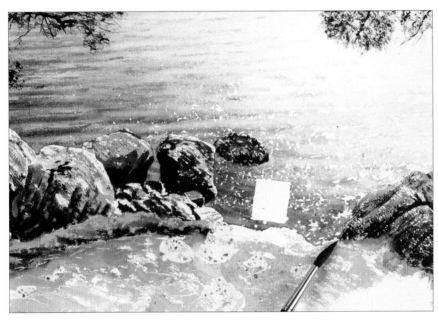

47 Mix a green from cobalt blue and cadmium lemon and paint it to create foliage extending to the right, then while it is wet, drop in Winsor green at the bottom.

46 Use the no. 7 brush to paint the ground on the right with burnt sienna and a little yellow ochre and the dry brush technique.

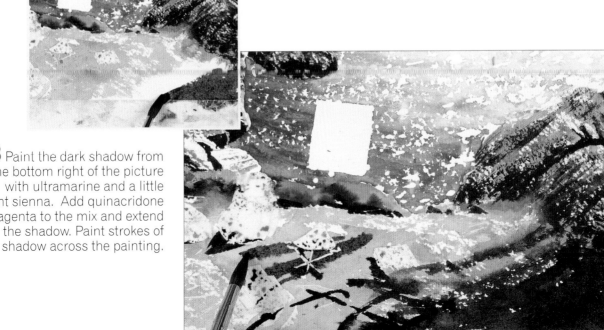

48 Paint the dark shadow from the bottom right of the picture with ultramarine and a little burnt sienna. Add quinacridone magenta to the mix and extend the shadow. Paint strokes of shadow across the painting.

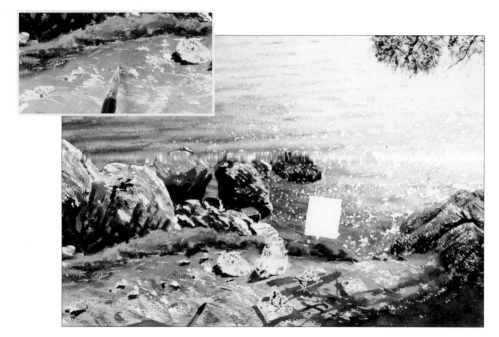

49 Use the dipping pen and masking fluid to mask sticks in the foreground. Paint more burnt sienna with the no. 4 brush and the dry brush technique, then paint the darks next to rocks and twigs with ultramarine and burnt sienna.

50 Place masking tape over the painting on the easel, then paint in the legs with ultramarine and burnt sienna, going over the masking tape.

51 Peel off the masking tape. Use the same mix to paint more dark shadows on the rocks on the right.

52 The painting board on the easel is in the shade, so paint a wash of cobalt blue with a tiny bit of burnt sienna, leaving a highlight at the edges. Allow to dry.

53 Mask the corners of the painting on the board with the dip pen and masking fluid, then mask the whole painting area with a fine brush. Allow to dry, then paint the board with burnt sienna and ultramarine. Dry.

54 Remove the masking fluid from the painting area, then mask just the white edge of the paper with the dip pen and masking fluid. Allow to dry.

55 Suggest the painting on the easel with Winsor blue (red shade) at the top and ultramarine at the bottom. Paint the land mass in the painting with Winsor blue, ultramarine and burnt sienna, and greenery at the top with Winsor green.

56 Remove the masking fluid from the bag and the other items in the foreground. Paint the bag with cadmium orange and quinacridone magenta. Allow the wash to dry, then paint in a stronger mix of the same colours. While this is wet, drop in ultramarine for shadow.

57 Add another layer of red to build its strength, then make a black mix of ultrmarine and burnt sienna to paint details such as the zips and straps.

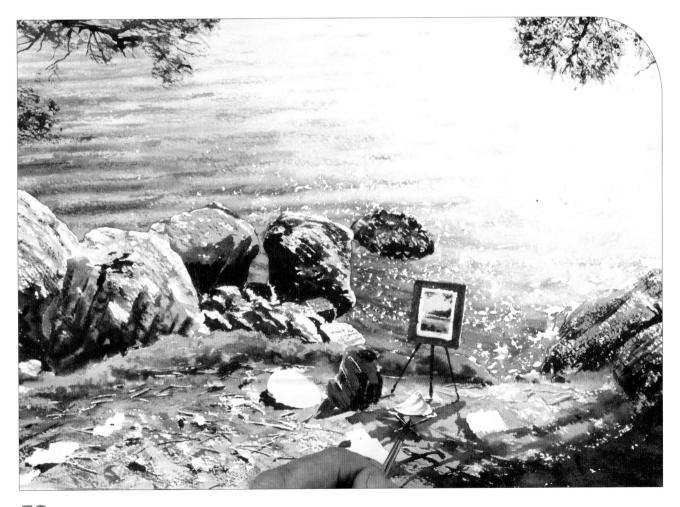

58 Paint a pale wash of yellow ochre over the hat. Apply clean water to the seat and paint shadows on it with a pale mix of ultramarine, quinacridone magenta and a little burnt sienna. Paint dark details and shadows underneath the seat with ultramarine and burnt sienna.

59 Divide the paint boxes into sections with a pencil and use the dip pen and masking fluid to mask the division lines.

60 Add shape to the hat with the no. 4 brush and a mix of burnt sienna with a little cobalt blue. Paint a dark shadow at the base with ultramarine and burnt sienna.

61 Paint shadows alongside the masked divisions in the paint boxes with a mix of cobalt blue and burnt sienna. Allow to dry.

62 Paint colours in the paint boxes, choosing whatever looks good from your own palette.

63 Drag water across the rocks on the left of the foreground, then drop in burnt sienna and cobalt blue. Add darks with ultramarine and burnt sienna and paint this mix under the sticks as well.

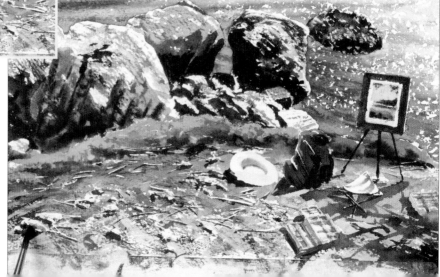

64 Paint grasses in front of the right-hand paint pox with Winsor green, ultramarine and burnt sienna, then drop in cadmium lemon wet in wet.

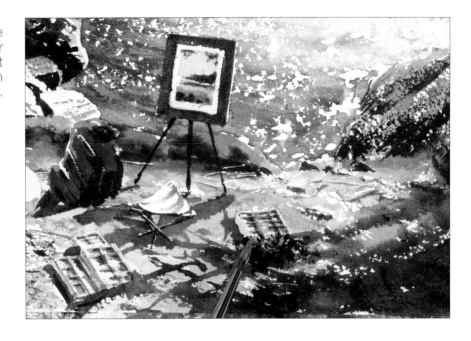

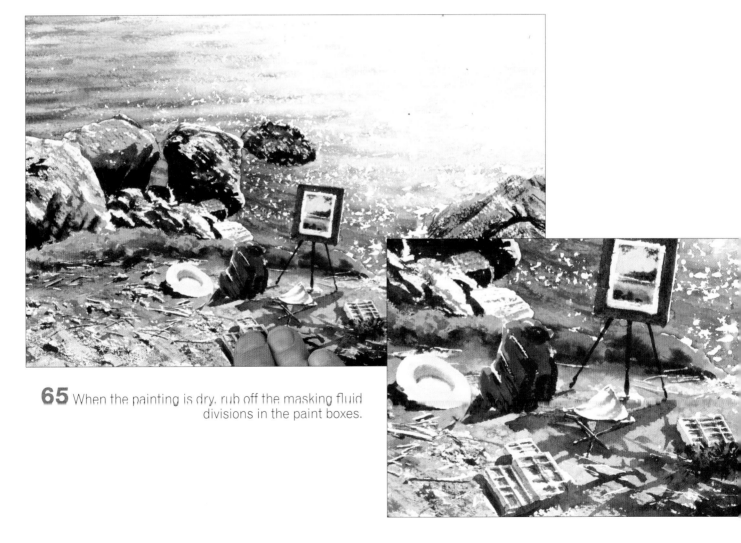

65 When the painting is dry, rub off the masking fluid divisions in the paint boxes.

Overleaf

The finished painting.

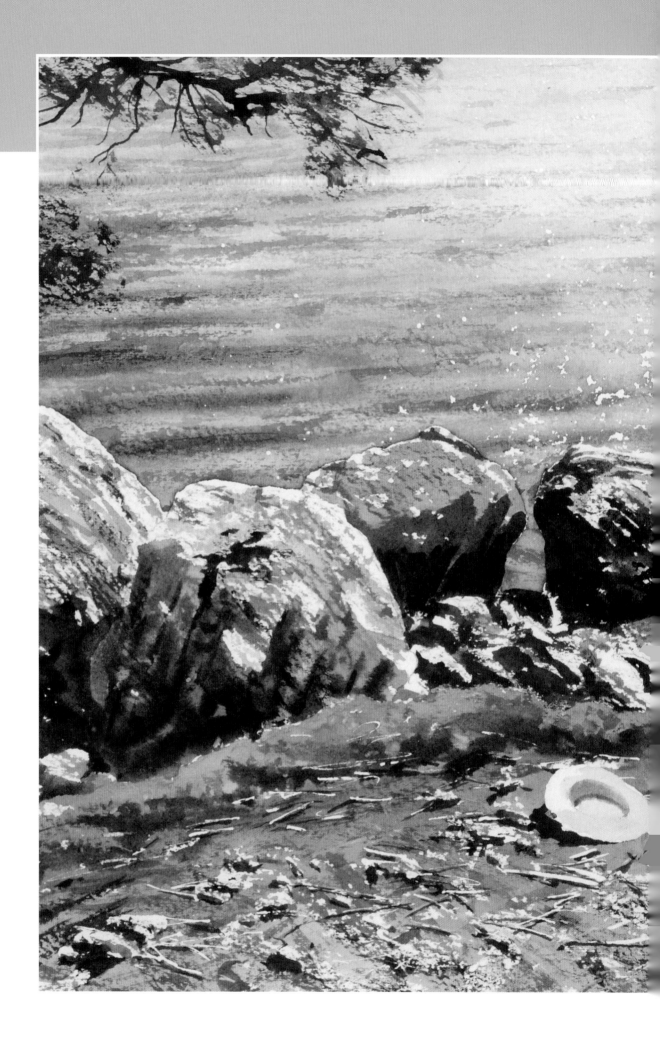

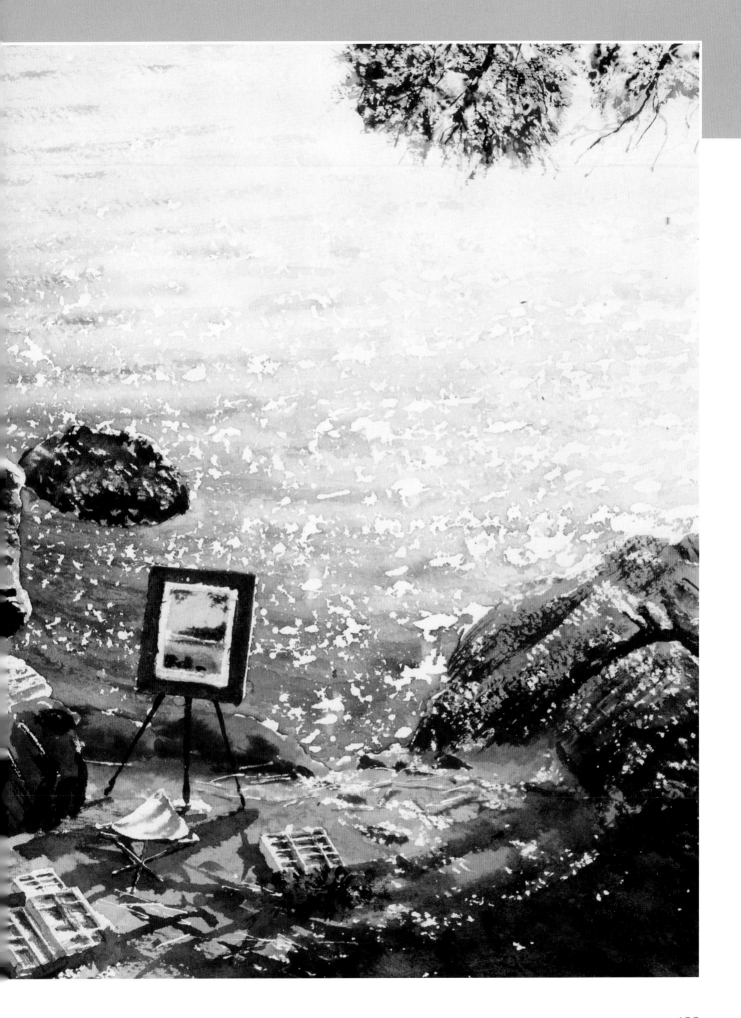

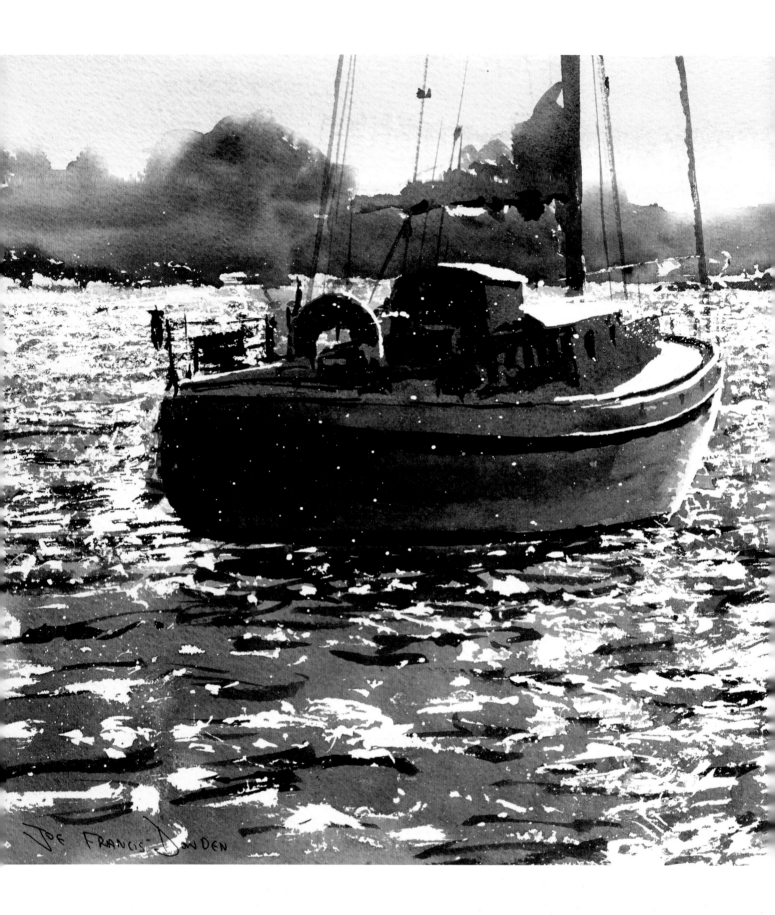

'Scurri', Chichester Harbour

This painting is almost a monochrome, showing that you can get bright sunlight without colour. It is based on a photograph taken into the sun, a fleeting instant in time as our launch motored past.

I used protective masking for the light glinting on the boat. A glint is a reflection. Sunlight is so powerful that anything will provide a glint with the sun at the right angle, even rock or masonry. Here it was the shiny hull.

I masked hints of shoreline detail. I switched to constructive masking techniques for the water. Constructive masking brings something extra to a painting which could not be achieved any other way. I used cheap hog hair brushes to mask white highlights. The right-hand side was virtually covered with just a few gaps in the masking. This is the area below the sun. I gradually reduced the quantity of masking, making numerous rough horizontal marks, wider spaced in the foreground, closer and finer further away. As the brushes get messed up by masking fluid, the marks look more convincing. Then the brushes start to get unusable so I use another one. It took three-quarters of an hour to brush on. I also spattered droplets of masking fluid, using the edge of a piece of paper to protect the boat sides.

When this was dry, I painted the sky with a mix of neutral tint and a little cadmium orange. I let it dry again and wet the skyline only, this time applying the colour to the trees and letting it spread upwards, meeting the edge of the wash with a hard edge in some places, retaining a soft edge in others. The distant boat sail was partly lifted out from the dark lower background and partly painted against the sky.

The sea was painted with neutral tint on its own, keeping the colour wet and free-flowing, and letting the masking do the work. I painted it paler on the right, and denser and darker on the left. On the right-hand side, I just painted a few strokes of paint here and there, very pale, so the sparseness of colour is achieved by the combination of masking and brushing. It is guesswork because you can't judge what it looks like until removal of the masking.

I painted the boat, carefully mapping out its shape in silhouette, with a dark grey of neutral tint, keeping the hull side paler at the front near the glint. When this was dry, I painted the interior dark shadows and lines with neutral tint.

I had an hour and a half to do the entire painting for the local art society, and this was mostly spent masking. Up until this point there was very little to see, just a mess of masking. Finally I removed all the masking fluid. The painting appeared very suddenly in one go, to the relief of everyone, not least myself.

Ploce, Dubrovnik

I used the hog hair masking technique for the water as on page 110. I also used a toothbrush and sprayed thousands of tiny droplets all over the sea by dragging my thumb across the bristles. I masked all the whites in the city with a small, neat synthetic brush.

When it was dry I mixed plenty of cyan blue, one of the phthalo blues. I brushed it wet in wet into the sea, being careful not to get it on to the unmasked parts of the city. I made it pale in the distance and strong in the foreground, brushing more dark into the harbour area and adding a few dark wave accents with Payne's gray. This was done rapidly in the space of a few minutes. Colour looks best when it is left alone.

I lifted a little colour off the distant sea for the texture of a windblown area. Then I painted the distinctive red roofs with light red, Naples yellow and a little cadmium red. The town was painted this colour and then the buildings were painted by applying shadow with cerulean blue and burnt sienna with ultramarine blue in between them. Payne's gray was added for strong darks before the masking was removed.

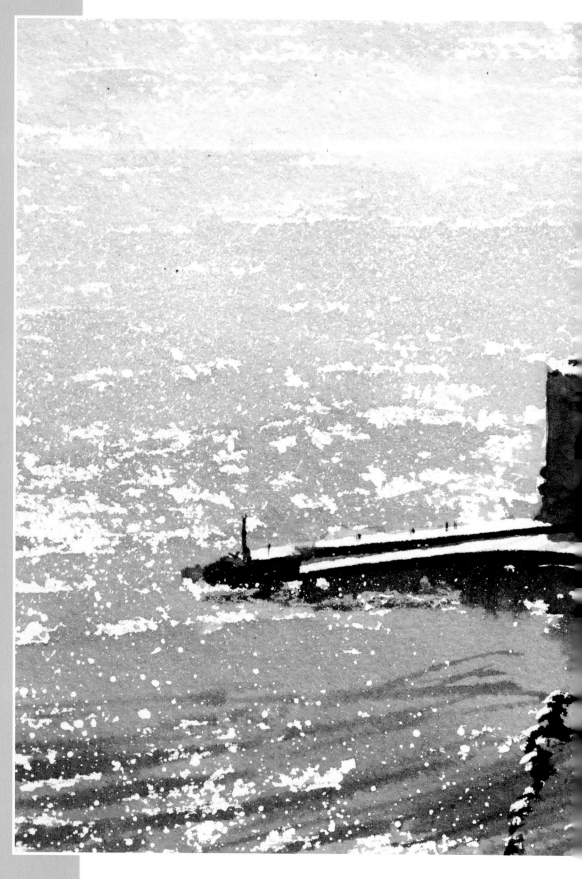

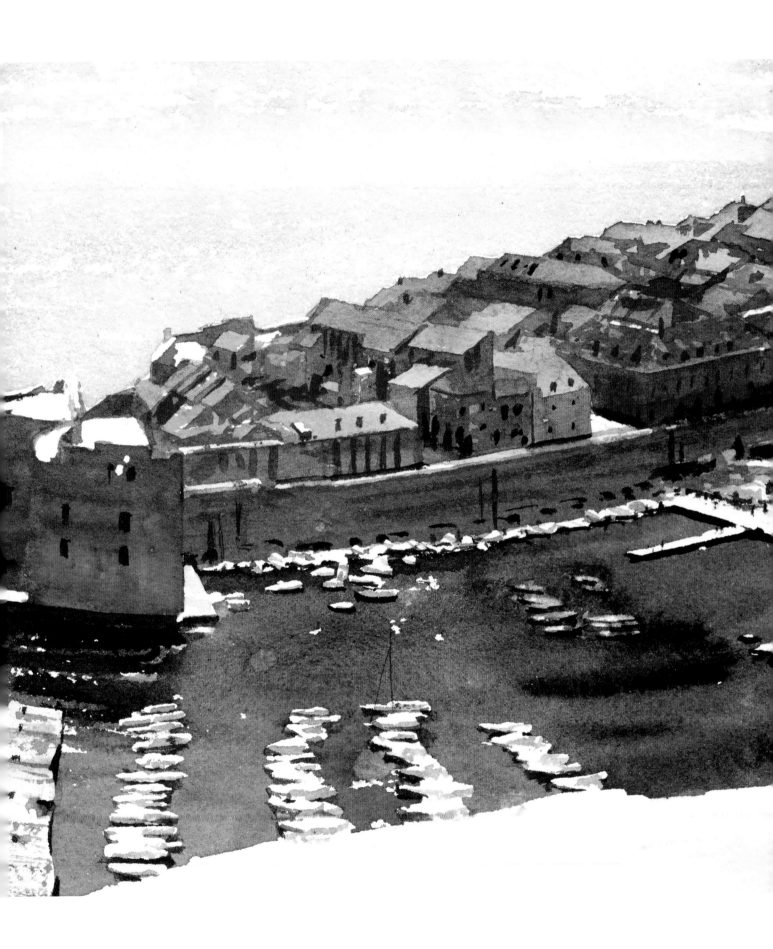

Sailing Boat

This project, showing a sailing boat at Littlehampton, is about how to make light dazzle. You can't dazzle the observer by shining a light through the back of the painting, but you can use these techniques to achieve the effect of strong light. They include creating glare. You will notice that even the car park glints in the evening light. The classic scene of a yacht, known as a Falmouth Quay punt, heaving to the last swells as it sails in on the evening tide is well suited to watercolour. Rich washes and reserved whites help to define its distinctive features.

You will need

Masking tape

Masking fluid, gummed up brush, ruling pen, dipping pen and colour shaper

Brushes: cheap hog hair, 2.5cm (1in) flat, no. 12 round, no. 7 round, no. 4 round, fan blender

Colours: cobalt blue, burnt sienna, quinacridone gold, quinacridone magenta, Winsor blue (red shade), Winsor green, burnt umber, ultramarine blue

Kitchen paper

Ruler and pencil

1 Draw the scene. Mask the highlighted parts of the cars in the distance and the edge of the boat with masking fluid and a ruling pen. Place a strip of masking tape along the bottom of the left-hand sail to protect it from masking fluid in step 2. Mask some sparkles on the water with a gummed-up fine brush.

2 Crush the bristles of a cheap hog hair brush and pick up masking fluid. Apply it all over the sea, overlapping the bottom of the masked sail, to create sparkles.

3 Remove the masking tape. Use the cheap bristle brush to mask the sails. You can also use a colour shaper to get the edges right.

4 Use the 2.5cm (1in) flat brush to paint water over the sky, down to the waterline. Change to a no. 12 round and paint on a pale grey wash of cobalt blue, burnt sienna and a touch of quinacridone gold and quinacridone magenta.

5 Add more quinacridone magenta and burnt sienna to the mix on the left.

6 Add more cobalt blue to the mix at the waterline to darken it, and tip the painting up so that the washes tend to spread up the sky area.

7 Paint a line of cobalt blue in the distance with a no. 7 brush, wet in wet, then allow the painting to dry.

8 Paint the distant sand dunes with a wet mix of cobalt blue and burnt sienna, then drop in a stronger mix at the bottom so that it will spead upwards.

9 Repeat to paint the section of sand dunes showing between the sails. On the right, paint a strip of water, then use the no. 4 brush to paint a bluer, darker mix of the same colours, going over some of the masked cars.

10 Wash the same bluer, darker mix over the cars on the left, then immediately paint burnt sienna underneath for the harbour wall.

11 Repeat the bluish line of cars and the brown harbour wall across the painting.

12 Wet the sea area with the no. 12 brush, leaving a few dry areas on the left where there will be plenty of light. Use the no. 7 brush to paint on a pale mix of Winsor blue (red shade), quinacridone magenta and Winsor green, with a touch of burnt sienna to muddy it, on the left of the boat. Save the blaze of light just left of the mast and under the sail by leaving the area dry and paint free.

13 Paint to the right of the sail in the same way, then make a stronger mix of the same colours and paint it on the far left.

14 Continue painting the darker mix all around the boat, rewetting the paper and applying darker paint repeatedly.

15 Paint a strong, dark mix to the right of the boat and below it, and while this is wet, paint the reflection of the red sail with quinacridone magenta and burnt sienna. This should merge with the sea colour.

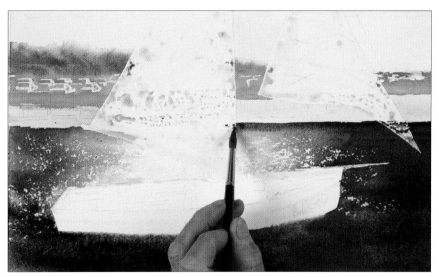

16 Continue darkening the sea colour as before, then paint a particularly dark line along the waterline. Allow the painting to dry.

17 Create the shapes of shadows in the sand dunes with clear water on the no. 4 brush, then flood in a dark mix of cobalt blue and burnt sienna.

18 Paint the dark shapes around and between the cars with a very dark mix of the same colours.

19 Paint the windscreens and the visible back windows with Winsor blue (red shade).

20 Paint the windscreens of the cars in the middle in the same way, then add the darks around the cars.

21 Continue, painting the cars on the far right in the same way. Paint the side of one car with a mix of burnt sienna and quinacridone magena.

22 Check with a ruler that the harbour wall is perfectly straight and horizontal. Paint the wall with ultramarine and burnt sienna, using the ruler to help you at the top.

23 Change to the no. 7 brush and make a new sea mix from Winsor blue (red shade), Winsor green, quinacridone magenta and burnt umber. Paint this down the wall first, and add burnt umber at the bottom in the middle.

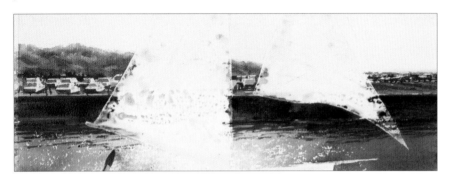

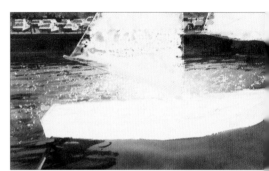

24 Paint the rippled reflections going down into the water with the tip of the brush and the same dark mix, then add more burnt umber to paint the reflection in the middle. Continue with the new sea mix, going through the sparkle area.

25 Keep plenty of strong wet colour on the palette and paint the ripples around the back.

26 Continue painting directional ripples through the red reflection.

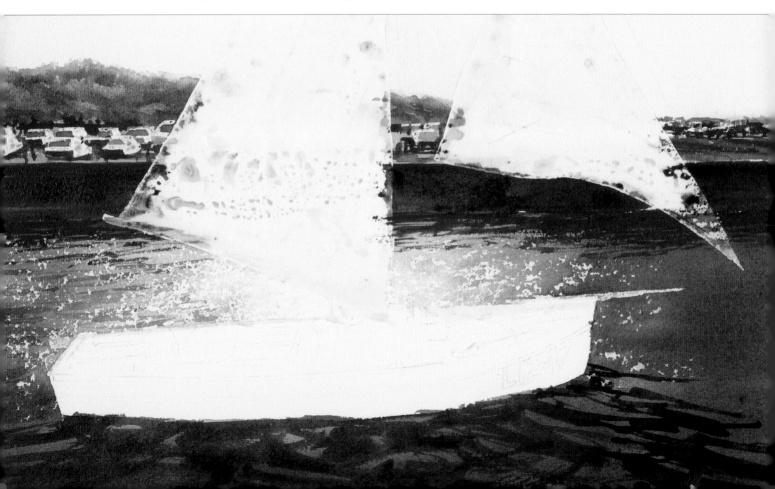

27 Suggest car interiors and window reflections with fine ultramarine blue and burnt sienna marks using the no. 4 brush.

28 Suggest bumpers by painting a line of water along their tops, then dabbing with kitchen paper to lift out colour, and headlamps by painting little vertical lines with water and lifting in the same way.

29 Paint rear lights with tiny touches of quinacridone magenta.

30 Paint a thin blush of cobalt blue and burnt sienna to suggest a chain link fence behind the cars on the right. Place masking tape along the top of the fence and use a darker mix to paint posts.

31 Mix ultramarine and burnt umber and use the no. 7 brush to paint an undercoat for the side of the boat.

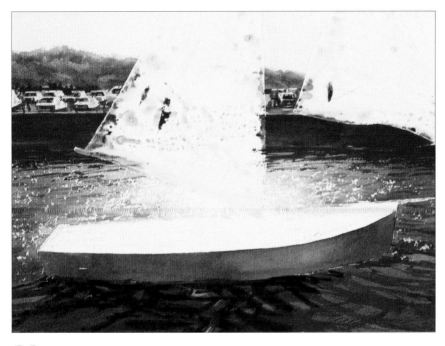

32 Paint dark ripples under the boat, in a different pattern from those already there, with a dark mix of Winsor blue (red shade), quinacridone magenta and Winsor green. Allow to dry.

33 Remove the masking fluid from the cars, and use cobalt blue and burnt sienna to re-establish the shapes if necessary, and Winsor blue (red shade) for the windscreens. Paint the car body colour with cobalt blue and burnt sienna.

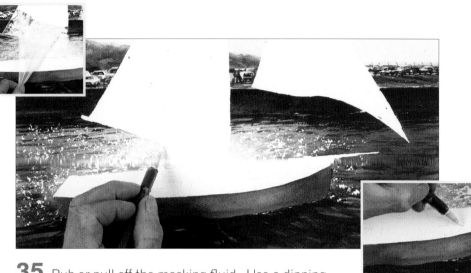

34 Refine details on the cars, painting side windows with a pale grey mix of cobalt blue and burnt sienna, the sides of cars with a darker, bluer mix, and wheel arches with a very dark mix.

35 Rub or pull off the masking fluid. Use a dipping pen and more masking fluid to mask sparkles going into the edge of the sail. Also mask where the light catches boat details and people. See steps 49 to 55 and the finished painting to observe these masked lights.

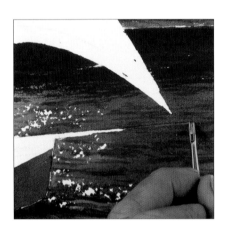

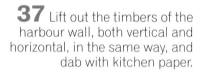

36 Take a small, damp flat brush and lift out paint for the highlight on the boom, then dab with kitchen paper.

37 Lift out the timbers of the harbour wall, both vertical and horizontal, in the same way, and dab with kitchen paper.

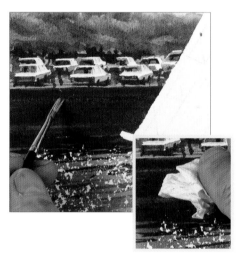

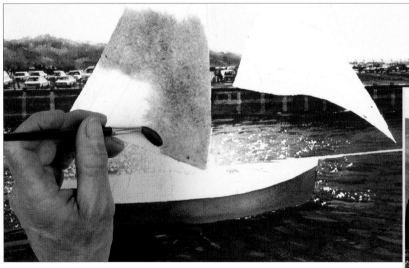

38 Wet the whole of the left-hand sail with clean water and the no. 7 brush. Paint burnt sienna from the top down. Drop in quinacridone gold at the top.

39 Make a strong mix of quinacridone magenta and burnt sienna and smooth this in wet in wet.

40 Mix cobalt blue and burnt sienna and drop this in to darken the sail.

41 Smooth the colour downwards with the fan blender. Add more darks wet in wet with cobalt blue and burnt sienna on the no. 7 brush.

42 Wet the right-hand sail and apply a coat of burnt sienna and quinacridone magenta. While this is wet, add shadows to suggest form with burnt sienna and cobalt blue.

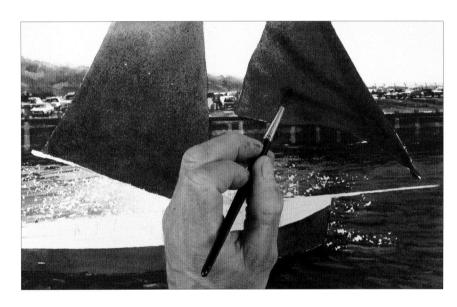

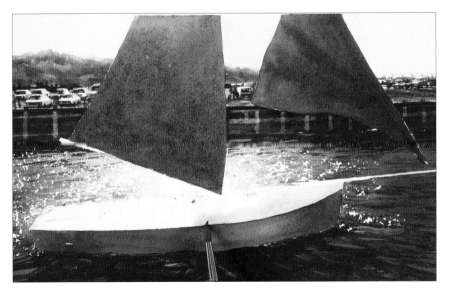

43 Wet the deck and drop in a pale mix of burnt sienna with a litle cobalt blue, working round the white box.

44 When the sails are dry, apply a glaze of quinacridone gold with a little burnt sienna to warm and enrich the colours.

45 Paint the shadow in the boat, and of the box on deck, with a mix of cobalt blue and burnt sienna. Paint the shadow cast by the boom with the same mix. Wet the boom and paint the shaded underside with ultramarine and burnt sienna. Use the no. 4 brush to paint the full length of the boom with a dark mix of ultramarine and burnt sienna, leaving a highlight at the top.

46 Use the same mix to paint dark shadows of the details on the deck.

47 Mix ultramarine, burnt sienna and quinacridone magenta to create various strengths of shadow inside the boat. Soften the edges with clean water.

48 Paint the wood colour inside the boat with burnt sienna. This should help to create the shape of the figure.

49 Continue painting the darks in the bottom of the boat with ultramarine, burnt sienna and quinacridone magenta, then paint more of the wood colour in the stern with burnt sienna and a little ultramarine.

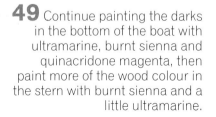

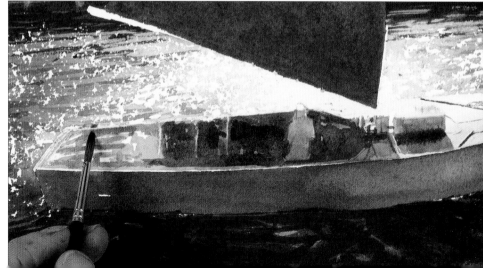

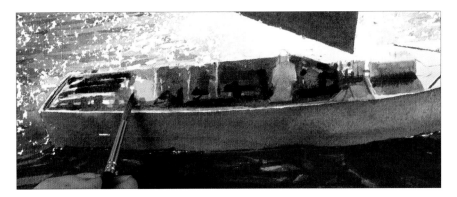

50 Paint more darks with the the ultramarine, burnt sienna and quinacridone magena mix. Paint negatively around the lighter figures.

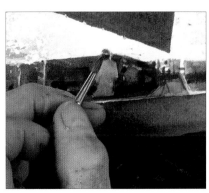

51 Use the no. 4 brush and burnt sienna to paint the right-hand figure's head, hat and arms.

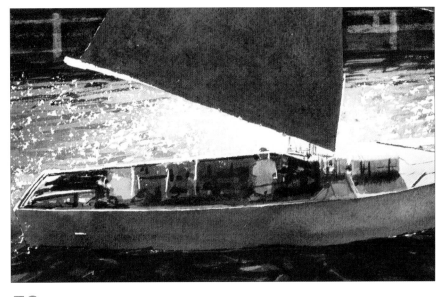

52 Add fine detail to the figure and the boat with a dark mix of ultramarine and burnt sienna, painting negatively to refine his shape. Allow to dry, then remove the masking fluid from the boat.

53 Work on the details of the other figures: paint cobalt blue for the tall figure in the middle and add burnt sienna for his head. The next figure to the left wears burnt sienna clothing. Suggest the shirt of the left-hand figure with a pinkish mix of burnt sienna and quinacridone magenta, and drop in cobalt blue.

54 Paint in a tiny head as you can always make heads bigger later, with burnt sienna and quinacridone magenta. Drop in ultramarine and burnt sienna on the shaded side of the figure and add the arm on the helm. Allow to dry.

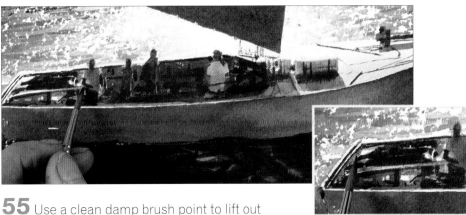

55 Use a clean damp brush point to lift out colour for the tiller, joining it to the figure's arm. Add browns in the stern with a mix of burnt sienna and ultramarine.

56 Use a dark mix of burnt sienna and ultramarine to paint all the fine detail of the main sail.

57 Mix quinacridone magenta with burnt umber and paint the mast.

58 Add all the detail of the furled sail and wires attached to the mast.

59 Paint the darker shade on the right-hand sail with quinacridone magenta, burnt sienna and a little ultramarine.

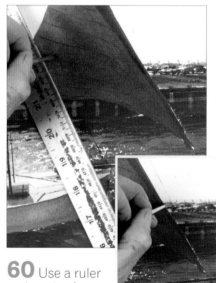

60 Use a ruler and a mix of ultramarine and burnt sienna to paint one of the lines of rigging. Beyond the sail, continue the line with quinacridone magenta. Paint the line to the right of the sail freehand.

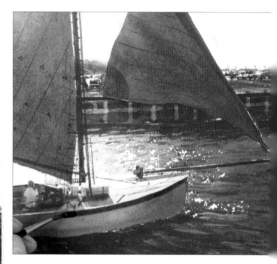

61 Paint along the rim of the boat with a strong, dark mix of ultramarine and burnt umber.

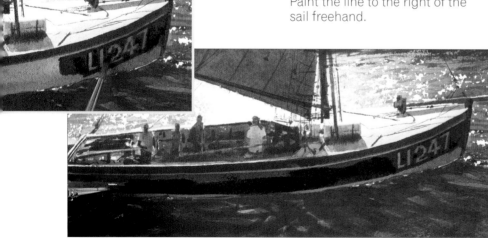

62 Paint negatively around the boat letter and numbers and continue painting the dark side of the boat.

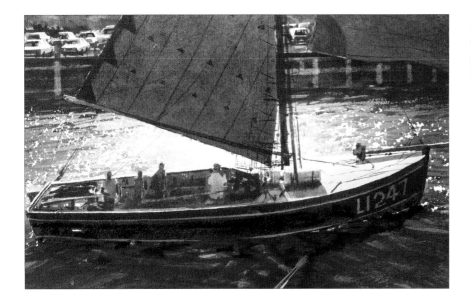

63 Add dark ripples with the same mix of ultramarine and burnt umber to bring everything together.

64 Lift out paint with a damp brush and dab with kitchen paper to create the bow wave, then drag a little colour in from the surrounding water.

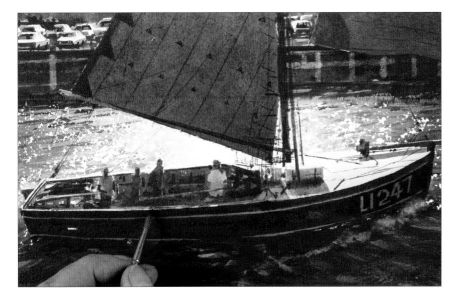

65 Make a shadow mix of burnt sienna, ultramarine and quinacridone magenta and paint broken shadows over the gunwhale.

Overleaf

The finished painting.

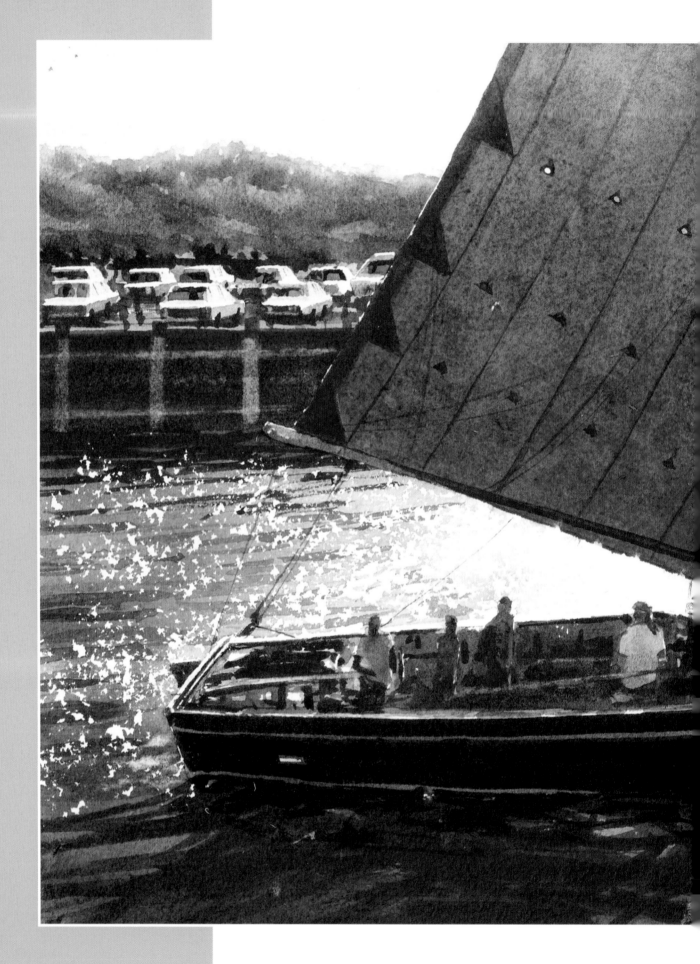

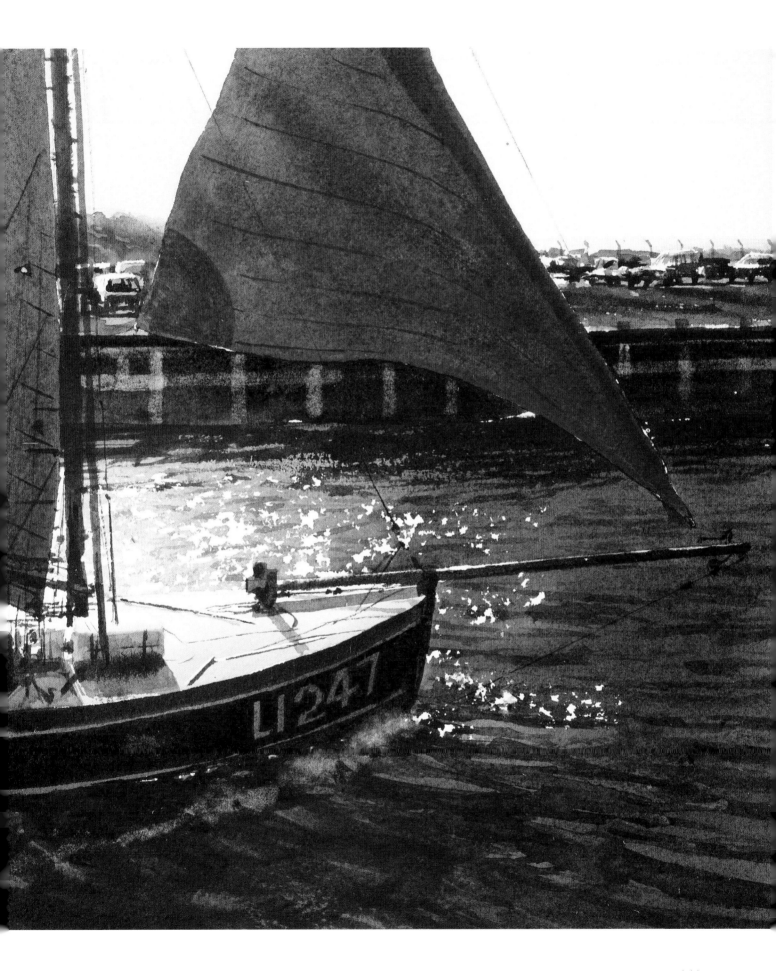

'Freetime' on the River Ant near the Wayford Bridge

The colours for the trees in this painting were green gold, quinacridone gold, phthalo green and Payne's gray for darks, burnt sienna for warmth, and cobalt blue with burnt sienna added to green gold for a distant, low-key green. These were used in the reflection. A blue-grey from cobalt blue and burnt sienna was applied to the sky to help the white boat shapes stand out. The river was wet and the sky colour was brushed into the lower part of the water only, and left to dry. The trees were loosely brushed and spattered using quinacridone gold and green gold. I spattered paint into water spatter for the trees.

Notice the almost dead straight lines of hulls on the waterline. The curved deck of 'Freetime', the nearby boat, is restrained. One method is to draw a straight line here, and then put a slight deflection down and draw a shallow curve. This is important because artists often mistakenly put too much curvature here. The mast and rigging had been masked. The rigging goes up to a single point drawn above the painting area so that it all lines up. I wet the side and back of the boat, applied colour and allowed it to flow across the hull, leaving a light area at the front. When this was dry, I wet the near side only, applied colour to the underneath and allowed it to flow up. This made the side darker than the back, leaving the facet at the rear lighter.

I wet most of the tree reflection first, then brushed in very wet colour. I kept it away from the light boat reflections and applied a little gum arabic to the white reflection areas with a few brushstrokes. I used a clean, wet brush to shape the reflections in the surrounding wash. The gum arabic kept these soft-focus whites stable and slowed the progress of paint into the still-wet white. This is a way of reserving blurred-looking light and creating wet-looking reflections. I continued to apply deep, rich colours to the 'mass zone', the area where everything seems to blend together. Then I rippled off the bottom of the reflection in the 'break zone' with its hard, rippling edge. The mast was very carefully lifted when the wash dried with a sable brush and dabbed with kitchen towel.

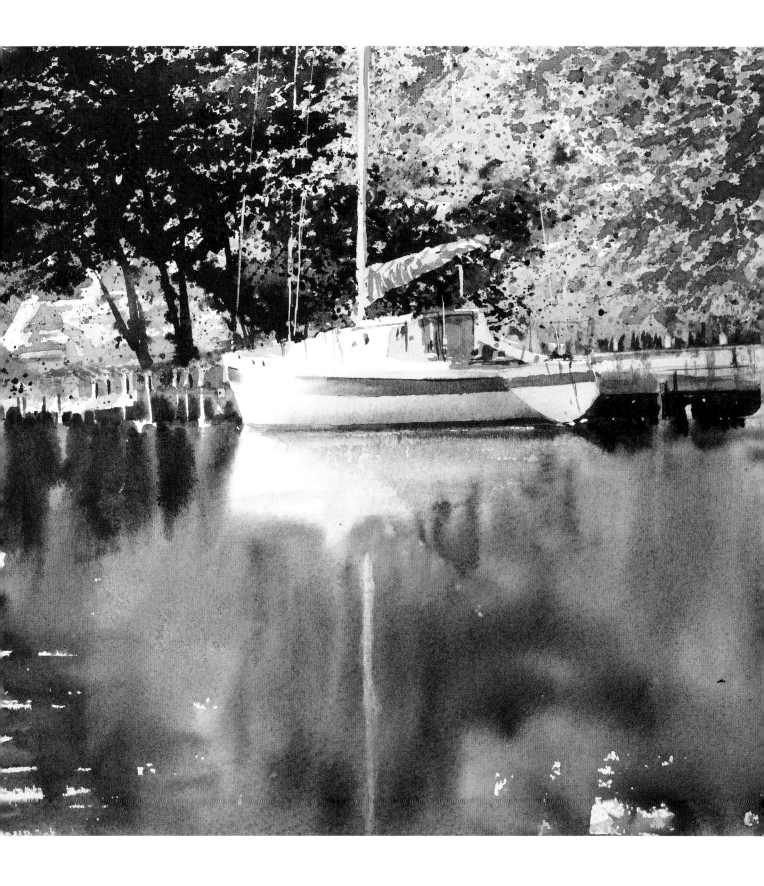

Arabian Pool

Painting underwater stones can be one of the most exhilarating subjects. I have observed clear pools where you can see to the bottom in many locations. Few scenes are more beautiful than an Arabian mountain Wadi such as this one in the Sultanate of Oman. It appears shallow, but is deeper than it looks. This is because of refraction, the bending of light when it travels through water. A painting technique for making the rocks appear to be underwater is used here. The rocks are squashed in proportion down to slim, linear shapes, which makes them seem underwater, even if you know nothing about refraction. There are other techniques in this project for painting water you can see through. Use the systems shown, whether you want realism or something more expressive.

You will need

Masking tape

Masking fluid, colour shaper and masking fluid brush

Brushes: no. 7 round, no. 4 round, 38mm (1½in) hake

Colours: cobalt blue, burnt sienna, Naples yellow, quinacridone magenta, cerulean blue, ultramarine blue, cadmium orange, burnt umber, green gold, quinacridone gold

Scrap paper for mask

Kitchen paper

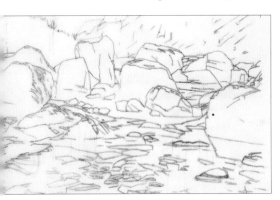

1 Draw the scene. I keep a tracing of the drawing so that I can keep referring to it as I paint.

2 Mask the edges of the painting area with masking tape. Apply masking fluid to the tops of the rocks with a colour shaper, then to the very slim stones in the water with a masking fluid brush. Allow to dry.

3 Use a no. 7 round brush with a pale mix of cobalt blue and burnt sienna to put in the sky and background. Use the point of the brush to go round the edges of the rocks.

4 Paint a pale layer of colour on the rocks mixed from Naples yellow, cobalt blue, burnt sienna, quinacridone magenta and cerulean blue. Use a dry brush to create texture in places.

5 Vary the colour as you go, picking up the different colours that make up the mix. Make the mix darker at the bottom. Allow to dry.

6 Wet the area of the background rocks and drop in a mix of burnt sienna, ultramarine and quinacridone magenta.

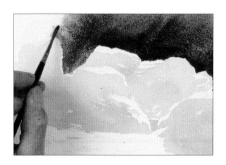

7 Still working wet in wet, continue with a browner mix to the right, and add a touch of cadmium orange.

8 Add more blue to the mix on the right. Paint negatively round the rocks with a no. 4 brush and a dark mix.

9 Change to the no. 7 brush and paint a pale bluer mix for the distant rocks on the left.

10 Make a very dark mix of ultramarine and burnt sienna and paint texture in the rock face, still working wet in wet.

11 Mask the rest of the painting with scrap paper. Pick up the same colour mix on your brush, fairly wet, and tap the brush against your hand to spatter paint over the background rocks. Allow to dry.

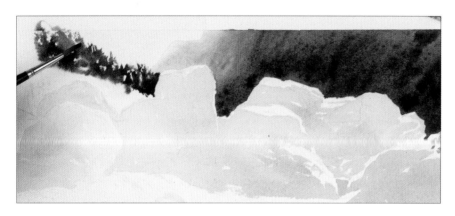
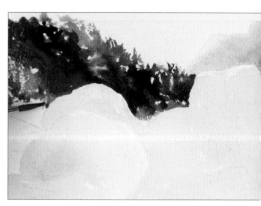

12 Change to the no. 4 brush. Wet the area on the left. Mix ultramarine, burnt umber, green gold and cadmium orange and put in palm trees, with some dry brush work and some wet.

13 Continue painting the palms, varying the colour mix, adding more orange and more ultramarine in places. Add cerulean blue to create a different green. Paint a mix with more cadmium orange and green gold down towards the rocks.

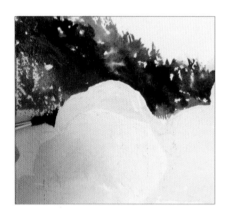

14 Drop in a strong, dark mix of the palm colour, with lots of blue.

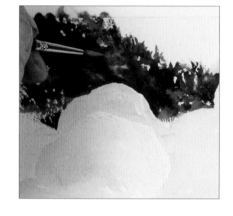

15 Paint on dabs of neat cadmium orange to create warm highlights.

16 Begin to darken the middle ground rocks with a mix of cerulean blue, burnt sienna, Naples yellow and quinacridone magenta.

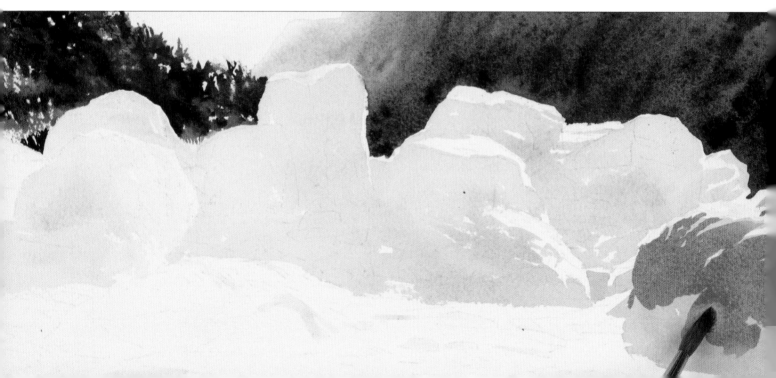

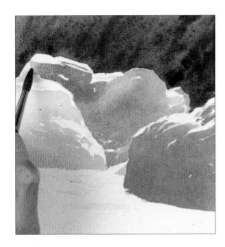

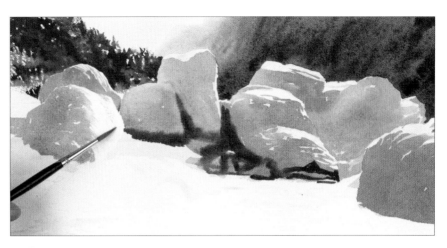

17 Continue painting the middle ground rocks with another layer of colour, varying the mix as you go.

18 Mix burnt sienna and ultramarine to create the dark shadows in these rocks and paint them in wet in wet, using the no. 4 brush. Paint a pale mix of the same colour on to the left-hand rock using the dry brush technique.

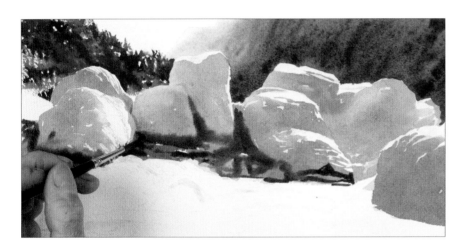

19 Add lots of burnt sienna to the mix and continue painting the shaded areas of the middle ground rocks.

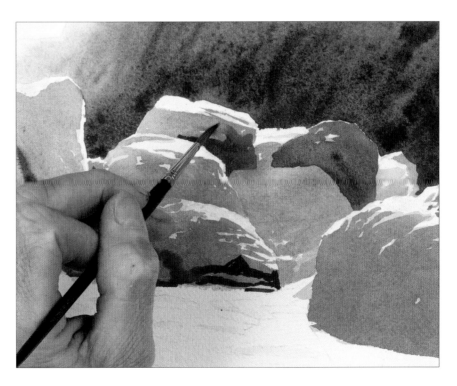

20 Use the burnt sienna mix to paint warm dark tones on to the rocks on the right.

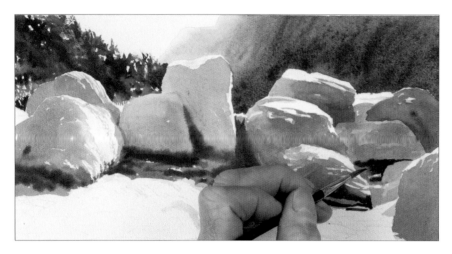

21 Mix cerulean blue, burnt sienna and quinacridone magenta and begin to build up the pattern of the rocks.

22 Paint a dark crack with ultramarine and burnt sienna above a light area, to suggest a ledge or fissure.

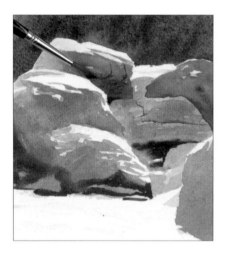

23 Continue painting cracks where the existing paint suggests, and soften any hard edges with water.

24 Brush water across the tall rock as in the dry brush technique, leaving some of the paper surface dry. Brush burnt sienna into the water to create texture. This is called water feathering.

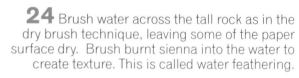

25 Add shadow around the crack between the two rocks with burnt sienna and cerulean blue.

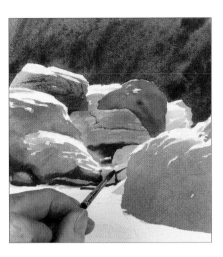

26 Paint more dark details with burnt sienna and ultramarine and soften the edges with clean water.

27 Paint the dark detail of the rock on the far right with a mix of ultramarine and burnt sienna with a bit of cerulean blue and quinacridone magenta.

28 Add more dark shadow on the left-hand side, and create texture with the dry brush technique.

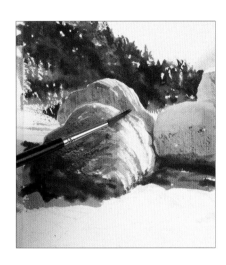

29 Paint very pale shadows with a light wash of cobalt blue and burnt sienna.

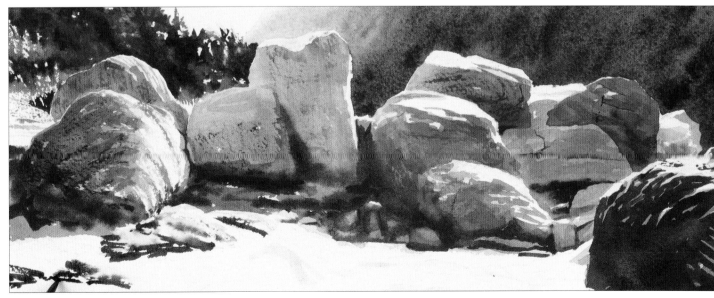

30 Brush water on to the rocks below these middle ground rocks, leaving some dry paper, then paint a dark mix of ultramarine and burnt sienna into the water.

31 Paint a further layer of the same dark mix on to the rock on the far right.

32 Lift out colour using a damp brush to create highlights on top of the rock then dab with kitchen paper.

33 Brush with a damp brush, then dab with kitchen paper to lift out a palm trunk on the left of the painting.

34 Do the same to create some curved palm fronds.

35 Paint palm tree fronds at the top of the lifted out trunk with a mix of ultramarine, burnt umber and green gold.

36 Mix cerulean blue and burnt sienna and paint the shadowed side of the rock at the water's edge. Add darker shadow with ultramarine and burnt sienna.

37 Wash over the area of the sky reflection in the water with the no. 7 brush and a mix of cobalt blue, burnt sienna and green gold.

38 Soften the edges of the reflection outwards with clean water, then drop a bluer mix into the middle, wet in wet.

39 Drop in green gold and allow to dry.

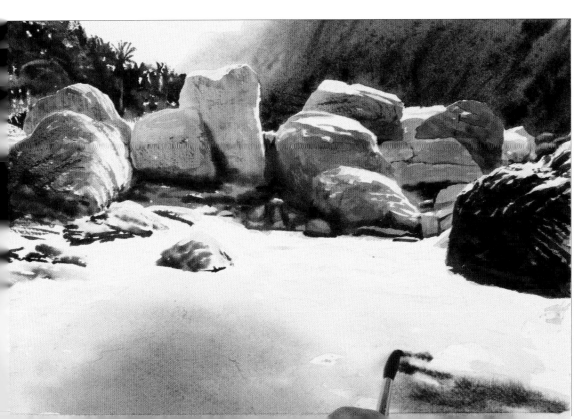

40 Wet the whole water area. Brush in a mix of quinacridone gold, burnt sienna and a little cobalt blue.

151

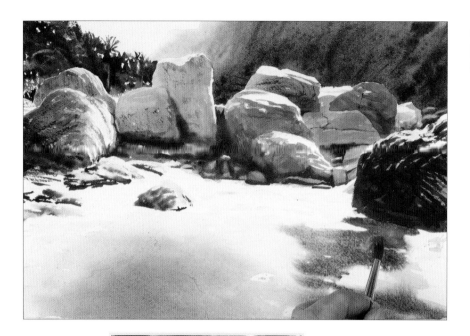

41 Vary the mix by adding a bit of burnt sienna and cadmium orange, and paint up to the right-hand rock.

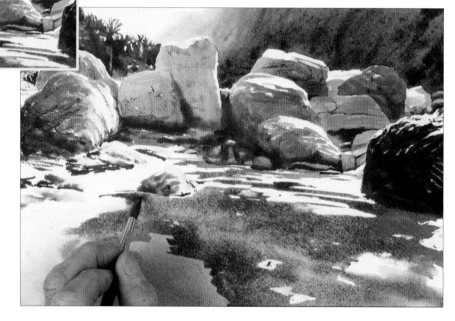

42 Use the point of the brush to paint thin, horizontal brush strokes towards the rocks, leaving some white paper. Paint round to the left of the water area, leaving the sky reflection free of the deeper colour.

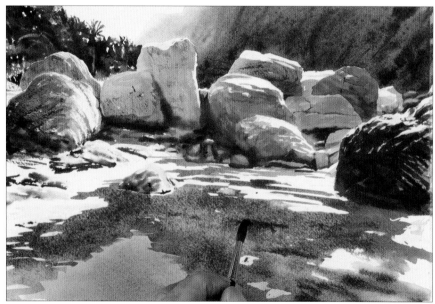

43 Use the no. 4 brush to paint the finer details of the water's edge on the left. Add more green gold to the mix. Use the no. 7 brush to put in soft darks suggesting shadows under the underwater stones, painting wet in wet with a mix of ultramarine and burnt sienna. Allow to dry.

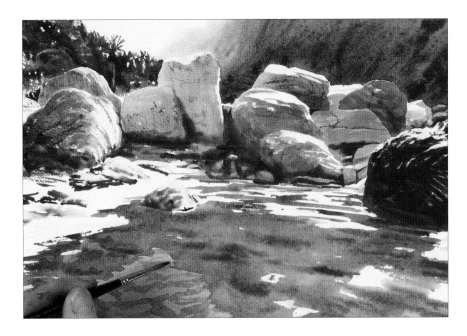

44 Note the underwater rocks below the bluish sky reflection. Paint their shadows wet on dry with a mix of cobalt blue, burnt sienna and green gold.

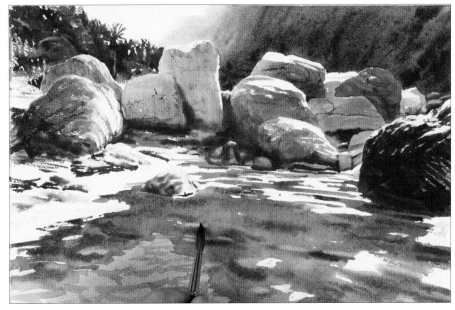

45 Lift out colour to suggest the lighter parts of the underwater stones in the shadowed part of the pool, using a damp brush, then dabbing with kitchen paper.

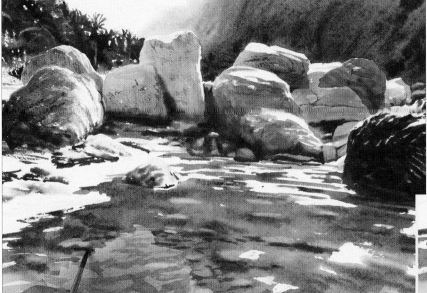

46 Use the no. 4 brush to paint more dark shadows, suggesting stone shapes under the water with cobalt blue, burnt sienna and green gold. Lift colour from the lighter parts of the rocks within the sky reflection with a damp brush, then dab with kitchen paper.

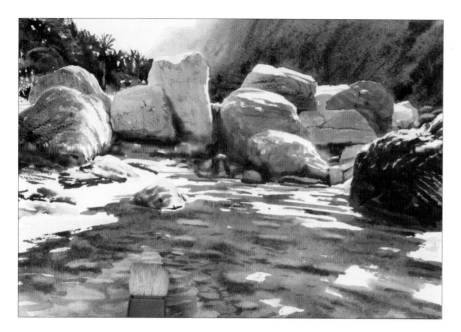

47 Brush the whole area of the water with clean water, using a 38mm (1½in) hake brush. Use the no. 7 brush to loosen up the edges of the sky reflection.

48 Create vertical reflections down into the water with downward strokes of the no. 7 brush, lifting out colour.

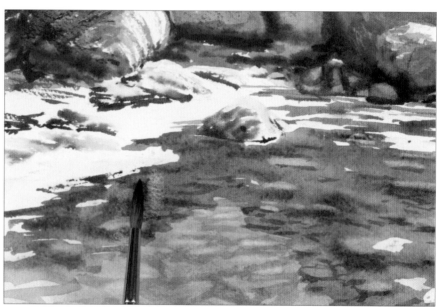

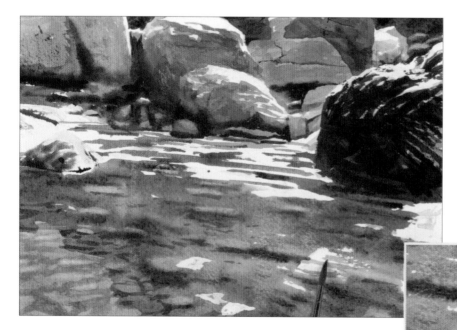

49 Remove some of the masking fluid. Use the no. 4 brush to dab colour on the bright rocks showing through the water surface, with a pale mix of Naples yellow, cobalt blue and burnt sienna. Paint shadows under the rocks with a dark mix of ultramarine and burnt sienna.

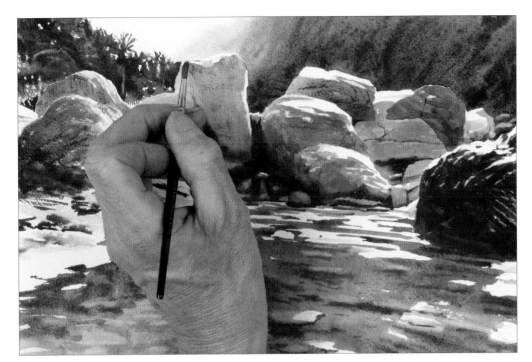

50 Remove the rest of the masking fluid. Drag the paler rock colour over the rocks on the left, and the tops of the middle ground rocks, leaving some white paper for highlights.

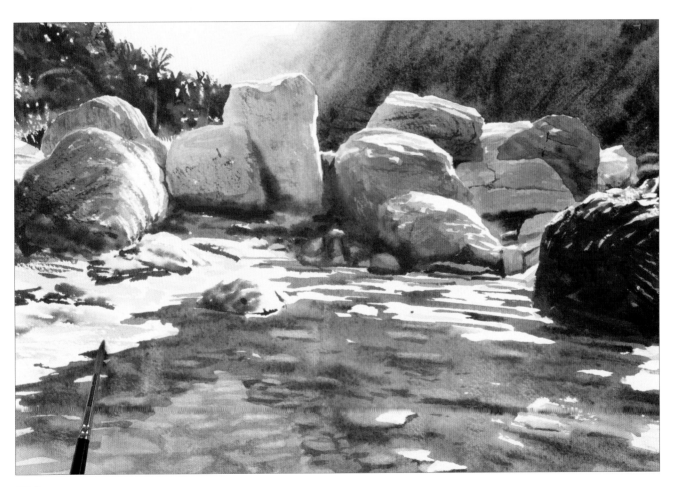

51 Continue painting the highlights on the rocks, using ultramarine and burnt sienna on the darker rocks and the pale mix of Naples yellow, cobalt blue and burnt sienna on the sunlit rocks.

Overleaf

The finished painting.

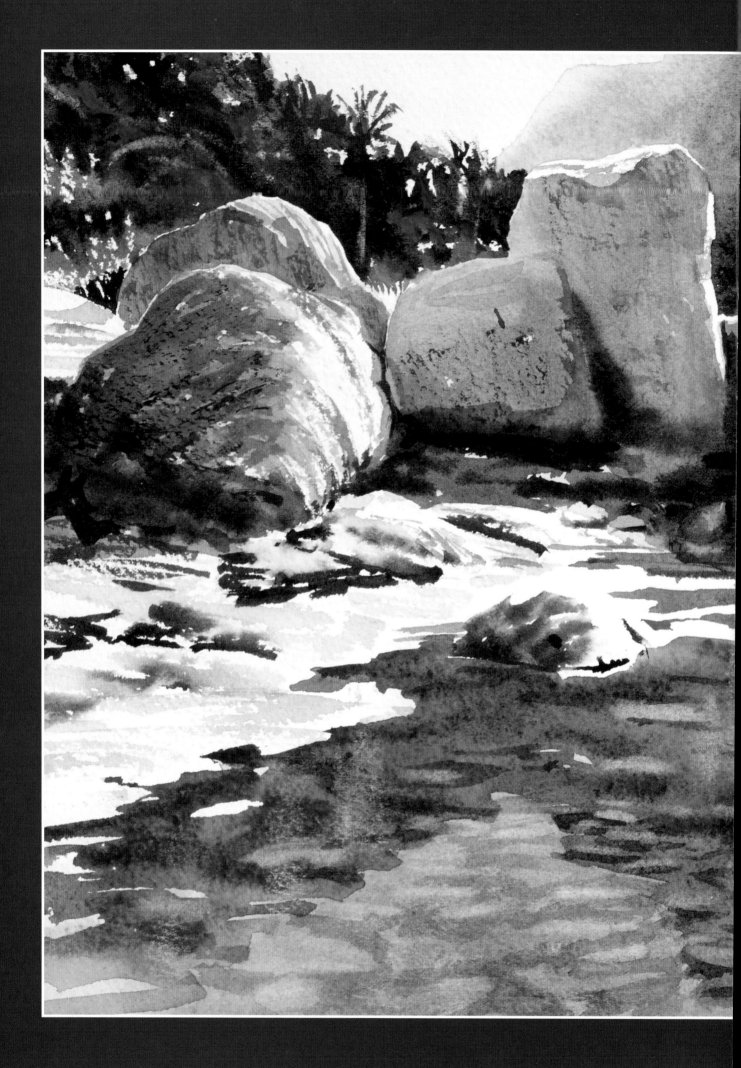

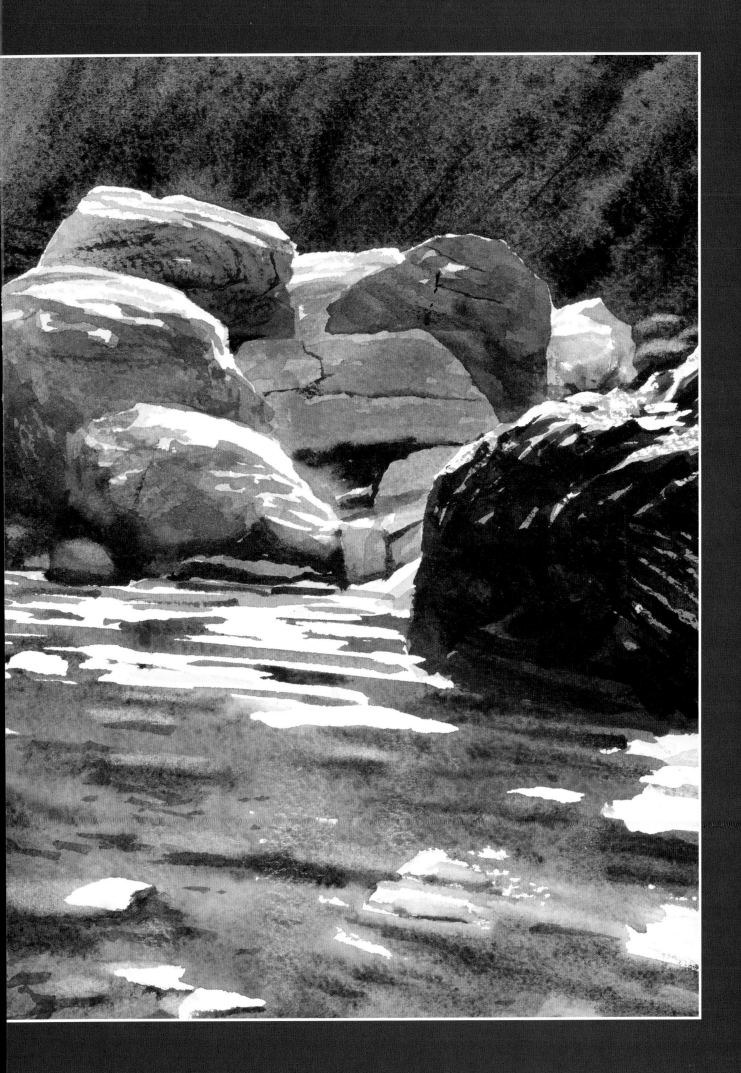

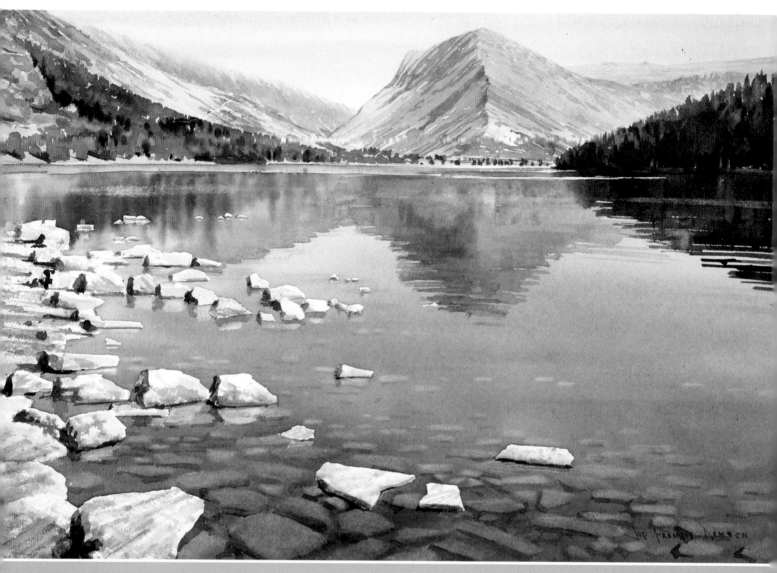

Fleetwith Pike and Buttermere

I wanted to use this scene as a vehicle for painting underwater stones. I exaggerated the clarity of the stones and enlarged them greatly. The monolith is Fleetwith Pike in the Lake District, with the Honister Pass to the left, and behind it, Dale Head rises.

I masked the rocks first. I applied a wash of water to almost the whole image, saving one small light in the distant hill for a house shining in the sun. I applied very pale yellow ochre to the lower sky, then brushed cobalt blue and burnt sienna from the top down over the whole painting in a flat wash, reserving the light in the hill.

Next I brushed water on to the whole mountain area up to the ridge and added a pale, violet-grey mix of cobalt blue, quinacridone magenta and burnt sienna. I brushed this below the ridge and let it find its own way there. This gave a soft edge to the mountain ridge. I painted the lower mountain slopes with a very low-key green of cadmium lemon, cobalt blue and yellow ochre, and in places added some burnt sienna. When this was dry, I brushed on a pale but slightly darker version of the same colour, creating the shadow side of the central mountain, and streaks of colour for texture elsewhere. I then let this dry too. Finally I brushed darker streaks for another layer of texture.

The wooded lower slopes were painted with ultramarine blue, cadmium lemon and burnt sienna, and for the right-hand side, phthalo green and Payne's gray, with cadmium lemon dropped in when still wet. The distant streak in the water was masked.

Once this was dry, I wet the lake. A wash of quinacridone magenta and burnt sienna was brushed into the foreground and blended up so that by halfway up, it was clear water. The foreground water should look very red at this stage. I brushed a very pale phthalo blue wash, greyed with burnt sienna and quinacridone magenta, down from the far lake edge, getting very strong in the foreground. I added more colour into the foreground of phthalo blue, quinacridone magenta and burnt sienna in an almost black mix. When this was dry, I added the mountain reflection mass with a very wet wash on dry paper, using the mountain colours. Notice the vertical streaks of colour dragged down wet in wet. The dark forest to the right was reflected with Payne's gray and phthalo green.

I removed the masking and touched in a little phthalo blue, greyed with the mountain grey colour. A soft streak of wind on the surface was lifted with a damp brush. I then lifted out the rocks using a damp sable and dabbing with a piece of kitchen paper. Try to lift many different random shapes. This is a little difficult with the elongated shapes you need to suggest that the rocks are underwater. The larger stones in the foreground are less elongated and larger. Start lifting stones in the distance and work back into the foreground, making them bigger as you get nearer. When I had finished lifting out colour for the stones, I touched them back in with burnt sienna. While they were wet, I painted some shadows around them in the water. Once they were dry, I removed the masking and touched in the rocks. I dragged grey across them and then added dark to the shadow sides. I varied the colour a little.

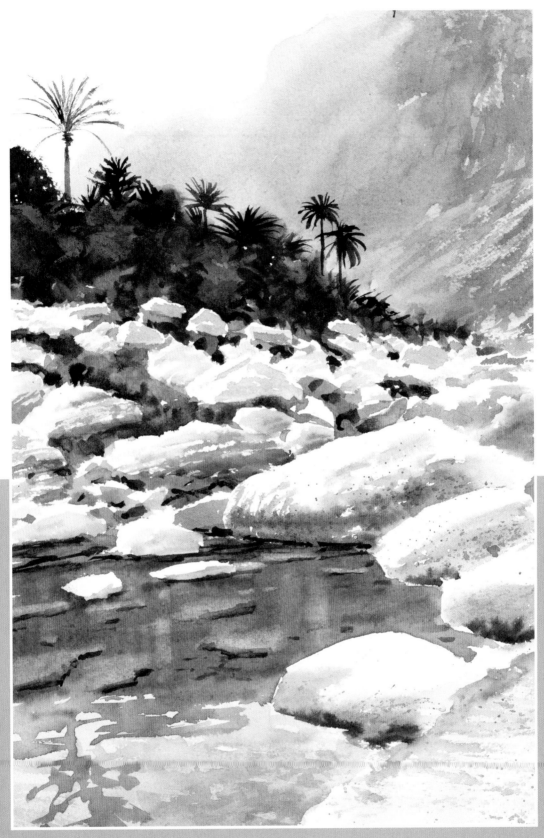

Rocks and Palms in the Sultanate of Oman

*None of the rocks were masked in this painting. I reserved their lights, choosing to paint round them instead.
For the mountains, I appled colour into a water wash to get the misty effect. I painted a violet-grey sky reflection
wash in the water, and when this was dry, I placed another very light wash over this in the foreground, leaving
a few lights as a subtle hint at underwater stones. The warm grey wash reflecting the palm tree backdrop was of
green gold, burnt sienna and cobalt blue. A few stones were lifted out very softly and indistinctly, and they were
given grey shadows on their sides. It was important to keep them very flattened off. There are also a few lifted
vertical lights in the water. The surface rocks were loosely touched in.*

Index